TELEPEN

100292337 9

KT-569-062

SHEFFIELD HALLAM UNIVERSITY
LEARNING CENTRE
WITHDRAWN FROM STOCK

Typefaces for desktop publishing

Alison Black

Typefaces for
desktop publishing
a user guide

Architecture Design and Technology Press

LONDON 1990

First published in Great Britain in 1990 by
Architecture Design and Technology Press
128 Long Acre, London WC2E 9AN
An imprint of Longman Group UK Limited

copyright © 1990 Alison Black

ISBN 1-85454-841-7

All rights reserved; no part of this publication
may be reproduced, stored in a retrieval system,
or transmitted in any form or by any means,
electronic, mechanical, photocopying, recording,
or otherwise without the prior written permis-
sion of the publishers.

British Library Cataloguing in Publication Data:
a CIP record for this book is available
from The British Library

Printed and bound in Great Britain by
Butler and Tanner Ltd, Frome

Acknowledgements

The idea for this book arose from meetings of a working party on desktop publishing, organized under the auspices of the British Library, Office for Humanities Communication. I was a member of the working party, together with Catherine Griffin, May Katzen, René Kerfante, Paul Luna, John Miles, David Saunders, Richard Simpson, Richard Southall and Michael Twyman. I would like to acknowledge the contribution of those members of the working party who read and commented on a first draft of the text or responded to requests for assistance with illustrations. My special thanks are due to Paul Luna, who organized our meetings at Oxford University Press; to David Saunders, who arranged a donation of typefaces from the Monotype Corporation to the Department of Typography & Graphic Communication at Reading University, in order to help increase the range of illustrative material in the book; and to Richard Southall, whose detailed comments improved my discussion of the technology of typeface reproduction, and who produced several complex illustrations. I would also like to thank Tom Neville, of Architecture Design and Technology Press, for taking on the book in its infancy and for his flexibility over its subsequent development and production.

I prepared most of the book whilst I held a postdoctoral research fellowship in the Department of Typography & Graphic Communication, University of Reading, and was fortunate to have access to the Department's desktop publishing facilities. I am grateful to those colleagues and students, many of whose work is represented in the book, who kept me cheerful as the task wore on. I benefited from the enthusiasm of Andrew Boag, with whom I learnt much of what I now understand about DTP, and of Steve Taylor, who took an active interest in the book from its earliest stages and was an invaluable production assistant as it neared completion.

I received help from a wide circle of people, including Terry Byrne, Clive Girling, Mike Glover, Rachel Hewson, Pauline Kaplan, Pat Norrish, Peggy Smith, Jane Stephenson, David Stout, Rob Waller and Malcolm Wooden. I am indebted to Mike Johnson, who answered a barrage of technical queries and produced materials for some of the illustrations, and to John Lane, who read the text very closely and made suggestions for improvements that prevented me from making some outright blunders. I am grateful, too, to Robin Kinross for his rapid and diligent reading of page proofs.

Many other people have helped and encouraged me, often simply by waiting for 'normal communication to resume': I have relied on the patience of my close friends and of my family. My greatest debt, though, is to the designer of the book, Paul Stiff, without whose constant practical and moral support this book is unlikely to have been written, probably would not have been produced, and certainly would not have been produced to its current standard. ASB July 1990

Contents

About this book viii

part 1 Criteria for choosing typefaces

chapter 1 **The character set** 3

 1.1 Standard character sets 5

 1.2 Augmenting standard character sets 7

chapter 2 **Legibility** 10

 2.1 Legibility at the character level 12

 Characters that are too distinctive 12

 Characters that are not clearly differentiated 13

 Appearing size 14

 2.2 Legibility at the word level 15

 The vertical dimension 15

 Horizontal cohesion 15

chapter 3 **Typeface performance in context** 19

 3.1 Performance and document content 26

 Character distribution within the text 26

 Text elements that need to be differentiated 28

 Differentiation with emphasis 28

 Differentiation without emphasis 34

 3.2 Performance and document format 37

 Vertical spacing and type size 39

 Word spacing, justification mode and line length 39

 Spatial relationships between text and page 43

 3.3 Performance and document genre 45

 Appropriateness 45

 The conventions of typeset documents 50

 Emphasis 51

 Characters with special functions 51

 The use of tabulation and word spaces 52

chapter 4 **When nothing works** 53

part 2 Typeface production, reproduction
 and multiplication

chapter 5 **Technology and typeface management** 57

 5.1 Bitmap and outline character descriptions 57
 Bitmap descriptions 58
 Outline descriptions 60

 5.2 Raster imaging, page description languages and font formats 64
 Raster image processing 64
 Page description languages 65
 Font formats 67

chapter 6 **Technology and typeface appearance** 69

 6.1 Laser printer technology 70
 'Write-black' and 'write-white' laser printers 70
 Boosting the clarity of laser-printed images 72

 6.2 Imagesetting and the photographic process 73
 Imagesetting on paper and on film 73
 The photographic process 73

 6.3 Printing and photocopying 74
 6.4 Quality control and record keeping 75

chapter 7 **DIY character production** 77

 7.1 Methods of character production 78
 Interactive character production packages 78
 Programming character descriptions 80

 7.2 Procedures in character production 81
 Researching characters 81
 Drafting 82
 Evaluation 83

part 3 The technical description of typefaces

chapter 8 **Terminology for typefaces and their variants** 87

 8.1 Typefaces, variants and fonts 87
 8.2 Character sets and characters 90

chapter 9 **Measuring typefaces** 91

 9.1 The vertical dimension 93
 Dimensions of a character 93
 Space between lines 95

 9.2 The horizontal dimension 96

 Further reading 99
 List of illustrations 100
 Index and glossary 103

About this book

This book is about choosing and using typefaces in desktop published documents. It should be helpful to authors who are desktop publishing their own documents, to people advising authors (computer centres, design studios and publishing houses), to people in corporate desktop publishing, and to student designers who are getting to grips with designing texts.

Many books on desktop publishing focus on designing as an aesthetic problem, remote from the nitty gritty of production. But this book places decision-making about typefaces within the wider context of working with current technology to plan usable documents. The chart opposite indicates some of the questions that need to be asked when decisions about typefaces are made, and shows where help in answering those questions can be found in the book.

Wherever possible, real desktop published documents (some good, some bad) have been used as illustrations to show the things that can succeed, or go wrong, in real-life desktop publishing. Browsers may wonder that so much could be written about typefaces; aren't they, after all, nothing more than a menu selection? But that is the 'gee whizz', quick and easy view of DTP, which, as most desktop publishers know, rarely delivers the promised 'professional look'. Not all the detail in the book will bear on every decision about typefaces. But the detail is given on the principle that is better to make informed decisions about what to take into account and what to ignore than to blunder on in ignorance of everything beyond the menu.

The book can be read as a continuous text (although part 3, on the technical description of typefaces may seem rather dry: it is intended, mainly, to flesh out technical details of the discussion in parts 1 and 2). It should also be possible to dip into different sections of the text whilst working on a document. The contents list and the chart opposite should help guide you to the information you need, and cross-references within the text should encourage you to jump from place to place. The index and glossary (p.103) provide a further route through the text. New technical terms are italicized at their first occurrence in the text: their definitions and further references can be found in the index and glossary.

Much of the book deals with looking at typefaces and seeing how they work. So 'reading' this book should be as much about examining the illustrations and their captions as reading the words of the main text. Details of the illustrations are listed on pages 100–102. A word of apology may be necessary here: as far as possible, illustrations were chosen that could be relied upon to make their point clearly. But some of the details that affect the appearance of typefaces are small and, whilst clear in the originals, may have lost some of their definition in reproduction.

The book has been written in general terms to cover desktop publishing using the wide range of equipment currently available. But some of the discussion cannot avoid mention of particular hardware or software. Such references should be taken in their most general sense. For example, most of the discussion of medium resolution output devices focuses on laser printers, but much of what is said could apply to other medium resolution devices, such as inkjet printers. Changes in DTP technology may mean that some specific references, particularly to software, may become obsolete. But changes in software usually bring improvements and so are to be welcomed. If, in the long term, all references to the quirks of DTP software and its handling of typefaces were to become out of date, it would, indeed, be something to celebrate.

The chart opposite lists the kinds of information you need to gather about typefaces in order to be sure that they will meet your needs, and points you to the relevant chapters and sections of the book for more detail.

Document requirements	The typeface and DTP system
Are there typefaces with the characters needed for the text?	Examine typeface character sets (section 1.1) and available sets of symbols (section 1.2). Will a combination of typefaces be necessary? (section 1.2) Is there software available to generate characters for non-text setting, e.g. maths? (section 1.2) Does the system allow DIY character production, e.g. for non-latin scripts? (chapters 4 and 7)
Would specific typefaces produce legible documents? Note distinctive character distributions in the text that may cause legibility problems (section 3.1).	Produce sample settings of candidate typefaces on your system (chapter 2). Check all the variants and sizes that are likely to be used: examine characters individually and in groups (section 2.2), and in the kind of format in which they will appear in the planned documents (sections 2.2 and 3.2).
Do typefaces offer the range of distinctions needed to articulate text structure? Analyse the text to see which elements require different treatments. Note especially where contrasts in treatment are needed (chapter 3).	Produce samples that resemble pages of documents (chapter 3). Test the capacity of individual typefaces to signal contrasts (section 3.1). If more than one typeface is necessary, experiment to see which combinations give best contrast or best harmony (section 3.1). Can the different typefaces be used together in the system? (section 5.1)
Are the typefaces appropriate for the genre? Check existing documents of the same genre, noting their formatting conventions (sections 3.2 and 3.3).	Consider the implications of formality in particular typefaces (section 3.3).
Are typefaces suited to the planned method of document production?	Examine samples from the output device to be used and, ideally, samples that have followed the full production route planned for your document (chapter 6). If appropriate, consider steps to ensure good quality reproduction from medium resolution originals (section 6.1). Discuss production route and any problems with typesetting bureau, printer or publisher (sections 6.3 and 6.4).

part 1 Criteria for choosing typefaces

letters	A B C D E F G H I J K L M N O P Q R S T U V W X Y Z a b c d e f g h i j k l m n o p q r s t u v w x y z
numerals	1 2 3 4 5 6 7 8 9 0
orthographic & phonetic variants of latin letters	Ø Æ Œ ø æ œ fi fl ß Á Â Å Ç È Ë Ê Í Ì Ï Î Ó Ò Ú Ù Û Ÿ å ç ₁ ᵃ ᵒ
Greek letters	Δ Ω Π Σ ∂ µ π
diacritical marks	ˋ ˊ ˆ ¨ ˜
punctuation	· , ; : ! ¡ ? ¿ … ' ' " " « » ‹ › „ () [] { } \ \| / - – — _ ¬
symbols	& @ ™ © ® £ $ ¢ ƒ ¥ ¤ % ‰ ⋆ † ‡ # § ¶ + ± ÷ / = ≠ ≈ < > ≤ ≥ ∞ ~ · √ ∫ ' " ^ ° ˆ ˘ • ◊

Figure **1.1**
The characters that can be accessed from the keyboard of an Apple Macintosh computer when the typeface Bembo is used in its usual *encoding*. Note that the Greek letters and some of the symbols (including the Apple device) are Adobe symbols and not characters of Bembo.

Figure **1.2** (below)
A 'map' will help you find characters that are not visible on the keys. This map is supplied with Adobe Type Manager.

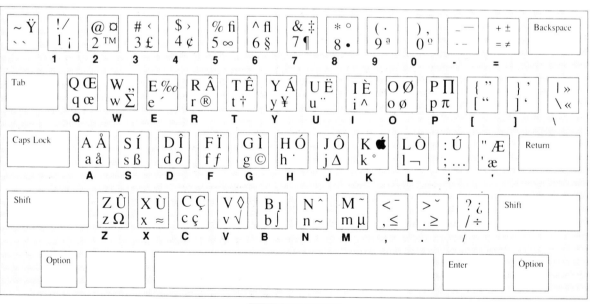

chapter 1 The character set

The typefaces you use should include all the characters needed for the documents you intend to produce. Typeface manufacturers often do not supply full listings of the *character sets* of their typefaces, and, where they do provide listings, some of the listed characters may not be immediately accessible within your system. So you should produce your own listing, testing the characters delivered by every key on your keyboard. Remember that many characters in a typeface are not visible on the keyboard but can be produced using the 'option' or 'alt' mode (and 'shift-option' or 'shift-alt' combinations too).

Organizing a character set into meaningful categories should help speed up checks for particular characters (Figure 1.1). Categorized character sets could be adapted for specific purposes. For example, if your documents have a mathematical focus, you might organize a character set around a 'mathematics' category that incorporates all the characters needed for mathematical setting. The inclusion of characters within particular categories depends partly on the technology with which a typeface will be used. For example, in the character set shown in Figure 1.1 some of the characters given under the heading 'symbols' (¯ and ˘) may appear to be diacritical marks, but they cannot easily be used as diacritics with standard Macintosh software running under an English-language Macintosh system.

In some systems you may be able to produce characters that you had not expected to find in a particular typeface. These characters are likely to be a sub-set of the general-purpose symbol characters included within a system to augment typeface character sets (see section 1.2). Although it may be useful to have access to these characters from within a typeface, it is worth bearing in mind that they are not designed specifically to match the typeface and may not always combine well with it. In Figure 1.1 the Greek characters (and the Apple device) are symbols and not characters of the typeface shown in the rest of the specimen, which is Bembo (see section 1.2 for more about symbols).

A keyboard map will help you get to characters from the keyboard (Figure 1.2). You may find a map in your system manual, but if not, it will be worthwhile spending time creating your own.

BRIEF CHECKLIST
1 Examining the character set

Produce a categorized character set with the hardware and software that you will use for document production.

Examine extended character sets and symbol fonts (if available) to find characters that are not in the standard character set.

If no font delivers the characters needed, consider producing them with a dedicated software package.

letters	A B C D E F G H I J K L M N O P Q R S T U V W X Y Z
	a b c d e f g h i j k l m n o p q r s t u v w x y z
numerals	1 2 3 4 5 6 7 8 9 0
orthographic & phonetic variants of latin letters	Ł Ø Æ Œ
	ł ø æ œ fi fl ß ı ª º
diacritical marks	` ´ ^ ¨ ~ ° · ˇ ¯ ˘ ˝ ‚ ˛
punctuation	. , ; : ! ¡ ? ¿ … ' ' " " « » ‹ › ‚ „ () [] { } \ \| / - – — ‗
symbols	& @ £ $ ¢ ƒ ¥ ¤ % ‰ * † ‡ # § ¶ •
	+ − = / < > ' " ^ ~ .

Figure **1.3**
The standard Adobe PostScript character set (in Times). The standard character set does not include the range of Greek and symbol characters, nor the fixed combinations of letters and diacritics that can usually be accessed from the keyboard (Figure 1.1). But it includes a Polish 'l' and a range of diacritical marks that can be combined with all other characters.

typeset documents

hyphenation	- hyphen	Consider—for the sake of argument—the period 1979–87. One index of the growth of consumer spend-ing among high-earning groups is the steadily increas-ing level of imports of vintage champagne, sports cars, and silver-plated bathroom fittings.
elision	– en dash	
parenthesis	– en dash or	
	— em dash	

typewritten documents

hyphenation	- hyphen	Consider - for the sake of argument - the period 1979-87. One index of the growth of consumer spending among high-earning groups is the steadily increas-ing level of imports of vintage champagne, sports cars, and silver-plated bathroom fittings.
elision	- hyphen	
parenthesis	- hyphen or	
	-- double hyphens	

Figure **1.4**
Typewriting characters have more general functions than the characters of printing types. See also Figures 3.47 and 3.48 (p.51).

1.1 **Standard character sets**

Usually type manufacturers have a standard character set
for all their *latin-script* typefaces, so you probably only need
to check one typeface produced by a particular manufac-
turer for the availability of characters in all their latin-script
faces. However, not all hardware and software combinations
will reproduce every character provided by the manu-
facturer, so you should always make your checks with the
hardware and software that you plan to use for document
production. For example, only a subset of the listed char-
acter set for Adobe *PostScript* language typefaces can be
reproduced when they are used in the font *encoding scheme*
(the mapping between keyboard and characters) adopted by
most suppliers. The full PostScript character set (Figure
1.3) can be reproduced if fonts are re-encoded following a
'recipe' given in the *Adobe PostScript language tutorial and
cookbook* (1985 edn, p.209), although the process of re-
encoding is laborious. If you cannot reproduce a character
that you know should be in the typeface, check that your
software is up to date. If there are no obvious software
problems and a character still cannot be reproduced, ask
the manufacturer of the typeface for advice about the con-
ditions under which it can be reproduced. If you need to
describe particular characters to other people it may help to
consult the listings of character names in International
Standards for character sets (see Further reading for details
of some relevant Standards).

Note that if your DTP system includes typewriter faces,
these may have a smaller character set than the printing
typefaces in your system. Printing types include a wider
range of accents and symbols, and some more specialized
punctuation marks than typewriter faces (Figure 1.4). For
example, in typewritten documents, the hyphen serves sev-
eral functions (hyphenation, elision, parenthesis). In typeset
documents, however, the hyphen is used only for hyphen-
ation; the en-dash is used to signal elisions (for example,
between page numbers or between dates) and the en-dash
or em-dash to signal parenthetical information or broken
speech (see section 3.3 for further discussion of the con-
trasts between typewritten and typeset documents).

Character sets from various manufacturers may differ in
the special characters (such as ligatures, diphthongs or frac-
tions) they include (Figures 1.3 and 1.5). And the special
characters that are included may vary in their usefulness.
For example, Adobe's standard character set includes 'fi'
and 'fl' ligatures which can substituted for separate 'f's 'i's
and 'l's to improve horizontal cohesion (see section 2.2);

letters

A B C D E F G H I J K L M N O P Q R S T U V W X Y Z
a b c d e f g h i j k l m n o p q r s t u v w x y z

Figure **1.5**
Part of the TEX
character set. One
of the ways it
differs from the
PostScript character
set is in its inclusion
of Greek letters.

numerals

1 2 3 4 5 6 7 8 9 0

orthographic
& phonetic
variants of
latin letters

Ł Ø Æ Œ

ł ø æ œ fi fl ffi ffl ß ı ȷ

Greek letters

Γ Δ Θ Λ Ξ Π Σ Υ Φ Ψ Ω

diacritical
marks

` ´ ^ ¨ ~ ° · ˇ ¯ ˘ ˝
 ˌ .

punctuation

· , ; : ! ¡ ? ¿ ' ' " " () [] / - – —

symbols

& @ $ % * #
+ =

letters

A B C D E F G H I J K L M N O P Q R S T U V W X Y Z
a b d e i l m n o r s t

Figure **1.6**
Expert Set for Bembo. Note
that a character set may be
tailored specifically to indi-
vidual typefaces. Here, the
Bembo extension includes an
additional capital 'R' as an
alternative to the long-tailed
'R' in the standard character
set (see Figures 1.1, p.2, and
2.4, p.12).

numerals
& numeric
characters

1 2 3 4 5 6 7 8 9 0 1 2 3 4 5 6 7 8 9 0 1 2 3 4 5 6 7 8 9 0 1_1

⅛ ¼ ⅓ ⅜ ½ ⅝ ⅔ ¾ ⅞

orthographic
& phonetic
variants of
latin letters

Ø Æ Œ Đ Ł Þ ff fi fl ffi ffl R

Å Ã Ç È Í Ì Î Ï Š Ý Ž

diacritical
marks

´ ` ^ ¨ ~ ° ˘ ˇ
 ˌ ̦

punctuation

· ˙ · , · , ; : ! ¡ ? ¿ () ⁽ ⁾ - – — ̄ ˗

symbols

& ₡ ¢ ¢ ¢ Rp $ ₷ ˢ · ° ´ ˝ ~ ˇ ˗ /

but it has no 'ffl' and 'ffi' ligatures, even though these could improve the appearance of a text. (The TEX character set includes these ligatures; Figure 1.5). Note that typefaces can be adapted to include ligatures appropriate to particular languages. The character sets of many traditional German typefaces include 'ch' ligatures; Dutch typefaces include 'ij' ligatures. Just like the English-language 'f-' ligatures, these are not available in all systems and, even when available, are not always used.

1.2 **Augmenting standard character sets**

You can buy additional, 'extended' character sets for some typefaces (Adobe and Linotype call extended character sets *Expert Collections* and Monotype call them *Expert Sets*). Extended character sets vary from system to system but, depending on the characters already in the standard set, may include *small capitals*, ligatures, superscripts and subscripts, fractions and *non-ranging numerals* (Figure 1.6). Some desktop publishing software allows you to produce small capitals, fractions, superscripts and subscripts by transforming the character descriptions in the standard character set. But these characters will look better if they are specially designed as separate characters (see comparison in Figure 8.4, p. 88).

Many documents require characters, such as Greek letters and mathematical symbols, that may not be in the standard or extended character sets of available typefaces. These characters may be available in separate collections of symbols called *symbol fonts* (or *pi fonts*) that are designed to be combined with any typeface (Figure 1.7). The characters of symbol fonts may be described as font-independent because of their supposed general applicability. In reality, though, this general applicability may be more of an intention than a reality. If you use characters from symbol fonts, you should check that they harmonize visually with your main typeface (see section 3.1 on harmony among different kinds of character within a text). Symbol fonts often include Greek letters but may not include the diacritical marks necessary for Greek. They cannot be used for Greek text without the addition of diacritical marks (note that the Classical Greek shown in Figure 3.25, p. 36, and Figure 3.31, p. 40, was reproduced by adding diacritical marks to the Greek letters of a symbol font).

a

ΑΒΓΔΕΖΗΘΙΚΛΜΝΞΟΠΡΣΤΥΦΧΨΩ
αβγδεζηθικλμνξοπρστυφφχψω ς

1 2 3 4 5 6 7 8 9 0

ℵ ℑℜ ϒ∂℘ϑϖ ΠΣ
&∴ .,;:!?… ()[]{ }

⊃∩∪∈ ∉⇐ ⇒⇔⇑ ⇓←→↔↓↑⌋
⁄⁄√ ∠∀∇∃∋∅ ‾—
+±−=≠≈÷×·′″°~∝∞
<>∨∧⟨⟩≤≥≡≅

∣∥⟨⌊ ⌋⊥⌈ ⌉⎰⎱⟨ ⟩⎛⎝⎰

%#ƒ ©©® ™™⊗⊕
∗◊♣♠♥♦•

Figure **1.7**
a Adobe's PostScript symbol characters are intended to be combined with a range of typefaces.

b

If Φ is $\Phi_1 \to \Phi_2$ any special variant Ψ of Φ is of the form $\Psi_1 \to \Psi_2$ where Ψ_i is a special variant of Φ_i for $i = 1, 2$. By the induction hypothesis, $\Phi_1 \leftrightarrow \Psi_1$ and $\Phi_2 \leftrightarrow \Psi_2$ so $\Phi \leftrightarrow \Psi$. The case where Φ is $\sim \Phi_1$ is similar.

If Φ is $\Phi_1 \to \Phi_2$ any special variant Ψ of Φ is of the form $\Psi_1 \to \Psi_2$ where Ψ_i is a special variant of Φ_i for $i = 1, 2$. By the induction hypothesis, $\Phi_1 \leftrightarrow \Psi_1$ and $\Phi_2 \leftrightarrow \Psi_2$ so $\Phi \leftrightarrow \Psi$. The case where Φ is $\sim \Phi_1$ is similar.

b 9pt bold symbols are combined with a seriffed font, 10pt Times (top) and with a sans serif font, 9pt Frutiger (bottom). (See chapter 3 on the balancing of weight and appearing size that may be necessary when fonts from different typefaces are combined.)

Some mathematical characters are not available in any character sets but can be created using special equation processors. Equation processors may be built into desktop publishing packages (such as *Ventura Publisher Professional Extension*) or may be stand-alone programs (for example, *MathType* and *Formulator*). Similarly there are special programs to set chemical drawings, such as *ChemDraw*. You will need to experiment with these programs to be sure that their repertoire meets your needs (Figure 1.8). Check the legibility of the characters and structures you create (see Chapter 2 on legibility) and their compatibility with the typefaces you will use in your document (see discussion of harmony in section 3.1).

Figure 1.8
a Equation set using Ventura Publisher Professional Extension.
b Equation set using Formulator.
c Chemical structure drawn with ChemDraw.

a

$$G_{n,i}(x,\xi) = \begin{cases} \dfrac{(e^{\lambda_n \xi} + \tau_n e^{-\lambda_n \xi}) \cosh(\lambda_n[\xi - d])}{\lambda_n(\tau_n e^{-\lambda_n d} - e^{\lambda_n d})} & , \ 0 \le \xi < x; \\[2em] \dfrac{(e^{\lambda_n \xi} + \tau_n e^{-\lambda_n x}) \cosh(\lambda_n[\xi - d])}{\lambda_n(\tau_n e^{-\lambda_n d} - e^{\lambda_n d})} & , \ x < \xi \le d, \end{cases}$$

b

$$A = \frac{1}{n}\left\{ \sum_{k=1}^{n} Z_k - B \sum_{k=1}^{n} x_k \right\}$$

$$r^2 = \frac{\left[\sum_{k=1}^{n} x_k Z_k - \frac{1}{n}(\sum_{k=1}^{n} x_k)(\sum_{k=1}^{n} Z_k) \right]^2}{\left[\sum_{k=1}^{n} x_k^2 - \frac{1}{n}(\sum_{k=1}^{n} x_k)^2 \right]\left[\sum_{k=1}^{n} Z_k^2 - \frac{1}{n}(\sum_{k=1}^{n} Z_k)^2 \right]}$$

c

As DTP develops and more typefaces are created for specific applications the range of available characters increases. For example, it is now possible to buy 'typefaces' for musical notation or typefaces designed specially for large print and children's books. However, most non-latin scripts are still poorly catered for compared to latin scripts. If none of the typefaces for a particular system gives the characters or scripts you need, you should consider using a different system. But if no system has the necessary characters, it might be better to choose a system with which you can create your own characters and fonts (see chapter 7).

Most typefaces designed for setting text are legible, to the extent that readers can recognize individual characters when they are set in text. Typefaces that do not meet this basic criterion, because their characters are either highly irregular or over-geometrical, are not suitable for text setting (Figure 2.1). Such typefaces, often described as *display faces*, have a rôle in decorative headlines and advertising captions, but not where sustained reading is intended (see discussion of appropriateness in section 3.3).

Figure **2.1**
Typefaces in which the characters are difficult to identify or to differentiate can be excluded as unsuitable for text setting.

The numbers fleeing East Germany this year have now topped 200,000. Since last Friday alone, more than 50,000 have left. Yesterday's move has unpredictable consequences but was clearly taken in the hope that the exodus could be slowed by giving

Zapf Chancery

The numbers fleeing East Germany this year have now topped 200,000. Since last Friday alone, more than 50,000 have left. Yesterday's move has unpredictable consequences but

Avant Garde Gothic

The numbers fleeing East Germany this year have now topped 200,000. Since last Friday alone, more than 50,000 have left. Yesterday's move has unpredictable consequences but was clearly taken in the hope that the exodus could be slowed

Biffo Script

When thinking about legibility you are really considering how well a typeface supports the processes of fluent reading. Normally readers' eyes make a series of fixations across a row of text, taking in a cluster of words at each fixation. In latin-script texts, words within a cluster are recognized by their overall contour, particularly by the profile of the tops of the words, and by the distribution of black and white within them (see Figure 2.2, opposite). Reading words by their overall shape is much faster than reading them letter-by-letter. Sequential letter-by-letter reading is usually a last resort if the text vocabulary is unfamiliar or word contour information is somehow disrupted.

For reading to progress smoothly the characters of typefaces should harmonize with one another, both in their

BRIEF CHECKLIST
2 **Assessing typeface legibility**

Exclude typefaces that are stylistically unsuitable for text setting.

Examine candidate typefaces in the variants and sizes that you are likely to use in your documents, checking the legibility of individual characters.

Examine sample settings produced with your hardware and software to see how well the typeface characters combine with one another.

Test candidate typefaces on other people.

letterforms and their spatial characteristics. The words of a
harmonious text should always appear to be whole units
and eye movements should not be disrupted by characters
that 'jump out' of the text. At the same time the characters
should be distinct enough to produce patterns of black and
white that are unambiguous.

In order to determine how well candidate typefaces
satisfy legibility criteria you need to carry out a series of
checks, both on individual characters of the typeface and on
characters in combination in words. A note of caution is,
perhaps, worthwhile here: the easiest kinds of legibility
checks to carry out are those on individual characters,
where you are looking for specific details, but checks on
characters as they appear together in context will give you a
better feel for how a typeface will work when it is being
read. The best legibility 'checks' may well be those that
happen when you are using a document for its intended
purpose and, quite incidentally, notice some quirk or qual-
ity of its typeface. So, whilst detailed checks on individual
characters are important, you should always bear in mind
the broader picture of the document as a whole.

Legibility checks must be carried out on paper since
screen resolution is often too coarse to allow the fine judge-
ments needed. (Because of their greater reflectance, even
high resolution screens cannot reproduce the 'look and feel'
of type on paper.) You will need a type specimen for each
candidate typeface, showing it in all the variants and sizes
in which it may be used (see illustration of type specimen
in Figure 9.1, p. 92). You will also need samples of text set
in the candidate typefaces. The text samples should be pro-
duced with the word-processing or page make-up software
which you will use for your final document, since software
packages differ in their interpretation of the character spac-
ing data within a typeface (see section 2.2). You should try
to produce text specimens on the final output device you
intend to use, as changes in the resolution, and even in the
mechanism of the output device, will have a significant
effect on character appearance (see chapter 6 on technology
and typeface appearance). However, if you plan to use a
high resolution imagesetter for final output you may be able
to make some preliminary checks at medium resolution
before paying for high resolution specimens.

Remember that legibility checks should be applied to the
accents, punctuation and symbols you intend to use as well
as to alphanumeric characters. In some DTP typefaces there
may be a poor match between the symbols and other char-
acters of the typeface (see the design of the symbols in
Adobe's and Bitstream's versions of Galliard in Figure
5.13, p. 68). Pay particular attention to the relationship
between accents and letters since these are not always ade-
quately dealt with by type designers. If you are setting text

A line of cars stretched as far as the eye
could see from the border, with drivers

A line of cars stretched as far as the eye
could see from the border, with drivers

A line of cars stretched as far as the eye
could see from the border, with drivers

Figure **2.2**
A clearly defined word contour facilitates reading. The profile
formed by the tops of words is particularly salient in latin-script
texts.

in a script of which you do not have expert knowledge, ask an expert (a native reader or scholar of the script, but preferably someone who also knows about its typesetting conventions) to carry out the legibility checks with you (Figure 2.3).

Other people's opinions are nearly always helpful in assessing legibility, particularly the opinions of people from the intended readership of the text. But you may have to be skilful in eliciting those opinions. Asking people to say which of two typefaces is the more legible may simply induce them to respond with the typeface they prefer (for reasons that have nothing to do with legibility). If you can divert people from thinking about the typeface with a distraction task (such as checking the content of text set in a candidate typeface) you can see if they comment spontaneously on any aspects of typeface quality. You can then ask explicit questions about the legibility of the typeface as a second stage of your testing procedure.

A revelação é considerada importante porque veio de Adamec, e não do líder do partido, Milos Jakes, o qual está cada vez mais isolado. Há dois dias atrás, por exemplo, Jakes apelou, sem muito sucesso, que mais jovens viessem contribuir para revigorar as atividades do partido.

Figure **2.3**
Non-experts may not notice details such as a poor relationship between accents and letters, although these details would be obvious to native or expert readers.

2.1 **Legibility at the character level**

Characters that are too distinctive

First check typefaces for any quirky characters that are likely to create irregularities in the text and may catch readers' attention, giving unintended emphasis to particular words (Figure 2.4). These characters are only critical, of course, if they appear in your text.

a

The Queen was surprised by the report. Quickly looking at her agenda, she suggested they wait until after the Quarterly Review before discussing the German Question.

b

Relieved that someone knew the way, Ruth explained her plight. "Right", said the woman "I'll come with you. Rugby Road is just a few minutes from home." Reporting the incident to friends, Ruth said she felt rather fool-

c

the burgers: so grim, grudging and greedy

d

to people engaging in struggle

Figure **2.4**
Quirky characters may give a text a distinctive appearance, but they may distract readers by drawing attention to particular words. See the capital 'Q' in Bookman (**a**), the long-tailed capital 'R' in Bembo (**b**), the 'g' and 'r' in Gloucester Old Style (**c**), and the 'g' in Galliard italic (**d**).

Characters that are not clearly differentiated

Check for characters that are likely to be confused with one another, bearing in mind the context of the text.

People often comment on the potential confusion between the numeral '1', the capital letter 'I' and the lower-case 'l' in *sans serif* typefaces. Generally, confusions among characters are most likely where contextual information is limited, for example in lists, indexes or short titles (Figure 2.5). In practice, however, context often reduces confusion (Figure 2.6).

Small distinctions between characters may be difficult to discern when reproduced at lower resolutions, or when characters are *reversed out* (that is, produced in white against a black background) (Figure 2.7).

Some combinations of characters can be confused with other, single characters, especially in italic fonts. These confusions may be more a consequence of the spacing data built into the typeface, or of its interpretation by the software, than of the design of the character shapes themselves (Figure 2.8).

Never Speak Ill of the Dead

Helvetica

Never Speak Ill of the Dead

Baskerville

Figure **2.5**
The 'I' (capital 'eye') and 'l' (lower-case 'ell') might be confused with one another, or with the numeral '1', when this short title is set in the sans serif, Helvetica. This confusion is less likely to arise with the more differentiated characters of the seriffed typeface, Baskerville.

He bowed politely and asked how they had managed to find him.

bow how

Figure **2.6**
Context restricts potential confusion among characters – in this case between the lower-case 'b' and 'h' of Galliard italic.

Figure **2.7**
In Bodoni Book the 'I' (capital 'eye') is distinguished, in part, from the 'l' (lower-case 'ell') by hairline serifs, but this fine distinction may be less visible when the text is reversed out of black.
The distinction tends to survive better with the more robust serifs of New Century Schoolbook.
(Note that the characters have more generous horizontal spacing when reversed out; see Figure 2.12, p.16.)

Speak Ill of the Dead

Speak Ill of the Dead

Bodoni Book

Speak Ill of the Dead

Speak Ill of the Dead

New Century Schoolbook

stern	stem
cluster	duster
stern	*stem*
cluster	*duster*
stern	**stem**
cluster	**duster**
stern	***stem***
cluster	***duster***

Figure **2.8**
In the italic and bold italic variants of this sample, in Bookman, the combination of 'r' and 'n' resembles the single character 'm'. Similarly, in the italic variant, the combination of 'c' and 'l' resembles the single character 'd'.

Appearing size

Given two typefaces with characters that can be clearly discriminated but which are not too distinctive, the type-face with the larger *x-height* (height from the top of the lower-case 'x' to the *baseline*) is likely to be the more legi-ble, since most of the details of its character shapes are at a relatively large scale (Figure 2.9). Note, however, that the x-height itself may not be the sole contributor to legibility: typefaces with large x-heights often have wider characters and may also require more generous allowances of vertical space than typefaces with small x-heights (see Figures 3.29, p. 39 and 3.32, p. 40). So when they are used properly they carry with them, by default, spacing that is generous overall. And this overall spaciousness is more likely to underly legibility than large x-height alone. Using a type-face with a large x-height is not an automatic recipe for legibility, and substituting a typeface with a large x-height in a format designed for a typeface with a small x-height could deliver cramped and illegible text.

Figure **2.9**
Both these type samples are of the same nominal size – 48pt. But Lucida has a larger appearing size than Times, partly because it has a rela-tively large x-height. Both the text samples are set at 10pt with 13pt vertical spacing. Note that the characters of Lucida are wider than those of Times.

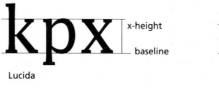

Lucida

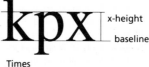

Times

The rest of Europe has watch-ed in fascination and fear.

Lucida

The rest of Europe has watched in fascination and fear.

Times

Typefaces with large x-heights are said to have a large *appearing size* (the named font size selected for a particular text is the *nominal size*). The *counters* of characters with bowls (such as 'p's and 'g's) tend to be more open in type-faces with large x-heights than in typefaces with small x-heights. So they reproduce well in printing and photo-copying (see section 6.3 on making multiple copies).

2.2 **Legibility at the word level**

The vertical dimension

Although a large x-height can contribute to legibility you should check that there is enough difference between x-height and *ascender height* for overall word contour to be clear (Figure 2.10). The clarity of word contour will also depend on the amount of vertical spacing between rows of type (see section 3.2).

Horizontal cohesion

You should examine the lateral spacing, or *fit*, of sample text to ensure that characters combine with one another without colliding or, at the other extreme, without producing gaps within words that might be perceived as spaces between words. The need for cohesion, however, does not mean that all the characters should be as close as possible without touching. Such a close fit would give very irregular spacing, since some character combinations, such as 'vy' or 'ry', always have space between them because of their character shapes. Ideally, the spacing of all the character combinations of a typeface should be adjusted to balance the spacing of the combinations with the widest gaps between them.

Type manufacturers program information about the lateral spacing of characters (the *font metrics*) into typeface descriptions. In typefaces intended for text, spacing information is usually designed using master characters at small sizes (see discussion of font scaling in section 8.1 and of horizontal measurement in section 9.2). At larger sizes – say, above 14pt (14 *point*) – simply scaling up lateral spacing allowances designed for text sizes gives more generous spacing than large characters need (Figure 2.11). Ideally, lateral spacing should be optically adjusted to the requirements of different font sizes. Desktop publishing software may soon be capable of making such non-linear adjustments but, at present, scaling routines are simple linear functions. So the spacing of text faces set at large sizes tends to 'fall apart'. Typefaces or typeface variants designed specifically for use at large sizes have their spatial parameters adjusted accordingly and so fit better than text typefaces scaled up to large sizes. Type sizes above 14pt are often referred to as *display sizes*. (This use of the term 'display' differs from its use to describe the decorative typefaces discussed on page 10.)

Type designers usually intend the horizontal spacing parameters of typefaces to be applied to dark characters on

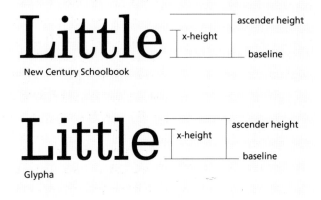

Figure **2.10**
Both these typefaces have a relatively large x-height, but the greater difference between x-height and ascender height in New Century Schoolbook means that it will tend to deliver clearer word contours than Glypha.

Figure **2.11**
The lateral spacing for the text typeface Trump Mediæval was designed using a 12pt master. When the typeface is set at 12pt the word 'awaken' is acceptably spaced, despite the relatively large space between the 'k' and the 'e'.
At 40pt, there is an over-generous space allowance between the letter combinations that have been marked.

a light background. If you reverse out type, so that it appears as white on a dark background, you may find that horizontal spacing is not generous enough and that, consequently, characters appear to run together (Figure 2.12). In this case you may need to make special adjustments to increase character spacing.

Figure 2.12
a Characters reversed out of a dark background may appear cramped if they are reproduced without any adjustments to the lateral spacing set for their reproduction in black against a light background.
b Increasing the lateral space improves the appearance of text that has been reversed out. This more generous spacing allowance is not necessary for black characters on a white background.

a

this is a battle for survival

this is a battle for survival

b

this is a battle for survival

this is a battle for survival

SMALL CAPITALS

SMALL CAPITALS

SMALL CAPITALS

Figure 2.13
Small capitals with standard text spacing appear too cramped. Opening up horizontal spacing improves their appearance. If spacing is increased too much the words tend to lose their cohesion.

Text set in all capital letters (whether full-sized capitals or small capitals) needs a more generous horizontal spacing allowance than text set in capitals and lower-case, to ensure that individual character shapes are clear (Figure 2.13). Increased character spacing usually improves the appearance of capitals and small capitals. But it should be used with caution where the capitals are embedded in text (for example, in formulæ or abbreviations) in case it disrupts the overall texture of the text (see section 3.1).

The font metrics of a typeface are interpreted by word-processing or page make-up software and by printer driver software. Unfortunately this interpretation varies among software packages so you need to check the spacing of output from your own configuration (Figure 2.14). Even within a particular software configuration, changes in text format have a profound effect on horizontal spacing: *justified* text is likely to have far less consistent character and word spacing than text that is *ranged left* (see section 3.2).

Figure 2.14
a Word 4.0 delivers bold characters with disproportionately large word spaces.
b In QuarkXPress 2.12 bold characters are appropriately spaced.
c, d In roman text, the default settings of Word (**c**) deliver tighter spacing than XPress (**d**). The difference is small over short sections of text but would still affect the positioning of text over the course of a long document.

a

A forum for human rights debate

b

A forum for human rights debate

c

An appropriate forum for human rights debate

d

An appropriate forum for human rights debate

Some software allows you to make global adjustments to horizontal spacing, using *letter-spacing* or *tracking* options. This is most likely to be useful when the default spacing of a typeface is too tight. If you are using tracking to give a closer fit to a typeface, beware: you may find global alterations improve the cohesion of some character combinations but make others worse (Figure 2.15). If this is the case you may be focusing too much on combinations that, because of their letter shapes, necessarily incorporate space. Alternatively it may be that the type has been badly designed or spaced to begin with, and tinkering with its overall spacing may not bring much improvement.

Figure 2.15
a Here, spacing between some character combinations (marked on the text) appears loose compared with other combinations.
b Tracking the text improves the spacing of the marked combinations but now other characters appear too close together.

a

navigated a path away from the walkway

navigated a path away from the walkway

b

navigated a path away from the walkway

navigated a path away from the walkway

You may be able to substitute ligatures for particular character clusters that appear unevenly spaced. But before using ligatures check that they genuinely enhance the appearance of the text and combine harmoniously with other characters (Figures 2.16 and 2.17). If you use ligatures ensure you are consistent by inserting them with a 'find and replace' routine after the text has been keyed in.

Figure 2.16
Ligatures may not always improve the appearance of a typeface.
In this sample of Galliard, the ligatures reduce the blotting effect of the joins between 'f' and 'i' and 'f' and 'l'. See the enlargement of the characters at 10pt, without ligatures (top) and with ligatures (bottom).
In Bodoni Book, the 'fl' ligature is perhaps less of an improvement on the separate 'f' and 'l' than in Galliard. See again the enlargement of the characters at 10pt, without ligatures (top) and with ligatures (bottom).

sensing fear, their first thoughts were to flee fi fl

sensing fear, their first thoughts were to flee fi fl

Galliard

sensing fear, their first thoughts were to flee fi fl

sensing fear, their first thoughts were to flee fi fl

Bodoni Book

first

Galliard

first

Bodoni

Figure 2.17
The extent to which a ligature harmonizes with other characters depends on the overall spacing of the text. If the characters are generously spaced, the ligature may appear to be a single character and so be distracting to the reader. Here the 'fi' ligature in Galliard harmonizes better than the 'fi' ligature in Bodoni.

If there are particular letter combinations that are either too widely or too narrowly spaced then you can sometimes make individual adjustments, or *kern*, the spacing of character pairs, using the kerning option provided in most page make-up programs. If you select this option the software will automatically close up the space between character combinations that commonly appear too widely spaced, such as 'To' and 'Va'. The degree to which space between particular characters should be closed up is specified in *kerning tables*, programmed into the typeface description by

the typeface manufacturer. But your software may allow you to adjust the values set in the tables (either increasing or decreasing the space between character pairs) or to kern character pairs that are not in the typeface kerning tables (Figure 2.18). Another note of caution is necessary here: typeface manufacturers sometimes use kerning as a means of compensating for type that has been badly fitted, so kerning tables may have far more kerned pairs than should be necessary. The pairs that are most likely to be useful are of T, V, W and Y (and possibly F and P) followed by a, e, o and u (and possibly i).

Kerning between character pairs may help to give a smooth appearance to titles and headings where the font metrics do not adapt well to larger sizes. Some typeface manufacturers recommend that characters below 12pt are not kerned since their kerning routines have imperceptible effects at small sizes.

Figure **2.18**
a The lateral spacing of this text (set, without kerning, in 24pt Palatino using Page-Maker 3.5) is particularly loose in the character combinations 'Po', 'Wi' and 'Vi'.
b Using automatic kerning closes up the lateral space in 'Wi' and 'Vi' but not in 'Po'.
c Manual kerning has been used to reduce the space between 'P' and 'o' and to slightly increase the space in the 'Wi' and 'Vi' combinations which have been closed up too much by automatic kerning.
d The variation in lateral spacing that is obvious at 24pt is less visible at 10pt (the text here is set without kerning), so kerning would not be necessary.

a Politics Without Violence

b Politics Without Violence

c Politics Without Violence

d Politics Without Violence

Bear in mind that certain character combinations will always appear widely spaced, even if they are kerned so that they touch (for example, the 'vy' and 'ry' combinations mentioned on page 15). Such combinations will have undue spatial emphasis if other pairs are kerned too much. You should always pay attention to the overall balance of spacing in the text when making interventions at the level of individual characters.

chapter 3 Typeface performance in context

Documents usually comprise different elements, such as text, headings, footnotes, lists, formulæ, captions and indexes (Figure 3.1, over page). Some of these elements need to be differentiated typographically (that is, not just by their content and their position on the page), and some need to be emphasized in relation to others through typographic differentiation. At the same time, the different elements of a text should form a visual unity.

To differentiate elements and yet maintain visual unity may seem contradictory, but *typeface families* are designed to do just that. Different text elements set in the roman, bold, italic, condensed or other variants of a typeface should be instantly distinguishable, though clearly related in style. Sometimes a single typeface family cannot represent all the elements of a document effectively, so you will need to combine two (or, very rarely, more than two) typefaces (see discussion in section 3.1 on differentiating text elements). If you plan to combine typefaces in a document, check that it is possible to use all the typefaces you need in your system (see chapter 5 on the management of typefaces).

The typography of each element within a text should fit the element's purpose, whether it be for sustained reading, skimming, optional consultation or to assist readers' navigation through the text. This range of purpose implies that, at the very least, any typefaces you choose should perform well at different sizes. Typefaces that meet the legibility criteria discussed in the previous section, in a range of variants and over a range of sizes, will be the most effective across different kinds of documents.

As with legibility, you can only be really sure that certain typefaces will work within a text by *seeing* how they perform. At this stage of examining typefaces your focus is on typeface performance in the context of a document as a whole, so you will need to produce typeface samples in formats that resemble those of finished documents. Manufacturers' samples (maybe just a few lines of text, or, sometimes, single columns of continuous text in dog Latin) are unlikely to resemble the format of your documents and so are a poor basis for predictions about typeface performance. Although producing your own, customized samples will involve additional time and expense, this extra effort should

Figure **3.1**
The documents you pro-
duce will include some of
these elements. Not all of
them will need different
typographic treatment. But
the treatments they are
given should always make
it as easy as possible for
readers to use them.

running
headline

page
number

labels
within
figure

List of
references

citation
identifier

article title

authors' names
& affiliations

keywords

copyright
line

caption to figure

abstract

text

sub-heading

correspondence address

Checklist of document elements

Main text
- ✓ Text
- — Parallel text
- — Displayed quotations
- ✓ Tables
- — Lists
- — Displayed verse
- — Listed programs
- — Displayed mathematics
- ✓ Chemical structures
- — Musical notation
- — Other special notations
- — References to notes
- ✓ References to figures
- ✓ References to tables

Notes
- — Footnotes
- — End notes
- — Marginal notes
- *Within notes:*
- — Headings
- — Displayed material

Captions
- ✓ To tables
- ✓ To figures

Sub-headings
- ✓ A–headings
- ✓ B–headings
- ✓ C–headings
- — D–headings

**Chapter/article
heading fields**
- ✓ Title
- ✓ Author(s)
- ✓ Author(s) affiliations
- ✓ Correspondence address

**Headings to other
main divisions**
- — Part titles
- — Headings to prelims
- — Headings to endpages

- ✓ **Labels** within figures

Text adjuncts
- ✓ Abstracts, summaries
- ✓ Key words
- — Study aids, reviews

**Preliminary
& endpages**
- — Imprints
- — Contents list
- — List of figures
- — List of tables
- — Preface
- — Acknowledgements
- — Appendices
- ✓ List of references
- — Bibliography
- — Glossary
- — Index

Page access
- ✓ Page numbers
- ✓ Running headlines

Publisher's details
- ✓ Copyright line
- ✓ Citation identifier
- ✓ Copying clearance

help you avoid producing documents or buying typefaces that do not satisfy your needs. The listing in Figure 3.2 suggests some procedures for preparing document samples, and Figure 3.3 (over page) shows an example. If you are making general predictions about typefaces that might be needed for future documents, where typescripts are not yet available, you should use text from documents of the same genre and topic area as a basis for samples.

The effectiveness with which different typefaces or families of typefaces work together depends, in part, on the features of their letterforms. For example, different text elements within a document may be distinguished by typefaces that have or do not have serifs, or by typefaces with varying degrees of contrast in the width of vertical and horizontal strokes. It is impossible to set absolute rules about the kinds of typefaces that can be successfully combined, but, usually, combinations are expected to show either a sharp contrast or a great similarity of characters, with little in between. If you mix typefaces with similar appearances

Analyse content and extent of document elements

Note, for example, the **relative frequencies** of
• fully-capitalized and initially-capitalized words (text with many capitals may rule out typefaces where capitals are over-emphatic in relation to lower-case letters; or where small capitals are not available). [section 3.1]
• numerals (in some typefaces numerals may not be clearly distinguishable; or non-ranging or fitted numerals may not be available). [section 3.1]
• words requiring emphasis or other functional differentiation (candidate typefaces must have enough variants to make the required distinctions within the document). [section 3.1]
• special characters, such as signs and symbols (the harmony among text typefaces and symbol fonts will need to be checked [section 3.1]).

For **headings**, note
• length of shortest and longest headings, typical heading length (type sizes and styles suitable for short headings may not suit long headings). [section 3.2]

For **text** elements, note
• typical length of paragraphs (will text be unrelieved blocks or will it be broken into short paragraphs?). [section 3.2]
• presence of technical vocabulary, and relatively long words (what column widths are likely? will word division be a problem? a relatively narrow typeface may be needed). [section 3.2]

Analyse relations among elements

Check the sequence of elements: changes from one element to another may require typographic signalling. It will help to compile a matrix of 'preceding' and 'following' text elements. Here, chapter headings are immediately followed by either A-headings or text, C headings are followed only by text, and so on.

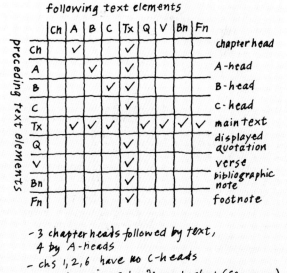

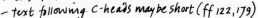

Figure **3.2**
Typographic decisions depend on familiarity with the content of a document. So, as well as knowing what elements make up your document, you need to analyse the quality of elements and their relations with one another. The information you gather by analysing document content will give a foundation for the experiments with typographic variables and document formats discussed in the rest of this chapter.

Figure 3.3
Produce sample pages to represent visually the information you have gathered about
your document (Figure 3.2). The samples should serve as test pieces: the basic decisions
about typefaces and document format that you make in producing them should
remain provisional until you have experimented fully with other available options.

a

72 Highways and byways in music

This broadly-based course explores aspects of
musical history less often encountered by the
general listener.

 day **Tuesdays** 9.45–11.45 am
 date from **25 Sept 90**
 10 meetings: £21.00
 place *Caversham Adult Centre, School Lane*
 tutor *Mr R.H. Jones, BMus*

73 The romantic symphony

The powerful symphonies of Beethoven, the
dramatic works of Berlioz, the craftsmanship
of Brahms, the melancholy romanticism of
Tschaikovsky: this course will rediscover and
explore the works of these and other great
composers of the nineteenth century.

 day **Tuesdays** 9.45–11.45 am
 date from **8 Jan 91**
 10 meetings: £21.00
 place *Caversham Adult Centre, School Lane*
 tutor *Mrs R.M. Gilmore, BMus LGSM PGCE*

b

Say: 'I am going to ask you to do some
sums. Can you tell me the answers?'.

Read out each of the following sums
and record responses on the scoring
sheet.

- 6 + 4 =

- 7 + 5 =

- 9 − 4 =

(**Note:** Not all subjects are familiar
with the terms 'plus', 'minus', and
'equals'. The terms 'add', 'take-
away', and 'makes' may be used.)

Figure 3.4
a A contrast between a seriffed and a sans serif
typeface is often used to differentiate text and
headings. Here, the distinction is between
Palatino and Helvetica. Helvetica (at a smaller
size) is also used to distinguish listings from text.

b Here a seriffed/sans serif contrast marks dis-
tinctions within a text. Iridium (seriffed) indicates
instructions to the reader about how to carry out
a task and Univers (sans serif) indicates the words
the reader must say when carrying out the task.

in order to signal distinctions, there is a risk that the change in typeface may go unnoticed.

In the context of a document, the clarity of distinctions among typefaces depends not only on the typefaces themselves, but on other cues to document structure, such as differences in content among text elements, their relative shapes or sizes, or their positions on the page. In Figure 3.4a, for example, the seriffed/sans serif distinction between Palatino and Helvetica reinforces a difference between elements that is already suggested by their position (headings come after a space and at the head of continuous text). The distinction is marked further by the emboldening of the Helvetica, but not the Palatino. In contrast, the seriffed/sans serif distinction in Figure 3.4b has to work much harder: a seriffed typeface, Iridium, is used to give the reader instructions about how to carry out a task and a sans serif typeface, Univers, is used for the words the reader must say when carrying out the task. The position of the marked elements cannot always be predicted and, because the elements of text are of equal importance, one element cannot be made bolder than the other. Using a sans serif typeface that has a larger x-height and narrower width than the seriffed typeface increases the contrast between elements.

Some people use historically-based classifications when they talk about the distinguishing features of typefaces. So you may hear a typeface described as 'Old Face' or 'Transitional' or 'Modern'. These classifications can provide a shorthand for discussion, but they are not always clear-cut. Many typefaces have the characteristic features of more than one class. And, as Figure 3.5 shows, there is nothing intrinsically old in the appearance of an Old Face typeface, nor modern in the appearance of a Modern. So in practical decision-making about typefaces to use in a text it is, perhaps, most useful to know the features of typefaces that contribute to their characteristic appearance.

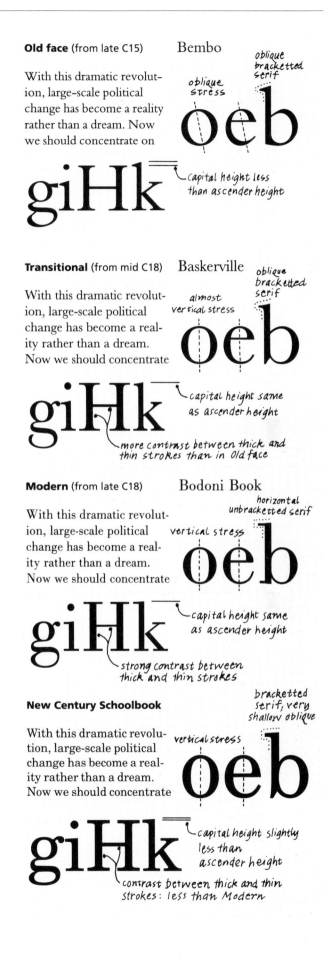

Figure 3.5
The first three typefaces are canonical examples of the historical classes 'Old Face', 'Transitional' and 'Modern Face'. Knowing the historical classifications does not help in the description of a typeface such as New Century Schoolbook: it has vertical stress, but heavier strokes overall than a Transitional typeface, less contrast than a Modern Face and serifs that fall half way between horizontal and oblique.

The names that manufacturers give to individual type-
faces also may not provide a reliable basis for making pre-
dictions about typeface appearance. Manufacturers may
choose names for new typefaces that link them to well-
known, existing typefaces. But the actual appearance of the
new typefaces may differ from the originals (Figure 3.6).

The matrix in Figure 3.7 (opposite) gives some landmark
features to look for when examining and describing type-
faces. Examining the features of characters should enable
you to side-step historical classifications and avoid con-
fusion between typefaces with similar names.

The matrix divides along its vertical axis into seriffed
and sans serif typefaces, reflecting a choice in type style
available in most DTP systems. Much is often made of the
decision whether or not to use a seriffed or sans serif face,
with strong preferences usually expressed on either side.
The discussion of character differentiation in section 2.1
touched on the possibility of confusing certain sans serif
characters in circumstances where contextual support is
limited. On the other hand, sans serif typeface families
often include a wider range of variants than seriffed type-
face families and so may be useful in documents, such as
listings or directories, where multiple distinctions between
elements of text are necessary (Figure 3.8). It is unusual to
find a book-length text of continuous prose set in a sans
serif typeface, but, in the end, the choice between seriffed
and sans serif rests on personal preference (see discussion
of appropriateness in section 3.3).

a

HOkpx

b

HOkpx

c

HOkpx

d

HOkpx

Figure **3.6**
a The original Monotype Times New Roman in Adobe Post-
Script language format.
b A version of Times New Roman re-designed by Monotype,
especially for DTP.
c The version of Times standardly used by Adobe, based on
Linotype Times.
d Times Ten, a version of Linotype Times, designed for use at
small font sizes.
The use of the name 'Times' for all these typefaces suggests that
they are all the same, but close examination shows that they dif-
fer in stroke thickness and contrast, and in character widths .

italic
Descriptive of both the graphic shape and
historical origins of a broad category of
letterforms, used primarily for latin script,
which exhibits features derived from
cursive handwriting in its small-letter
variant (though the term is equally applic-
able to capital letters).
Note Italic is contrasted primarily with roman, to
which it can be considered a functional accompan-
iment, by:
1 its tendency to slope in the direction of writing;
2 the differing graphic shape of some of its small-
letter characters (e.g. a *a*, f *f*, and g *g*); and
3 its cursive qualities. (The last two features
distinguish italic from 'sloped roman'.)
see *typeface, roman*

Helvetica

roman
Descriptive of both the graphic shape and the
historical origins of a broad category of
letterforms, used primarily for latin script,
which combines features derived from
classical inscriptional lettering (in its capital
form) and handwriting (in its small-letter
form).
Note The term is valid not only for alphabetic
variants such as capital and small-letter, but also
for variants of weight (e.g. bold, light) and width
(e.g. expanded, condensed); roman is contrast-
ed primarily with italic, from which it is broadly
distinguished by its upright and non-cursive
features.
see *typeface, italic*

Gill Sans

Figure **3.8**
The range of variants in sans serif typeface families, such as
Helvetica and Gill Sans can be useful for marking multiple
distinctions among elements within a text.

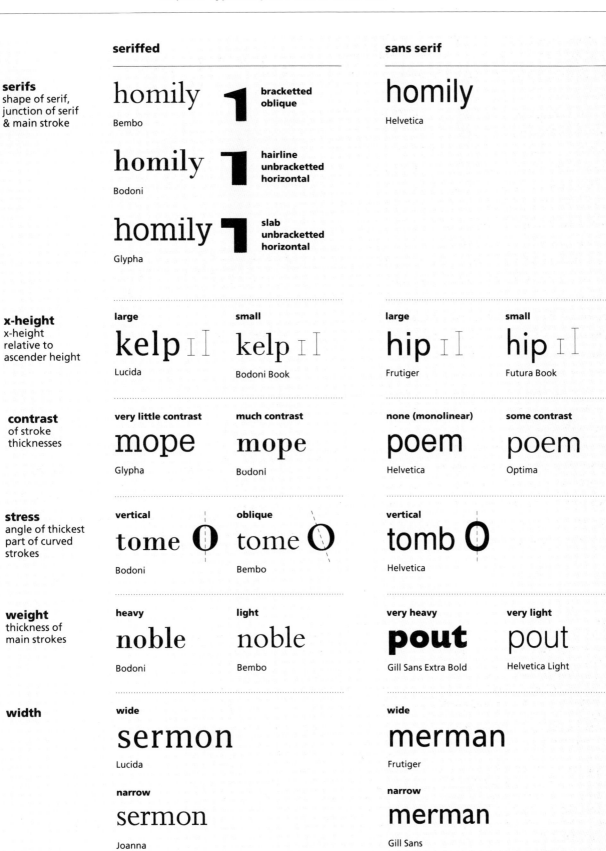

Figure **3.7**
The examples in this matrix illustrate
some of the features of letterforms that
contribute to the characteristic appear-
ance of a typeface.

3.1 **Performance and document content**

Many aspects of document content influence how well typefaces perform: from the character distribution within the text to the number and kind of distinctions needed among textual elements. By drawing attention to these different influences, the detailed discussion below may give the impression that, in the end, there will only be one or two typefaces that could be suitable for a particular document (see also section 3.3). In practice there are usually many typefaces that will perform adequately within a document, although there may be a relatively limited choice of typefaces for documents incorporating non-latin scripts. With latin scripts, however, it is very likely that you will be able to find suitable typefaces in the typical range provided by desktop publishing systems. The following discussion should alert you to potential pitfalls in typeface use and, where necessary, make you question the default options presented by a DTP system.

Character distribution within the text

The incidence of individual characters within a text (for example, accented characters or numerals) varies according to the language of the text and the text topic. There may also be variation in average word length, number of capitals and amount of punctuation. A typeface will appear different, depending on the distribution of characters within a text; decisions based on the appearance of a typeface in one set of circumstances may not apply generally.

One of the most striking differences among texts in different languages is the presence or absence of diacritical marks (Figure 3.9). Scripts that have diacritical marks should have adequate vertical space above rows of type so that the marks are clear to the reader (see also section 3.2). But you may also need to avoid typefaces that have narrow or heavy characters or have a large x-height, in order to prevent the text looking too dense.

Even among different languages that do not have diacritical marks character distribution can have an impact on typeface appearance. For example, Latin has more 'm's and 'u's than either English or Dutch, giving a typeface a relatively open and even texture on the page; this may be one reason why dog Latin has been so popular for type manufacturers' samples (see discussion on p. 19 of the preparation of samples). In contrast, the clusters of characters with ascenders and descenders in Dutch mean that blocks of text tend to have light and dark areas that do not occur in Latin, or even English (Figure 3.10). Highly contrasted typefaces

BRIEF CHECKLIST
3.1 Matching typefaces to document content

Note any special characteristics of text elements – such as unusual character distributions – and work with typefaces that cater for those characteristics.

Differentiate text elements as modestly as possible, consistent with clarity. Use distinctions of size and spacing as well as distinctions among variants of a typeface.

In single-script texts: if a single typeface cannot give adequate distinctions, use additional typefaces.

In texts with more than one script: work first with the script for which typeface choice is most limited, then select typefaces for the other scripts to balance the first typeface.

Check that the typefaces you plan to use can be combined on the intended output device.

Tak oto Jerzy Urban, który pomagał już partii na różne sposoby, teraz postanowił rzucić się w jej objęcia osobiście i ogłosił w „Polityce", że wstępuje do PZPR. Szanuję tę decyzję i nie dziwię się, że po latach współżycia na kocią łapę, postanowił związek zalegalizować.

A revelação é considerada importante porque veio de Adamec, e não do líder do partido, Milos Jakes, o qual está cada vez mais isolado. Há dois dias atrás, por exemplo, Jakes apelou, sem muito sucesso, que mais jovens viessem contribuir para revigorar as atividades do partido.

Figure 3.9
Diacritical marks, for example in Polish, fill in space that is open in unaccented languages, and can give text a dense appearance (see also Figure 3.31, p.40). The distribution of diacritical marks varies from script to script – compare, for example, these Polish and Portuguese texts.

In what appeared to be a U-turn on past policies, he said the government saw tourism as "an important right" and told the Federal Assembly: "Travelling abroad with the aim of staying abroad permanently has been made sim-

In wat zich liet aanzien als een totale ommekeer ten opzichte van de voorafgaande politiek, vertelde hij dat de regering toerisme zag als "een belangrijk recht", en vertelde de Algemene Vergadering dat: "buitenlandse reizen

cum unius et eiusdem rei contingat plures causas esse, quarum quædam sunt uniuersaliores, quædam minus uniuersales. Quædam uero sunt "particuliares et proximæ". Ita enim contigit accidentia quædam esse communia et

Figure 3.10
The different character distributions across unaccented languages, for example, the English, Dutch and Classical Latin shown here, influence the overall appearance of a text.

may accentuate any tendency toward patchiness. Similarly the capitalized nouns in German may give uneven patches in a text, especially if set in a typeface where the capital letters are heavy in relation to lower-case letters.

Within a particular language, texts that are likely to need the most careful choice of typeface are those that include unusually high concentrations of particular kinds of characters. Clusters of capital letters (for example, formulæ in chemical texts) may disrupt the consistency of typeface texture, especially if, as mentioned above, there are weight differences between capital and lower-case letters.

Special care needs to be taken with numerals also (for example, in dates or statistics). Unlike most characters, the numerals of standard DTP character sets are usually of uniform height. So they may contrast in the vertical dimension with the words of a text, which have a distribution of characters with ascenders and descenders. Some typeface manufacturers have produced non-ranging numerals (available in extended character sets) which can be used as an alternative to aligned (or 'ranging') numerals. Non-ranging numerals vary in their vertical alignment and so improve the balance between numerals and letters in the vertical dimension (Figure 3.11).

a

these early lithographed books contributed to book design and production at the time was probably negligible: there were not many of them and, with a few notable exceptions they would not have been widely read. Moreover, they vary considerably in

are all printed in one of two sizes and have a page size of either 328 × 210 mm or 214 × 175 mm (when bound). (The largest of the items in their original wrappers measures 345 × 212 mm). These sizes are almost certainly Tellière folio and quarto. Folio

b

are all printed in one of two sizes and have a page size of either 328 × 210 mm or 214 × 175 mm (when bound). (The largest of the items in their original wrappers measures 345 × 212 mm). These sizes are almost certainly Tellière folio and quarto. Folio

c

are all printed in one of two sizes and have a page size of either 328 × 210 mm or 214 × 175 mm (when bound). (The largest of the items in their original wrappers measures 345 × 212 mm). These sizes are almost certainly Tellière folio and quarto. Folio

Figure 3.11
a A comparison of these two extracts, taken from the same document, shows how numerals have a 'texture' or 'visible rhythm' that differs from the texture of continous text.
b In the vertical dimension, non-ranging numerals blend better with letters than ranging numerals, although their fixed-width spacing means that they still tend to produce lighter areas in the text.
c Using a fitted '1' improves the cohesion of ranging numerals in the horizontal dimension (see discussion on p.28).

In addition to introducing a contrast with letters in the vertical dimension, the numerals in standard DTP character sets are not usually proportionally-spaced, but lie within a fixed width (usually one en), regardless of their shape. Consequently some numerals are surrounded by more space than others and can break up the horizontal cohesion of the text.

Fixed-width numerals are necessary for columnar setting in tables or calculations (see Figure 3.49, p. 52). Ideally, typefaces should include separate sets of numerals: fixed-width for tabular work and proportionally-spaced for text. If whole sets are not included, then, at the very least, there should be a proportionally-spaced, or fitted, substitute for the numeral '1', which causes the greatest unevenness in horizontal spacing (Figure 3.11). Typeface manufacturers have been slow to meet this need. Some have introduced proportionally-spaced numeral '1's (in extended character sets) although not for all the different kinds of numerals within the character set, for example the non-ranging numerals or superscripts and subscripts.

In contrast to texts that may be disrupted by capital letters or numerals, texts that have long words and sentences and, consequently, few breaks for punctuation (such as legal texts) may appear very dense, particularly if produced in a typeface that has heavy or narrow characters.

Text elements that need to be differentiated

The typefaces and variants of typefaces that you choose to mark elements of text should be different enough to make the text structure immediately visible to readers and to leave no doubt that the differentiation is deliberate (see Figure 3.4, p. 22). Clear differences between elements are easier for readers to remember as they move from page to page (Figure 3.12). In general it is better to avoid overloading your reader with multiple fine distinctions within a text. Some editing, for example to limit the number of heading levels, may help clarify document structure. If you are not sure which sections of your text should be differentiated and which should not, then you should consult writers' and editors' style manuals, such as *The Chicago manual of style* or Butcher's *Copy editing* (see Further Reading).

Differentiation with emphasis

Differentiation with emphasis is likely to be necessary to articulate the heading structure of a text or to draw readers' attention to particular text elements. Although the guideline of clear differentiation holds, the means of emphasis you choose should be as modest as possible, consistent with clarity (Figures 3.13 and 3.14).

a

to use this would disrupt comprehension generally, and be reflected in poor performance on the comprehension questions.

Method

Design

Four groups of subjects read and answered questions on 16 short texts, each text incorporating a single target word. Half of the target words (eight words) were new and half part-familiar. (Word familiarity was determined operationally. See Materials section below.)...

The dependent variables were the length of consultation of the initial type of information within the dictionary entry, the number and length of consultations of the optional information and the number of correct answers to the comprehension questions.

Materials

Target words: Sixteen target words were selected in a pre-test of 40 low-frequency nouns and verbs.

b

to use this would disrupt comprehension generally, and be reflected in poor performance on the comprehension questions.

Method

Design

Four groups of subjects read and answered questions on 16 short texts, each text incorporating a single target word. Half of the target words (eight words) were new and half part-familiar. (Word familiarity was determined operationally. See Materials section below.)...

The dependent variables were the length of consultation of the initial type of information within the dictionary entry, the number and length of consultations of the optional information and the number of correct answers to the comprehension questions.

Materials

Target words: Sixteen target words were selected in a pre-test of 40 low-frequency nouns and verbs.

Figure **3.12**
a The difference in size between the higher-level heading 'Method' (set at 10.5pt) and the lower-level headings (set at 9.5pt) may not be noticed when there is intervening text, especially as the headings are only single words.
b Increasing the size of the higher level heading to 11.5pt clarifies the distinction between levels of heading. (The illustrations are reduced to 75%; the type sizes described above refer to the full-size original.)

a

borrowings or funding of the business has either been increased or decreased during that particular financial year.

New machinery investment

This relates to the particular financial year, and is total puchases of new machinery minus sales of any second-hand items.

Output from cattle and sheep less cost of concentrates

Measured in £s per forage hectare, this approximates to the 'gross margin' (see above) from grass...When reliable food records are not available, an allowance for any pig and poultry food has been made on the basis of standard requirements.

Power and machinery costs
Include fuel, electricity, repairs, vehicle tax and insurance and an allowance for depreciation. A deduction is made for the private use of a car. Machinery depreciation is

b

borrowings or funding of the business has either been increased or decreased during that particular financial year.

New machinery investment

This relates to the particular financial year, and is total puchases of new machinery minus sales of any second-hand items.

Output from cattle and sheep less cost of concentrates

Measured in £s per forage hectare, this approximates to the 'gross margin' (see above) from grass...When reliable food records are not available, an allowance for any pig and poultry food has been made on the basis of standard requirements.

Power and machinery costs
Include fuel, electricity, repairs, vehicle tax and insurance and an allowance for depreciation. A deduction is made for the private use of a car. Machinery depreciation is

c

borrowings or funding of the business has either been increased or decreased during that particular financial year.

New machinery investment

This relates to the particular financial year, and is total purchases of new machinery minus sales of any second-hand items.

Output from cattle and sheep less cost of concentrates

Measured in £s per forage hectare, this approximates to the 'gross margin' (see above) from grass...When reliable food records are not available, an allowance for any pig and poultry food has been made on the basis of standard requirements.

Power and machinery costs
Include fuel, electricity, repairs, vehicle tax and insurance and an allowance for depreciation. A deduction is made

Figure **3.13**
a The change of style (from roman to italic) may not give adequate contrast between the sub-headings and text.
b Emboldening the headings, as well as italicizing them, gives more emphasis.
c Increasing the type size tends to over-emphasize the headings (and would extend some over more than one line).

tains a chart dealing with this subject (Figure **5**). Instead, the price of a quarter of wheat as sold by the farmer to the middlemen is the central value receiving the graphic spotlight averaged for five years and compared with the wages of the 'good mechanic' (Figure **15**), averaged for twenty-five years and again compared with the wages of a good mechanic (Figure **16**), and averaged yearly and plotted independently as seen in Figure **17**. Figure **17**, incidentally, only appeared in the second and third editions of the *Letter* both published in 1822. It is only in Figure **18** that we see any data

Figure **3.14**
In this text, references to figures are, perhaps, over-emphatic. Such a treatment might be justified if you expect the reader to look at the figures first and then access parts of the text from them.

The modesty principle should lead you first to choose variants of the main text face for emphasis. However, you need to make repeated visual checks to ensure that the variants are effective. If you choose italic variants for emphasis, you should check that they do not appear much lighter than the corresponding roman variant (Figure 3.13). They may need further marking by weight, size or space. The difference between italic and roman fonts may be unclear if the italic is a mathematically *sloped roman* rather than a true italic (see Figure 8.3, p. 88). Remember, too, that italic fonts can present legibility problems (see Figures 2.6 and 2.8, p. 13).

A particular problem at medium resolution is an attenuation of the distinction between variants of different weights, so a bold variant can sometimes appear only marginally heavier than the corresponding roman (Figure 3.15). This lack of distinction is worse if you are using a laser printer that has a relatively large *marking spot*, which tends to coarsen fine images (see Figure 6.6, p. 71). If you intend to produce originals for a document at medium resolution (for example, on a 300 dpi laser printer) a working solution to this problem is to use a typeface family that comprises a wide range of weights, and to select variants from the family with more contrast than a roman/bold distinction (sans serif typeface families are most likely to have a range of weights; see Figure 3.8, p. 24). This procedure is not ideal, however; the real solution to the problem lies in the design of the typefaces themselves, which should be better adapted to medium resolution.

If you are restricted to a typeface that does not have a wide range of weights you may be able to augment the effect of emboldening by additional typographic marking, such as increasing the size of the emphasized text or increasing vertical space above and below it (Figure 3.16). Note that you need to control vertical space carefully if you are combining fonts of different sizes (see Figures 3.21, p. 33, and 3.26, p. 37).

In latin-script texts you should avoid using all capitals to emphasize text of more than a few words since capitals deprive readers of information about word contour that is necessary for fluent reading (see Figures 2.2, p. 11, and 2.13, p. 16). Underlining, too, can disrupt word contour if your software places the underlining rule too close to the baseline of the typeface characters (Figure 3.17). Besides, underlining is usually only used for emphasis in typewritten, not typeset, documents (see section 3.3 for discussion of the conventions of typeset documents).

Even given the range of variants in some typeface families, and the additional typographic variables of size and space, it may still be difficult to differentiate the elements of a complex text without going outside a single typeface

a

borrowings or funding of the business has either been increased or decreased during that particular financial year.

New machinery investment
This relates to the particular financial year, and is total purchases of new machinery minus sales of any second-hand items.

Power and machinery costs
Include fuel, electricity, repairs, vehicle tax and insurance and an allowance for depreciation. A deduction is made for the private

b

borrowings or funding of the business has either been increased or decreased during that particular financial year.

New machinery investment
This relates to the particular financial year, and is total purchases of new machinery minus sales of any second-hand items.

Power and machinery costs
Include fuel, electricity, repairs, vehicle tax and insurance and an allowance for depreciation. A deduction is made for the private

c

borrowings or funding of the business has either been increased or decreased during that particular financial year.

New machinery investment
This relates to the particular financial year, and is total purchases of new machinery minus sales of any second-hand items.

Power and machinery costs
Include fuel, electricity, repairs, vehicle tax and insurance and an allowance for depreciation. A deduction is made for the private

Figure **3.15**
a On a medium resolution laser printer the distinction between roman and bold text may be unclear.
b If a light variant is substituted for the roman, the distinction is clearer, and the overall heaviness of the text on the page is reduced.
c There is no need to substitute a light variant for a roman if the text is output on a high resolution imagesetter where roman and bold are distinct.

a

borrowings or funding of the business has either been increased or decreased during that particular financial year.

New machinery investment
This relates to the particular financial year, and is total purchases of new machinery minus sales of any second-hand items.

Power and machinery costs
Include fuel, electricity, repairs, vehicle tax and insurance and an allowance for depreciation. A deduction is made for the private

b

borrowings or funding of the business has either been increased or decreased during that particular financial year.

New machinery investment
This relates to the particular financial year, and is total purchases of new machinery minus sales of any second-hand items.

Power and machinery costs
Include fuel, electricity, repairs, vehicle tax and insurance and an allowance for depreciation. A deduction is made for the private

c

borrowings or funding of the business has either been increased or decreased during that particular financial year.

New machinery investment

This relates to the particular financial year, and is total purchases of new machinery minus sales of any second-hand items.

Power and machinery costs

Include fuel, electricity, repairs, vehicle tax and insurance and an allowance for depreciation. A deduction is made for the private

Figure **3.16**
a The distinction between Helvetica and bold Helvetica is poorly defined when text and headings are produced at the same size (9.5pt) and set at 300 dpi.

b The distinction is augmented by increasing the size of the headings by half a point (to 10pt).

c Both text and headings are set at 9.5pt, but the headings have 15pt additional space above and 4pt additional space beneath them.
(The illustrations are reduced to 77%; the type sizes described here refer to the full-size original.)

a

It is a well-worn convention of the Arthurian romances that a knight should contrive to have his successes made known at Karidol. This is done typically by releasing a vanquished opponent on parole and commanding him to return to the Court to report there the name of the knight by whom he was defeated, or else by getting some other messenger to perform that same task. Iwein modifies that convention by having news of his successes relayed directly to Gawein. To be sure, sending the news to Gawein is natural since the episode involves Gawein's sister (as in Chrétien), yet Iwein's gesture means more than this, for he uses the opportunity to acknowledge Gawein as his mentor. Having freed a baron from the depredations of the giant Harpin, Iwein both instructs him to take news of his success to Gawein and at the same time encloses a lapidary tribute to his source of knightly inspiration:

b

It appears now to be the vogue to work with self-nominated fabliaux (those which are designated as fabliaux by their own authors, or by scribes). Jodogne, Ménard (in spite of his disclaimer), Noomen, and others do so.[5] The assumption is, of course, that while works not *called* fabliaux may or may not *be* fabliaux, those so designated by the author certainly *are*, and it is from them that we can derive the characteristics of the genre. Presumably the characteristics thus isolated could then help us identify as fabliaux a certain number of texts not so-called.[6]

It must be noted, however, that while such an approach might appear eminently sensible, the presupposition underlying it presents certain problems. First, it attributes to medieval authors a generic

Figure **3.17**
a In this text (set in Word 3.01) the underlining rule has cut through character descenders. It has also disrupted the vertical spacing: rows of text with underlined words are shifted upwards so that they are closer to the row preceding them and further away from the row that follows them.

b In a different text within the same publication as 3.17a, emphasis is given, more conventionally, with italics rather than underlining. Clear word contour and regular vertical spacing are maintained.

family. A second typeface may be needed because attempting to signal all the levels of heading in a text requires type sizes that are inappropriate for text setting (see section 3.2); or because headings are very long and, unless condensed, will take up several lines. Note that condensed typefaces may be useful not only to emphasise long headings, but also to de-emphasize lengthy passages of text (for example, notes or references) that are subordinate to the main text (Figures 3.18 and 3.19, over page).

If you use a second typeface for emphasis you should play on the contrasts in style, scale, weight and width of the typefaces to make the distinctions between text elements obvious. Distinctions marked by seriffed and sans serif typefaces are usually clear. In most cases they also involve a difference in both x-height and degree of stroke contrast,

White and green

Chapter 6
Gender and dance: evaluating
dance programmes for boys

Linda Jasper

RICHARD COLLINS

THE film further provides material
'proof' that there is only an increm
(fashion photography) and sadism

To me, dance is the most immediate art form because it uses the body as the instrument of expression. Without the use of tools, equipment or material, a piece of art can be made and performed by the individual. This use of the body affords unique opportunities for the individual to learn how to manage and control body movement while realizing full, expressive movement potential.

In the process of making dance, many skills are brought into play: selection of appropriate material from initial improvisations; decisions on timing, phrasing and spacing the movement material to shape a final form; to make a group piece, sensitive cooperation to accommodate individual ideas and personalities; on completion, informed criticism and evaluation by participating members and their audiences. This combination of physical and compositional skills with social interaction creates an art form which should be central to education in the arts.

As dance development officer for Berkshire, I have been concerned with creating dance programmes to enrich and educate people's lives. I aim to bring people together in schools and communities for individual enjoyment and personal development through the social and artistic functions which dance embodies.

The programmes include community dance classes and catering for a variety of styles and tastes, from ballet, tap and contemporary, to Morris and Kathak. My concern that the individual be a creator of dance as well as a practitioner, has resulted in the establish-

ment of seven district youth dance groups and a county youth dance company, as well as four adult companies. All these groups meet to choreograph their own work, and some work with professional choreographers. They all aim to perform their work at least twice during the year.

In addition to initiating and coordinating these programmes in the community, I collaborate with the PE and dance advisory teachers. This usually takes the form of special projects in schools or dance residencies. Sometimes my work involves bringing artists from visiting dance companies to work with classes of children in the local theatre; sometimes it involves bringing together special education unit children to work in a comprehensive school on a day of dance. The activities generate commitment and enthusiasm from people in all districts of the county and they are always well supported.

Concerns

I have become increasingly concerned, however, that the work attracts a predominantly female clientele. There are very few men or boys within the dance programmes. Throughout my career—which has taken me into the professional dance world and colleges of higher education, as well as into schools and the community—I have observed that with the exception of the rare few who make it a career, male involvement has been minimal. Dance is rarely seen as an appropriate or worthwhile recreative or educa-

Evaluating boys' dance programmes • 97

report

White and green and not much read

RICHARD COLLINS

[1] See also: Eight Programme Makers, 'Channel 4 – One year On', *Screen* March-April 1984, vol 75, no 2, pp 4–75; John Ellis, 'Broadcasting and the State Britain and the Experience of Channel 4' *Screen* May–August 1986, vol 27 no 3–4 pp 6–77; John Ellis, 'Channel 4 – Working Notes', *Screen* November–December 1983, vol 74, no 6 pp 37–51; and Sylvia Harvey, 'De regulation, Innovation and Channel 4

THE film further provides material for such an analysis by producing its own 'proof' that there is only an incremental difference between voyeurism (fashion photography) and sadism (murder).[1] The black and white photographic blow-ups of Tracy salvaged from the death car seem undeniable evidence of the fine line between looking and killing, or, held at another angle, between advertising imagery and pornography.

This, then, is to suggest the kind of evidence in the film which would support an analysis of it as patriarchal discourse, in its use of the female image as fetish to assuage castration anxiety, and through its rich offering of views to please the male spectator. There's even an inescapable suggestion of voyeurism as pathology, since the gaze is that of the actor whose star persona is fatally haunted by the protagonist of Psycho. To explain the ideological function of the film in terms of the construction of male pleasure, however, is to 'aid and abet' the film's other ideological project. In following the line of analysis I have outlined, one is apt to step into an ideological signifying trap set up by the chain of meanings that lead away from seeing the film in terms of racial conflict. Because there are so many connotative paths – photographer exploits model, madman assaults woman, voyeur attempts murder – we may not immediately see white man as aggressor

[2] Simon Blanchard, 'Where Do New Channels Come From?' in Simon Blanchard and Dave Morley (eds), *What's This Channel Four?*, London, Comedia, 1982; Stephen Lambert, *Channel 4 – Television With a Difference*, London, British Film Institute, 1982; the quotation is from p 1; and Sylvia Harvey, op cit

against black woman.[2] Other strategies encourage the viewer to forget or not notice racial issues. For instance, the narrative removes Tracy from racially polarised Chicago to Rome, where the brown Afro-American woman with Caucasian features is added to the collection of a photographer who names his subjects after prized objects or their qualities. Losing her black community identity, Tracy becomes Mahogany, acquiring the darkness, richness and value the name connotes; that is, her blackness becomes commodified. Mahogany functions ideologically for black viewers in the traditional Marxist sense, that is, in the way the film obscures the

48 *Screen* 30 1 & 2 Winter/Spring 1989 Collins *White and Green and not much read*

Figure 3.18
In this chapter-opening page (A4 in the original), changing typeface from Times (for the text, sub-headings and author name) to Helvetica Bold Condensed (for the chapter title) emphasizes the title, avoids a further increase in type size and keeps the title compact. The change of typeface also adds interest to a conventional chapter heading.

[2] Simon Blanchard, 'Where Do New Channels Come From?' in Simon Blanchard and Dave Morley (eds), *What's This Channel Four?*, London, Comedia, 1982; Stephen Lambert, *Channel 4 – Television With a Difference*, London, British Film Institute, 1982; the quotation is from p 1; and Sylvia Harvey, op cit.

against black woman.[2] Ot
not notice racial issues. Fo
racially polarised Chicago
woman with Caucasian fe
who names his subjects a
black community identity,
darkness, richness and val
becomes commodified. M

Figure 3.19
Here the sans serif, Univers, has been used in its bold condensed variant to emphasize headings in relation to the main text (set in Times). It has also been used in its condensed variant to signal the subordinate status of side notes. In both cases, the condensed variant has limited the amount of space taken up by the text element. (The original page size is 240 × 168 mm.)

although Figure 3.20 shows an exceptional case of a seriffed/sans serif distinction (between Joanna and Gill Sans) where the different typefaces have many similarities. Distinctions marked only by differences in x-height, degree of contrast or direction of stress may not be clear enough.

If you are changing typeface in order to emphasize headings within a text, you should ensure that the vertical spacing of the headings clearly signals their relationship to the text that follows them. There should always be more space visible above a heading than beneath it to separate the heading from the preceding text and link it to the following text. If you insert headings at the same vertical space settings as the rest of the text they may look closer to the preceding text than to the following text because of the capital letters (and any ascenders) they include. The closing up between heading and preceding text will be accentuated if the typeface in the heading has a larger x-height than the main text face or if it is set at a larger size than the text (Figure 3.21).

a

Advantages of lithography for colour printing
Soon after the Great Exhibition of 1851, chromolithography became the leading process for colour printing in Britain. It had several advantages over other forms of colour printing…

Drawing on the stone
Initially, chromolithographs were either produced in lines or flat areas of colour by means of a greasy ink on polished stones, or in varied tones by means of a greasy

lithography lithography

b

Advantages of lithography for colour printing
Soon after the Great Exhibition of 1851, chromo-lithography became the leading process for colour printing in Britain. It had several advantages over other forms of colour printing…

Drawing on the stone
Initially, chromolithographs were either produced in lines or flat areas of colour by means of a greasy ink on polished stones, or in varied tones by means

lithography lithography

Figure **3.20**
a The distinction between text (in Times) and headings (in Helvetica) is signalled by a change in x-height and contrast of the letterforms as well as by the presence or absence of serifs.
b The similarities in letterform features of the seriffed Joanna, used for the text, and the sans serif Gill Sans, used for the headings, tends to give a more uniform effect than the distinction between Times and Helvetica.

a

information and the number of correct answers to the comprehension questions.
Materials
Sixteen target words were selected in a pre-test of 40 low-frequency nouns and verbs: 18 judges, drawn from the same population as the experimental groups, rated

b

information and the number of correct answers to the comprehension questions.
Materials
Sixteen target words were selected in a pre-test of 40 low-frequency nouns and verbs: 18 judges, drawn from the same population as the experimental groups, rated

c

information and the number of correct answers to the comprehension questions.
Materials
Sixteen target words were selected in a pre-test of 40 low-frequency nouns and verbs: 18 judges, drawn from the same population as the experimental groups, rated

Figure **3.21**
a When set in the same typeface as the text, the capital letters and ascenders in headings can make them appear closer to the text preceding them than to the text following them.
b Headings in a typeface with an x-height that is large relative to the x-height of the text typeface will appear closer to the text preceding them than headings set in the same typeface.
c Headings that are larger than the main text will appear closer to the text preceding them than headings of the same size as the main text typeface.

You can separate a heading from the preceding paragraph by inserting space above it. The amount of space you will need will depend on the x-height of the typeface used in the headings (Figure 3.22). The most controlled way to increase the amount of space surrounding headings in a DTP system is to use the 'space before' and 'space after' options given when you set up styles for headings. If you try to create extra vertical space around headings simply by increasing the vertical spacing (or '*leading*') of the headings the results will be less predictable: 'leading' adjustments may distribute space both above and below the heading and so can weaken the visible association between heading and following text. (See section 3.2 for more on vertical space settings.)

Figure **3.22**
Adding 4pt vertical space above the heading gives adequate separation from the preceding paragraph in Times but is, perhaps, less satisfactory in Helvetica which has a larger x-height than Times. Adding 6pt vertical space clarifies the relationships between heading and text in Helvetica. There can be no doubt about the relationships between text and headings with 9pt above the headings. (The illustrations are reduced to 84%; the type sizes and vertical spacing described here refer to the full-size original.)

length of consultations of the optional information and the number of correct answers to the comprehension questions.

Materials
Sixteen target words were selected in a pre-test of 40 low-frequency nouns and verbs: 18 judges, drawn from the same population as the experimental groups,

10/12pt Times, 4pt space before heading

length of consultations of the optional information and the number of correct answers to the comprehension questions.

Materials
Sixteen target words were selected in a pre-test of 40 low-frequency nouns and verbs: 18 judges, drawn from the same population as the experimental groups,

10/12pt Times, 6pt space before heading

length of consultations of the optional information and the number of correct answers to the comprehension questions.

Materials
Sixteen target words were selected in a pre-test of 40 low-frequency nouns and verbs: 18 judges, drawn from the same population as the experimental groups,

10/12pt Times, 9pt space before heading

length of consultations of the optional information and the number of correct answers to the comprehension questions.

Materials
Sixteen target words were selected in a pre-test of 40 low-frequency nouns and verbs: 18 judges, drawn from the same population as the experimental groups,

10/12pt Helvetica, 4pt space before heading

length of consultations of the optional information and the number of correct answers to the comprehension questions.

Materials
Sixteen target words were selected in a pre-test of 40 low-frequency nouns and verbs: 18 judges, drawn from the same population as the experimental groups,

10/12pt Helvetica, 6pt space before heading

length of consultations of the optional information and the number of correct answers to the comprehension questions.

Materials
Sixteen target words were selected in a pre-test of 40 low-frequency nouns and verbs: 18 judges, drawn from the same population as the experimental groups,

10/12pt Helvetica, 9pt space before heading

Differentiation without emphasis

Your document may include elements (such as main text and quotations, or parallel texts in different languages) that need to be differentiated. In this case, however, it may be important to differentiate elements without emphasizing some at the expense of others, so that readers do not interpret the differentiation as a cue to skip elements that seem less emphasized. For example, reading the captions to illustrations in a technical text (such as this!) may be critical for an understanding of the text as a whole. But if you mark

captions with variants of the main text typeface (such as italic or condensed fonts) you may imply that they have subordinate status. This is apart from considering the legibility of these variants in large blocks of text (Figure 3.23).

To distinguish text elements without giving inappropriate emphasis to some and not to others you need to combine typefaces that contrast in style, but nevertheless have the same appearing size and weight and, perhaps less critically, width. This means manipulating distinctions between seriffed and sans serif typefaces, degree of contrast and direction of stress. Although the principle holds that the differences between typefaces should be clear and should not appear to be accidental, there may already be cues to difference in the content and positioning of the elements. In these situations, contrasts between seriffed and sans serif faces that seem too bland to articulate relationships between text and headings may be appropriate (Figure 3.24).

or monitor in any detail the work in progress, nor determine in any systematic way how the students' attitudes and behaviour changed. An uncomfortable atmosphere was created, which Linda, my assistant, and I tried very hard to disguise for the sake of the students.

In order to retrieve as much information as possible, a meeting was arranged with my coordinator, myself, Linda and the video team. It was agreed at this meeting that notes they made on each session be shown to me, in the absence of the release of the videos; that there would be an evaluation session with all present when the film would be discussed and the discussion tape-recorded; that the team should write an account of the five sessions which I could incorporate into the case study, at my discretion.

I was not able to retain any of the video film which the students produced over the five weeks. My evaluations and assessments of progress largely depended upon recall. The following extract from the team's final written evaluation explains their position:

'Professionals coming into an institution such as a school, need the support and understanding of staff, and have also to be aware of the possible problems or limitations under which the staff operate. It is useful to look at this relationship as a partnership. For the partnership to be equable, it is important that enough discussion takes place in advance and that both parties are completely aware of the criteria under which the other is operating. It is not acceptable within this framework to change the criteria unless there is adequate discussion and agreement.

Some problems seemed to arise from a misunderstanding of our role. These specifically related to the recording of workshops and the use of video, recorded in workshops.

We undertook the workshops 1) for the students' benefit and 2) so the staff could find out more about a community video approach. We were not asked at the outset about making video recordings available and would not have undertaken to do so. Confidentiality is obviously important, but also workshops are not about producing slick end-products on tape; they are about the process and involvement that takes place during them. This cannot be understood or recognised by viewing a few seconds of video tape (a thirty minute workshop often produces no more than one or two minutes on tape). This is aside from the fact that video is a very partial medium and that material can easily be manipulated to present practically any viewpoint.

Likewise, unless considerately dealt with, taking photographs in a workshop situation can be very destructive to the work and very distracting. People seeing themselves on video often get embarrassed and they need support, not be put under further pressure.

Other problems arose that were particularly related to workshop practice. While these problems

Instructions to authors
Full papers (< 5000 words) should be submitted in 3 copies. A separate cover page must contain the title of the paper, name(s), affiliation and complete mailing address (including phone, fax, e-mail) of the author(s) together with an abstract (about 250 words) and three keywords. The name of the first author mentioned will be used for all correspondence unless otherwise stated.

Instructions aux auteurs
Les textes complets (< 5000 mots) seront soumis en 3 exemplaires. Ils comporteront sur la première page, le titre de la communication, le nom et l'adresse complète de(s) auteur(s) (y compris téléphone, fax et courrier électronique), un résumé d'environ 250 mots et trois mots clés. Le premier auteur sera contacté pour toute correspondance sauf avis contraire.

Figure **3.23** (above)
An italic variant of the main text face has been used here to indicate a quotation giving an alternative to the author's view of the project being described. The italic seems to suggest that the quotation has subordinate status (which may have been just what the author intended) and may discourage the reader from reading the quotation fully.

Mixing typefaces of different scripts, or mixing symbols with text typefaces, requires particular care. The weight, patterns of stress and appearing size of characters vary across scripts, giving some an intrinsically more emphatic appearance than others. In order to balance the appearance of typefaces from different scripts, use the script that offers the least choice of typefaces as your starting point (for some scripts there may only be a single DTP typeface available) and choose fonts from the scripts with a wider range of typefaces to match it. Remember that fonts of the same nominal size but from different typefaces may not have the same appearing size (see Figure 2.9, p.14). So certain combinations of typefaces will need to be set in different sizes in order to look the same size (Figure 3.25, over page).

Whilst harmony among scripts is generally to be recommended, a few words of a second script embedded in a text may be lost unless given some additional marking. In this case italics may increase the distinction between scripts (Figure 3.25).

Type manufacturers have been slow to produce DTP typefaces for non-latin scripts (an exception is Lucida which has character sets for both Greek and Hebrew, and Cyrillic will follow). So many non-latin typefaces are likely to be one-off, bitmapped fonts, produced at specific sizes

Figure **3.24**
The relatively subtle distinction between Gill Sans and Joanna is adequate to mark these parallel English and French texts, where the differences in content are immediately obvious to the reader. Compare this usage with Figure 3.20 (p.33) where the same contrasting typefaces may not give adequate emphasis to headings. The distinction between Gill and Joanna might also be inadequate to indicate different text elements with positions and content that are not predictable (such as the instructions to the reader and words for the reader to repeat, shown in Figure 3.4b, p.22).

Figure **3.25**
a The combination of the 10pt Greek typeface with 10pt Times is poorly balanced so that the Greek text appears emphasized compared with the English text.
b When the Greek is reduced from 10pt to 9pt it harmonizes better with the 10pt Times.
c In contrast to the longer text in **a** and **b**, this short Greek title tends to disappear into the rest of the text.
d Italics help to distinguish Greek from English.

a

contains *Προλεγόμενα εἰς τὰς Πράξεις* by Joannes [Chrysostomus]. The commentaries are stated to be: ῾τοῦ μὲν ᾿Οικουμενίου; εἰς τὰς Πράξεις τῶν ᾿Αποστόλων, εἰς τὰς ἑπτὰ καθολικὰς λεγομένας ᾿Επιστολάς, εἰς

b

contains *Προλεγόμενα εἰς τὰς Πράξεις* by Joannes [Chrysostomus]. The commentaries are stated to be: ῾τοῦ μὲν ᾿Οικουμενίου; εἰς τὰς Πράξεις τῶν ᾿Αποστόλων, εἰς τὰς ἑπτὰ καθολικὰς λεγομένας ᾿Επιστολάς, εἰς τὰς Παύλου

c

Edited, with a dedicatory letter in Latin to pope Clemens VII, by B. Donatus, and a letter Τοῖς φιλέλλησι, verses and a note to the reader, all in Greek, the volume includes the appropriate New Testament texts in Greek, and also

d

Edited, with a dedicatory letter in Latin to pope Clemens VII, by B. Donatus, and a letter *Τοῖς φιλέλλησι*, verses and a note to the reader, all in Greek, the volume includes the appropriate New Testament texts in Greek, and also

and for particular output devices (see chapter 7 on DIY character production). This specificity may limit the choice of fonts to combine with a script. Note that conventions for the size of text typefaces vary from script to script. If you have a choice of sizes, and are not an expert user of a script, check with an expert user (ideally someone who is familiar with the publishing conventions of the script) that the size you have chosen is appropriate.

If you combine different fonts within a row of text you need to be sure that the combination will not interfere with the regular, vertical spacing of the row in relation to other rows. Fonts from different typefaces may be aligned to different vertical positions within the overall vertical space set using the 'leading' option (see Figure 9.7, p. 95). Similarly fonts of the same typeface but of different sizes may have different alignments within vertical space. Most software compensates for different alignments by adjusting the vertical spacing so that fonts align evenly within a block of text. Other software is not capable of such adjustments and so disrupts the regular text spacing in order to accommodate different fonts. You can only be sure about the effects of combining typefaces on alignment if you examine the relevant sections of your text prepared with the software you intend using. And, of course, do not rely on feedback from a screen display to make fine judgements of alignment: examine output on paper (Figure 3.26).

a

two of the texts which several subjects did not complete. *Comprehension* Two general comprehension questions, based on the text content, were prepared for each of the texts. The questions were designed to ensure that sub-

two of the texts which several subjects did not complete. *Comprehension* Two general comprehension questions, based on the text content, were prepared for each of the texts. The questions were designed to ensure that sub-

two of the texts which several subjects did not complete. *Comprehension* Two general comprehension questions, based on the text content, were prepared for each of the texts. The questions were designed to ensure that sub-

b

two of the texts which several subjects did not complete. *Comprehension* Two general comprehension questions, based on the text content, were prepared for each of the texts. The questions were designed to ensure that sub-

two of the texts which several subjects did not complete. *Comprehension* Two general comprehension questions, based on the text content, were prepared for each of the texts. The questions were designed to ensure that sub-

two of the texts which several subjects did not complete. *Comprehension* Two general comprehension questions, based on the text content, were prepared for each of the texts. The questions were designed to ensure that sub-

Figure **3.26**
a In Word 4.0 combining fonts of different sizes or from different typefaces within rows of text creates inconsistencies in the vertical spacing of the text block.

b PageMaker 3.5 maintains consistent vertical spacing despite the combination of different fonts within rows of text.

3.2 **Performance and document format**

The main variables of document format that will affect the performance of individual typefaces are vertical spacing and type size; and word spacing, justification mode (whether type is justified or ranged left) and line length. To get the most out of your typefaces you should experiment systematically with these variables, testing the range of possibilities allowed by the overall format of your document (Figure 3.27, over page).

For each element of a document you need to consider whether the combination of typeface and format gives the clearly defined words and the distinct rows of words that are essential for the sweeping and fixating eye movements underlying smooth reading (see chapter 2 on legibility). The spacing between characters should be consistently less than the spacing between words, and the spacing between words consistently less than the spacing between lines (Figure 3.28, p. 39).

BRIEF CHECKLIST
3.2 **Coordinating typeface and document format**

Ensure that vertical spacing is adequate for the text content and typeface.

Ensure that horizontal spacing, justification mode and line length are adjusted to give evenly-spaced text.

Bear in mind the relationship of the text area to the area of the page as a whole.

typeface **Joanna** measure 87mm

typeface **Gill Sans** measure 58mm

trial 1
unjustified,
default h+j
(no word
division)

size 10pt *vertical space* 10pt

One more attempt was made in the closing days of the eighteenth century to control the freedom of the press by law. There is something almost grotesque in the efforts made by legislators in 1799 to refit, on a full-grown and invincible press, the worn-out shackles by which the Stuarts had tried to curtail the growth of its childhood; and the Act of the 39th George III, cap. 79, in so far as it deals with printing, will always remain one of the surprises, as well as one of the disgraces, of the Statute-book. Among its worst provisions, the following affect letter-founders and letter-

size 8pt *vertical space* 8pt

And be it further enacted, that every person who shall sell Types for Printing, or Printing Presses as aforesaid, shall keep a fair account of all persons to whom such Types or Presses shall be sold, and shall produce such accounts to any Justice of the Peace who shall require the same; and if such person shall neglect to keep such account, or shall refuse to produce the same to any such Justice, on demand in writing to inspect the same, such person shall forfeit and lose, for such offence, the sum of twenty pounds. From and after the expiration of forty days after the

trial 2
unjustified,
default h+j
(no word
division)

size 10pt *vertical space* 12pt

One more attempt was made in the closing days of the eighteenth century to control the freedom of the press by law. There is something almost grotesque in the efforts made by legislators in 1799 to refit, on a full-grown and invincible press, the worn-out shackles by which the Stuarts had tried to curtail the growth of its childhood; and the Act of the 39th George III, cap. 79, in so far as it deals with printing, will always remain one of the surprises, as well as

size 8pt *vertical space* 9pt

And be it further enacted, that every person who shall sell Types for Printing, or Printing Presses as aforesaid, shall keep a fair account in writing of all persons to whom such Types or Presses shall be sold, and shall produce such accounts to any Justice of the Peace who shall require the same; and if such person shall neglect to keep such account, or shall refuse to produce the same to any such Justice, on demand in writing to inspect the same, such person shall forfeit and lose, for such offence, the sum of twenty pounds. From

trial 3
unjustified,
specified
h+j (allow
word divis-
ion, reduce
word space)

size 10pt *vertical space* 12pt

One more attempt was made in the closing days of the eight-eenth century to control the freedom of the press by law. There is something almost grotesque in the efforts made by legislators in 1799 to refit, on a full-grown and invincible press, the worn-out shackles by which the Stuarts had tried to curtail the growth of its childhood; and the Act of the 39th George III, cap. 79, in so far as it deals with printing, will always remain one of the surprises, as well as one of the

size 8pt *vertical space* 10pt

And be it further enacted, that every person who shall sell Types for Printing, or Printing Presses as aforesaid, shall keep a fair account in writing of all persons to whom such Types or Presses shall be sold, and shall produce such accounts to any Justice of the Peace who shall require the same; and if such person shall neglect to keep such account, or shall refuse to produce the same to any such Justice, on demand in writing to inspect the same, such person shall forfeit and lose, for such offence, the sum of

trial 4
justified,
default h+j
(no word
division)

size 10pt *vertical space* 12pt

One more attempt was made in the closing days of the eighteenth century to control the freedom of the press by law. There is something almost grotesque in the efforts made by legislators in 1799 to refit, on a full-grown and invincible press, the worn-out shackles by which the Stuarts had tried to curtail the growth of its childhood; and the Act of the 39th George III, cap. 79, in so far as it deals with printing, will always remain one of the surprises, as well as

size 8pt *vertical space* 10pt

And be it further enacted, that every person who shall sell Types for Printing, or Printing Presses as aforesaid, shall keep a fair account in writing of all persons to whom such Types or Presses shall be sold, and shall produce such accounts to any Justice of the Peace who shall require the same; and if such person shall neglect to keep such account, or shall refuse to produce the same to any such Justice, on demand in writing to inspect the same, such person shall forfeit and lose, for

trial 5
justified,
specified
h+j (allow
word divis-
ion, change
word space
parameters)

size 10pt *vertical space* 12pt

One more attempt was made in the closing days of the eigh-teenth century to control the freedom of the press by law. There is something almost grotesque in the efforts made by legislators in 1799 to refit, on a full-grown and invincible press, the worn-out shackles by which the Stuarts had tried to curtail the growth of its childhood; and the Act of the 39th George III, cap. 79, in so far as it deals with printing, will al-ways remain one of the surprises, as well as one of the dis-

size 8pt *vertical space* 10pt

And be it further enacted, that every person who shall sell Types for Printing, or Printing Presses as aforesaid, shall keep a fair account in writing of all persons to whom such Types or Presses shall be sold, and shall produce such accounts to any Justice of the Peace who shall require the same; and if such person shall neglect to keep such account, or shall refuse to produce the same to any such Justice, on demand in writing to inspect the same, such person shall forfeit and lose, for such offence, the sum of

Figure **3.27**
Carry out systematic experiments with typesize, measure, vertical spacing, word spacing, justification mode and hyphenation. Here typeface and measure have been held constant whilst the other variables have been manipulated.

The fall of the Eastern Bloc regimes did not come out of a clear blue sky for the Western Communists. Parties as different as the Stalinist-dominated Greek and French parties and the reformist minded parties of Britain and Italy have been gripped with internal argument about future strategies

The fall of the Eastern bloc regimes did not come out of a clear blue sky for the Western Communists. Parties as different as the Stalinist-dominated Greek and French parties and the reformist minded parties of Britain and Italy have

Figure 3.28
Characters cohere into words and words into lines of text when character spacing is consistently less than word spacing and word spacing consistently less than line spacing.
Flouting systematic relationships between words, lines and spaces, for example by producing text in which word spacing is greater than line spacing, reduces the coherence of the text, disrupting the eye movements underlying reading.

The fall of the Eastern Bloc regimes did not come out of a clear blue sky for the Western Communists. Parties as different as the Stalinist-dominated Greek and French parties and the reformist minded parties of

10/11pt Baskerville

The fall of the Eastern Bloc regimes did not come out of a clear blue sky for the Western Communists. Parties as different as the Stalinist-dominated Greek and French parties and the reformist minded parties of Britain and

10/11pt Garamond

The fall of the Eastern Bloc regimes did not come out of a clear blue sky for the Western Communists. Parties as different as the Stalinist-dominated Greek and French parties and the reformist minded parties of

10/13pt Baskerville

The fall of the Eastern Bloc regimes did not come out of a clear blue sky for the Western Communists. Parties as different as the Stalinist-dominated Greek and French parties and the reformist minded parties of Britain and

10/13pt Garamond

Figure 3.29
Baskerville, which has a relatively large x-height, tends to look cramped when set at 10pt with a vertical space setting of 11pt. In contrast Garamond, which has a smaller x-height than Baskerville, sits more comfortably within 11pt vertical space. Increasing the vertical space setting to 13pt improves the appearance of both typefaces, but especially Baskerville.

Vertical spacing and type size

You cannot apply a single set of spatial relationships across all typefaces and texts. Typefaces with a large x-height have a larger appearing size than typefaces of the same nominal size with a small x-height and so require more vertical space between lines (Figure 3.29). Vertical space may also need to be increased for texts with a high density of ascending and descending characters or capital letters. Similarly, there should be adequate vertical space for diacritical marks or vowel signs above and below characters to be clearly visible to the reader (Figures 3.30 and 3.31, over page).

Given the different spatial characteristics of typefaces and the different character distributions within texts it is better not to accept automatically the default (or 'auto') vertical space settings given by software packages. These settings are based on the nominal typesize of a text typeface, whatever its appearance (they often give a line increment of 120 per cent of the nominal type size, rounded to the nearest whole number of points). Different software packages and systems give varying degrees of control over vertical spacing if you override default settings. Small adjustments, made in a software package that allows fine tuning of vertical spacing, can substantially improve the performance of a typeface (Figure 3.32, over page).

Note that many software packages use the term 'leading' to refer to vertical space. The term is borrowed from the old technology of metal type, where it referred to strips of lead inserted between rows of metal type to increase their spacing (see Figure 9.9, p.95). In DTP 'leading' is used, rather confusingly, to refer to the total distance from the baseline of one row of type to the baseline of the next. Since different people may interpret the word in different ways, it is probably best to describe the space between rows of type simply as the 'vertical space', or 'line increment' and to measure it from baseline to baseline of successive rows of type (see Figure 9.10, p.95).

Word spacing, justification mode and line length

In DTP the consistency of spacing between characters and words, and, consequently, the consistency of the relationship among characters, words and rows of words in texts depends on the software and format in which the text is set.

If text is ranged left, the software will insert a word space of a consistent size between each word. The size of the word space varies among software packages. It should be approximately the width of the narrowest letter of a font; that is, the width of the lower-case 'i' in most seriffed fonts

Figure **3.30**
a Dutch words have more information about their constituent characters above the x-height (ascenders and the dots on 'i's and 'j's) and below the baseline (descenders) than English.
b A more generous allowance of vertical space may help readers pick out this information.

a

aankondiging is belangrijk omdat het van Adamec kwam en niet van de toenemend geïsoleerde partijleider, Milos

announcement is important because it came from Mr Adamec rather than the increasingly isolated party leader, Milos

b

aankondiging is belangrijk omdat het van Adamec kwam en niet van de toenemend geïsoleerde partijleider, Milos

announcement is important because it came from Mr Adamec rather than the increasingly isolated party leader, Milos

Figure **3.31**
a The vertical spacing of this Classical Arabic is so tight that there is potential for confusion between the letters and vowel signs.
b Opening up the vertical space clarifies the relationships between letters and vowels.
c The tight vertical spacing cramps the diacritical marks of this Classical Greek.
d Opening up the space is an improvement.

a

b

c

mentaries are stated to be: 'τοῦ μὲν Οἰκουμενίου; εἰς τὰς Πράξεις τῶν Ἀποστόλων, εἰς τὰς ἑπτὰ καθολικὰς λεγομένας Ἐπιστολάς, εἰς τὰς Παύλου πάσας: Τοῦ δὲ Ἀρέθα; εἰς τὴν Ἰωάννου Ἀποκάλυψιν'. Oecumenius's com-

d

mentaries are stated to be: 'τοῦ μὲν Οἰκουμενίου; εἰς τὰς Πράξεις τῶν Ἀποστόλων, εἰς τὰς ἑπτὰ καθολικὰς λεγομένας Ἐπιστολάς, εἰς τὰς Παύλου πάσας: Τοῦ δὲ Ἀρέθα; εἰς τὴν Ἰωάννου Ἀποκάλυψιν'. Oecumenius's com-

The Czechoslovak government yesterday bowed to overwhelming people's power and agreed to the opposition's key demand for an end to one-party rule. The announcement came at the end of a third round of negotiations

7/8pt Lucida

The Czechoslovak government yesterday bowed to overwhelming people's power and agreed to the opposition's key demand for an end to one-party rule. The announcement came at the end of a third round of negotiations

7/9pt Lucida

The Czechoslovak government yesterday bowed to overwhelming people's power and agreed to the opposition's key demand for an end to one-party rule. The announcement came at the end of a third round of negotiations

7/10pt Lucida

Figure **3.32**
The software gives this text, set in 7pt Lucida, a default or 'auto' setting of 8pt vertical spacing, but the text tends to look too tightly spaced, and word contours are crowded. Opening up vertical spacing to 9pt or even 10pt makes word contour more visible.

but possibly sightly larger than the 'i' in many sans serif fonts, probably about one quarter-em (Figure 3.33). But this recommendation for word spacing is very much a rule of thumb. If, for example, a typeface has poor character fit, then word spacing may need to be greater than a quarter-em to ensure there can be no confusion between word spaces and loosely spaced letter combinations; with a well-spaced typeface it may be possible to manage with less than a quarter-em. A narrow or bold typeface may need less word spacing than other typefaces. Spacing between characters, and, therefore, between words, must relate to the spacing within characters; and since in both bold and condensed typefaces, character counters can be very narrow, word spacing can be adjusted accordingly. Most software packages tend to give too generous an allowance for word spacing and some do not have facilities for changing the given allowance, in which case you should consider using a different software package.

Figure 3.33
Ideally word spaces should be approximately the width of the narrowest letter of a font: the width of the lower-case 'i' in most seriffed fonts but possibly slightly larger than the 'i' in many sans serif fonts. Here the word space is slightly less than the character 'i' in Janson Text, but slightly greater than the 'i' in Helvetica.

last night announced that the country's inhabitants would no longer need exit permits to travel to the West, amid reports of

mits to travel to the West, amid reports of

last night announced that the country's inhabitants would no longer need exit permits to travel to the West, amid reports of

mits to travel to the West, amid reports of

If text is justified the software will expand or contract word spaces as necessary in order to produce lines that range with one another at both the left and right side of a text column. This adjustment introduces inconsistency into horizontal spacing. Controlled variation in word spacing is usually acceptable – provided that, at one extreme, word spacing does not approach the size of the visible white space between lines nor, at the other extreme, approach character spacing. In most justified texts word spacing should probably range between one-sixth and one-half of an em (the ideal, again, being about one quarter-em).

Unfortunately, DTP software often does not allow much control over the word spacing of justified text. And some justification software compounds inconsistencies in word spacing by making additional adjustments to character spacing. The resulting disruption of systematic relationships between character, word and line spacing can reduce the legibility of a text. The degree of inconsistency will be greatest when the software is most constrained (for example, when the text is set in narrow columns and when hyphenation is not allowed), particularly if the typeface

characters are relatively wide or the text comprises long words. Some software allows you to define limits within which character and word spacing can be varied; in which case, you should experiment with narrow limits. But even when you define limits, justification algorithms sometimes override them if they cannot compute spacing solutions within them. If your software does not allow you to produce text with controlled character spacing, you should, as far as possible, avoid justified formats.

Hyphenation is an essential partner to justification (it also improves the appearance of ranged-left text; see Figure 3.39, p. 45). Without hyphenation, justification routines tend to open up spacing excessively, delivering very obvious areas of space between words or characters. The eye is very good at spotting patterns, so it links white word spaces into vertical or diagonal 'rivers' that disrupt the horizontal flow of the text (Figure 3.34).

Local changes in text spacing can have an overall effect on the global appearance or 'colour' of a typeface in a block of text, making the same typeface appear different according to its format (Figure 3.35).

Figure **3.34**
a In narrow, justified columns, hyphenation is essential for consistent word and character spacing.
b Without hyphenation most software compromises the consistency of word and character spacing.

a

The announcement came at the end of a third round of negotiations between the Prime Minister, Mr Adamec, and the opposition movement. It followed eleven days massive demonstrations and a general strike on Monday.

b

The announcement came at the end of a third round of negotiations between the Prime Minister, Mr Adamec, and the opposition movement. It followed eleven days massive demonstrations and a general strike on Monday.

Figure **3.35**
The variable word spacing in justified text (**a**) gives it a less predictable 'colour' than text that is ranged left (**b**). When all other variables are held constant, justified text tends to have a lighter appearance than unjustified text.
(In these illustrations, line endings have been made consistent to allow comparison.)

a

The Czechoslovak government yesterday bowed to overwhelming people's power and agreed to the opposition's key demand for an end to one-party rule.
The announcement came at the end of a third round of negotiations between the Prime Minister, Mr Ladislav Adamec, and the opposition Civic Forum movement. It followed 11 days massive demonstrations and a general strike on Monday.

b

The Czechoslovak government yesterday bowed to overwhelming people's power and agreed to the opposition's key demand for an end to one-party rule.
The announcement came at the end of a third round of negotiations between the Prime Minister, Mr Ladislav Adamec, and the opposition Civic Forum movement. It followed 11 days massive demonstrations and a general strike on Monday.

Spatial relationships between text and page

The performance of a typeface depends not only on the spatial relationships within a block of text but also on the relationship between the text and the rest of the page. Typefaces cannot simply be slotted into formats designed for typewritten pages, not least because their proportional spacing means that many more typeface characters can be fitted into a line than monospaced typewriter characters of comparable size (see section 9.2 on the horizontal dimension of typefaces). A simple substitution of typeset for typewritten characters will give lines with more characters than are easy to read. This is one of the most common faults to be found in desktop published documents. The optimum range for the number of characters per line for continuous reading is usually about 60 to 70 characters (Figures 3.36 and 3.37).

Figure **3.36**
Almost any typeface, if set to the format of a typewritten document, will produce pages of text that appear very dense and uninviting to the reader.

Running headline on right-hand page 243

The performance of a typeface depends not only on the spatial relationships within a block of text but also on the relationship between the text and the rest of the page. Typefaces cannot simply be slotted into formats designed for typewritten pages, not least because the proportional spacing of typeface characters means that many more can be fitted into a line than mono-spaced typewriter characters of a comparable size. A simple substitution of typeset for typewritten characters will give lines with more characters than are easy to read. This is one of the most common faults to be found in desktop published documents. The optimum limits for the number of characters per line for continuous reading are held to be between 60 and 70 characters.

Most DTP software has a default setting for line length that may be acceptable for large format, typewritten documents, or for display work, but not for typeset text. In most cases you should override this setting. If you are producing typeset text at relatively large page sizes, such as A4, you should surround your text block with a greater amount of space than is common for typewritten texts or set your text in two, or perhaps three, columns. If you are setting a single column of text on an A4 page, a relatively wide set typeface may improve the appearance of the page.

Just as you should avoid setting text at too wide a measure in large page formats you should also avoid setting text to too great a depth. Although there are no hard and fast rules, most continuous texts (for example, paperback novels) are set to a depth of approximately 40 lines per page. A page with very long columns may not pose the same legibility problem as a page with wide columns, but may still appear off-putting for the reader.

As well as examining candidate typefaces from the 'bottom-up', checking how they perform from character level, through word level, to text level, you also need to take a 'top-down' view and consider how appropriate typefaces are for the kinds of documents you intend to produce. This may mean balancing conventions for particular genres of documents with your personal preferences and with financial and system constraints.

Type manufacturers often give users guidelines to the appropriate application of their typefaces. These can be a helpful starting point, but probably require further thought. For example, a typeface recommended for setting tables may be appropriate for tables in most circumstances; but tables take many forms (for example, some are primarily numerical, others include more text) and are used for different kinds of reading task, ranging from quick reference to studied consultation. The recommended typeface may not fit the particular kind of table you are producing. It is worth bearing in mind that manufacturers' aims include selling as many of their

Running headline on right-hand page 227

The performance of a typeface depends not only on the spatial relationships within a block of text but also on the relationship between the text and the rest of the page. Typefaces cannot simply be slotted into formats designed for typewritten pages, not least because the proportional spacing of typeface characters means that many more can be fitted into a line than mono-spaced typewriter characters of a comparable size. A simple substitution of typeset for typewritten characters will give lines with more characters than are easy to read. This is one of the most common faults to be found in desktop published documents. The optimum limits for the number of characters per line for continuous reading are held to be between 60 and 70 characters.

Most DTP software has a default setting for line length that may be acceptable for large format, typewritten documents, or for display work, but not for typeset text. In most cases you should override this setting. If you are producing typeset text at relatively large page sizes, such as A4, you should surround your text block with a greater amount of space than is common for typewritten texts or set your text in two, or perhaps three, columns. If you are setting a single column of text on an A4 page, a relatively wide set typeface may improve the appearance of the page.

Just as you should avoid setting text at too wide a measure in large page formats you should also avoid setting text to too great a depth. Although there are no hard and fast rules, most continuous texts (for example, paperback novels) are set to a depth of approximately 40 lines per page. A page with very long columns may not pose the same legibility problem as a page with wide columns, but may still appear off-putting for the reader.

As well as examining candidate typefaces from the 'bottom-up', checking how they perform from character level, through word level, to text level, you also need to take a 'top-down' view and consider how appropriate typefaces are for the kinds of documents you intend to produce. This may mean balancing conventions for particular genres of documents with your personal preferences and with financial and system constraints.

Type manufacturers often give users guidelines to the appropriate application of their typefaces. These can be a helpful starting point, but probably require further thought. For example, a typeface recommended for setting tables may be appropriate for tables in most circumstances; but tables take many forms (for example, some are primarily numerical, others include more text) and are used for different kinds of reading task, ranging from quick reference to studied consultation. The recommended typeface may not fit the particular kind of table you are producing. It is worth bearing in mind that manufacturers' aims include selling as many of their typefaces as possible and so their recommendations may err toward a wider range of typefaces than is necessary. Most designers, however, use only a handful of typefaces in their working practice, selecting typefaces with which they are familiar and that work well across a range of documents.

Received wisdom about the match between certain type styles and particular genres of document can often be over-simplistic too. For example, many people believe that sans serif typefaces are particularly suitable for scientific and technical publishing. But if you examine a range of published scientific documents, you will find that many, perhaps the majority, are set in seriffed faces. [Figure 1.67: Illustration of range of scientific journals in seriffed and sans serif typefaces.] Examining documents of the kind you intend to produce that have been published professionally may provide the

Figure **3.37** (right)
Where over-long line lengths cannot be avoided you can take remedial action by increasing the vertical space between lines. This makes the text easier to read, but should be regarded as a last resort.

It was too late to buy a drink, but the square was full of people drunk with joy. Soldiers in uniform, mad slogans pinned to their backs, walked up and down, arm in arm, waving flags. Waiters abandoned hotel tables and joined in. Taxi drivers flew flags from their aerials and waved at everyone. Passengers leaned out of car windows ringing hand bells.

It was too late to buy a drink, but the square was full of people drunk with joy. Soldiers in uniform, mad slogans pinned to their backs, walked up and down, arm in arm, waving flags. Waiters abandoned hotel tables and joined in. Taxi drivers flew flags from their aerials and waved at everyone. Passengers leaned out of car windows ringing hand bells.

Most DTP software has a default setting for line length (often 6½ inches) that may be acceptable for large format, typewritten documents, or for display work, but not usually for typeset text. In most cases you should override this setting. If you are producing typeset text at relatively large page sizes, such as A4, you should surround your text with more space than is common for typewritten texts or set your text in more than one column. Look at a range of journals and books to see the arrangement of text and space on the page (Figure 3.38). If you are setting a single column of text on an A4 page, a typeface with relatively wide characters may improve the appearance of the page. Books with A4 formats often have type sizes that are at the top end of or larger than the normal range of type sizes for text setting (most typeset latin-script texts are set in fonts of between 9pt and 11pt in size). But you should avoid an excessive increase in type size in order to reduce the number of characters in a line.

Just as you should avoid setting text to too wide a measure in large page formats you should also avoid setting text to too great a depth. Although there are no hard and fast rules, most continuous texts (for example, paperback novels and Gutenberg Bibles) are set to a depth of about forty lines per page. Text set in very long columns may not pose the same legibility problems as text set to a wide measure, but may still be off-putting for the reader (Figure 3.39).

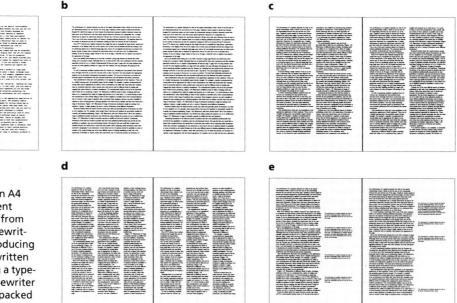

Figure **3.38**
Using a typeface on an A4 page demands different arrangements of text from those suitable for typewritten documents. Reproducing the format of a typewritten page (such as **a**) using a typeface rather than a typewriter face delivers densely-packed pages (**b**) (see also Figure 3.36, previous page). The relatively compact dimensions of typefaces allow multiple text columns (**c**, **d**), or a single text column with an additional, narrower column for notes or illustrations (**e**).

Electronic Publishing Vol 5 No 1

Electronic Publishing Vol 5 No 2

was an intriguing view of the problems involved in such an operation and it will be interesting to see how the situation develops. (*Editorial note*: the September meeting will be at the Open University, so you can go and see for yourself.)

The establishment of *The Independent* has been interesting, not only from a sociological point of view, but also in the technical context of Eddie Shah's ventures. Chris Hugh-Jones gave a very clear explanation of how the paper functions (when compared to a more conventional operation), together with a description of how the paper came into being An Atex system is used, just as by a number of other papers, but everything is only keyed once. Journalists, Sub-Editors, Editors etc all have access to the files and in this way the paper can be designed on the screen with no delay in output once a page has been finalized. Composed pages are then faxed to different parts of the country for printing and distribution.

Chris Hugh-Jones also talked about the Magazine, produced on Saturdays. The text is handled using Quark Xpress (which produces one or two typographical problems, for example in hyphenation) and then sent to the Scitex colour graphics work stations for merging with the graphics, which have been scanned in. Finally, Chris Hugh-Jones discussed the future. *The Independent* may well be ahead of the rest of the national press in its production techniques, but the suppliers to the newspaper industry are still some way behind those to the graphic arts industry.

Cathy Booth of the University of Exeter talked about teaching electronic document preparation as part of a modular degree course. One of the problems is that students start with such varying levels of knowledge and competence in computing. However, the use of two types of program provides the students with an insight into what is better for different types of publication. She chose the markup system PC-TeX, and the contrasting direct manipulation system, Pagemaker. The use of videos and projects helped considerably. Nonetheless, the biggest problem was the lack of resources, at least in relative terms as this kind of course is

one which ideally requires as much hands-on experience as possible. The biggest triumph was the quality of some of the students' projects.

The final speaker was Ted Johnson, who is an Aldus Fellow, which means that he has a free role to investigate directions in which Aldus is likely to move. He reviewed Aldus's place in the market and their future options. He described four areas (or directions), technical publishing, word processing, interactive drawing, and creative flexibility, into which Aldus could move, although they are to a certain extent mutually exclusive. Possible solutions rejected have been (a) to abandon the market and (b) to provide everything for everyone. This leaves splitting production lines as a short-term option, e.g. the development of Freehand as a separate product from Pagemaker. A more long term development is object-oriented implementation, so that object classes can be tested independently of the specific application, with the aim of producing zero-defect software. Another benefit would be cross-product object sharing, so that once defects are fixed for one product they are fixed for all. A final implication would be that object subclasses could be created for different market segments with customization by software vendors, VAR's, systems integrators, corporate information services departments, or even the sophisticated user. Essentially then the user would either buy a single customized product or a library from which he can put together his own product.

To sum up the conference is difficult. The range of people there was broad, from academia, through the commercial publishing world to the corporate. The speakers, taken together, provided an interesting overview of how EP has developed over the last few years and how it is likely to develop. There were no announcements of great break-throughs, but that was hardly to be expected. Perhaps the most important aspect of the meeting was the time spent informally (and the social arrangements for the conference were excellent, for which the local organiser, Roger Gawley, must take the major responsibility) and the

opportunity for discussion. As always, there were many familiar faces, but this time there were a significant number of not so familiar faces, and the opportunity for discussions with different people, or even with the same people in a different place, meant that the general view was that this sort of meeting should happen again.

D W Penfold (with contributions from Malcolm Clark)

Paperless Publishing

The last one-day BCS Electronic Publishing meeting of 1988 took place at SOAS on 1st December. The rather specialist theme was Paperless Publishing - essentially a broad-based view of electronic information dissemination, without that reassuring paper product.

I can remember the very first BCS Electronic Publishing meeting in May 1984, when one speaker described a farming-based use of Viewdata. Since then 'paperless publishing' has only emerged occasionally at the BCS Electronic Publishing meetings — mainly in the form of CD-ROM and integrated videodisc systems like the Domesday Book. This latest meeting attempted to explore more recent developments in Paperless Publishing, and in so doing opened my eyes to the existence of some other variant forms.

This was exemplified in the first talk, given by Dr Stephen Castell of BBC Datacast. He described various independent systems of information distribution using TV transmission, all controlled by BBC Enterprises. These systems include the Stock Exchange 'Market Eye', Post Office 'media board' advertising; and constant updates of betting office TV screens throughout the U.K. Obviously with such diverse clients, data communications must be secure, with each system operating independently, along dedicated transmission channels. The common data carrier is BBC Datacast —based on distributed databases, user terminals and off-line storage. Emphasis is on high speed, constant updates, reliability, security and 'transparency'. Future developments include the use of cable, satellite and radio.

based system (CAPS) I made it my task to search out the *voluntary* fellow sufferers and I was particularly interested to hear their experiences. As usual, the Dutch were there in force. I generally regard them as being pretty well ahead of the game in Europe and I must say it came as a bit of a shock to me to find that many of them were still taking ASCII text and adding their own mark-up to it. In the UK there are some encouraging signs with at least one other publisher/printer (besides the OU) developing an MS Word to SGML program.

Elegant conversion from the authoring word processing program to SGML is still very much the missing link. Avalanche Technologies have some of the way to solving it with FastTag which I believe is the XGML parser that is also used by DocuPro and Arbortext. To my mind a 'visual' system of hierarchy recognition misses out a lot of the subtleties of anything other than simple text.

There certainly seems to be no shortage of 'conventional' SGML parsers available at a price, Sobemap's Mark-It and Yuri Rubinsky's SoftQuad being two notable examples. These both work as stand-alone word processors and would be great if you could persuade all your authors to use one.

Xyvision and Interleaf both gave demonstrations of their SGML front-ends. Interleaf's was very neat but again it presupposed that the author was the person on the Interleaf keyboard. Doubtless it could take in ready-made SGML. In terms of major installed gencode based publishing systems Compugraphic with CAPS was noticeable by their absence.

This conference was significant because for the first time people were able to report back on the results of actually using SGML in competitive environments. The Oxford English Dictionary was offered up as an example of main-stream publishers using SGML which makes a lot of sense when you consider updating and multi-media presentations. On the military side concern was expressed at how the number of standard DTDs was growing on a daily basis (they originally thought they would only need 3 or 4) and secondly at the amount of time it took to write a DTD. Noises were made about months rather than weeks.

The other worry voiced by the militarists was that of retro-fitting SGML/CALS to existing documentation. How was it to be done and who was going to pay for it?

I have to confess that I found the discussions by the theoreticians on standards dry to the

point of excruciating as well as a slight annoyance that they were apparently failing to recognize the amount of hard work being undertaken by users in order to breathe life into these standards. But I did come away from the meeting feeling that SGML was actually being used by real people. When the conference comes to Europe again in two years time I believe that we will see that SGML has progressed significantly across all EP applications.

John Feltham, Open University

UK TeX Users' Group

The Third Meeting of the UK TeX Users' Group was held at the University of Aston, on 11 October 1989. The programme was presented in two parts, Fonts: how they are created and Fonts: how they are used. As one of those attending said, this was a nice TeX meeting – TeX didn't get mentioned by the speakers until after tea!

Summary of papers
David Kindersley: *Making letterforms*. This talk was built around a set of marvellous 35mm slides showing the various kinds of lettering that he had designed and carved. In particular these illustrated the freedom available to a designer making a fairly short inscription which could be seen as a work of art as well as conveying a message in words. Among the additional freedoms were the ability to superimpose letters within a word, to make minor adjustments to the sizes of the letters so that the words would fit the space and the chance to create a backward sloping italic to fit a design. Against that had to be set the necessity of making systematic adjustments to letter sizes so that words could still be read on, for example, a horizontal memorial set into the floor.

David Kindersley also talked about his search for a mathematical algorithm to ensure correct letter spacing in typesetting. This is built on the basis that letter spacing should be applied to groups of three letters – the middle of the three should be in the optical centre – and that it is possible to compute a 'centre' for each letter in a fount. His method ignores the bounding rectangle which was imposed on metal type.

Paul Bacsich (Open University) on *PostScript needs MoreMaths* a talk illustrated with overhead projector slides, spoke about his project to design additional characters to be used with PostScript so that output to be printed in a combination of Times and Symbol (for the Greek letters) could also include as

10

Figure **3.39**

a The combination of a narrow measure and small type size in long columns gives this text a list-like appearance. The effect is all the more extreme because the text has not been hyphenated and so its right-hand margin is very ragged. (The original page size is A4.)

b In a re-designed version of the text the type size is larger and the columns (reduced from three to two per page) wider. The total area occupied by text is the same in both versions, but the revision has a more balanced appearance. Hyphenation would also have helped, here, to give a smoother right-hand margin.

3.3 **Performance and document genre**

In addition to examining candidate typefaces from the 'bottom up', checking how they perform from character level, through word level, to text level, you also need to take a 'top down' view and consider how appropriate typefaces are for the kinds of documents you intend to produce. This may mean balancing conventions for particular genres of documents with your personal preferences and with financial and system constraints.

Appropriateness

Type manufacturers often give users guidelines to the appropriate application of their typefaces (Figure 3.40, over page). These can be a helpful starting point, but will probably require further thought. For example, as Figure 3.41

BRIEF CHECKLIST
3.3 **Matching typefaces to document genre**

Consider the conventions for the documents you intend to produce.

Avoid too high a level of formality.

Ensure that your conventions are appropriate to typeset, printed documents rather than typewritten documents.

shows, Adobe's guidelines recommend the use of Orator for highly legible lecture notes. But the alphabetic characters of Orator are all capital letters, with none of the lower-case letters that give distinctive profiles to words in latin scripts (see Figure 2.2, p.11). Most researchers and practitioners concerned with legibility advise that all-capitals are used only for very short sections of text (see also section 3.1). An examination of the text set in Orator suggests that this advice is well-founded: it has a neat appearance but is uncomfortable to read. Perhaps the guidelines should have warned users that Orator is not suitable for continuous text.

The Orator example is one particularly striking case of potentially misleading guidelines, but there are others. The problem with guidelines for the application of typefaces is, partly, that they can be too general. For example, a typeface recommended for setting tables may be appropriate for tables in most circumstances; but tables take many forms (some are primarily numerical, others include more text),

Figure **3.40**
a Part of a matrix, produced by Bitstream, to help users match typefaces to particular applications.
b Adobe give general recommendations about the qualities of individual typefaces.

a

Applications: Presentation Materials · Office Correspondence · Catalogs · Books · Flyers · Financial Reports · Proposals · Invitations · Instruction Manuals · Newsletters · Labels · Forms · Spec Sheets · Directories

Typeface	Presentation Materials	Office Correspondence	Catalogs	Books	Flyers	Financial Reports	Proposals	Invitations	Instruction Manuals	Newsletters	Labels	Forms	Spec Sheets	Directories
Bitstream Amerigo			■			■				■		■		
ITC Avant Garde Gothic				■		■				■				■
Baskerville			■		■									
Bodoni					■	■					■			
ITC Bookman		■	■		■	■		■	■					
Century Schoolbook		■	■	■		■	■	■						
Bitstream Charter		■	■		■	■	■		■	■		■		■
ITC Clearface			■			■				■		■		
Bitstream Cooper	■	■			■				■		■			
Courier (10 pitch)		■			■					■		■		

b

When to use New Century Schoolbook ▼

For lengthy text applications.
When maximum legibility is required.
For adverse printing conditions.

When to use ITC Galliard ▼

For proposals, newletters or announcements.
For an italic face with a calligraphic feel.
For a distinctive serif text face.

When to use ITC Franklin Gothic ▼

For catalogs, forms, price sheets and parts lists.
To combine with serif typefaces.
For publication titling.

Figure **3.41**
The manufacturer's recommendations for the use of Orator and a sample of text set in Orator.

When to use Orator ▼

For highly legible lecture notes.
For simple legible type.
For tabular charts where character alignment is needed.

ORATOR IS A TYPEWRITER
FACE ORIGINALLY DESIGNED
TO BE USED BY LECTURERS,
READING NOTES AT A DIS-
TANCE GREATER THAN THE
NORMAL READING DISTANCE.
IT IS A MONOSPACED TYPE-
FACE WITH A LARGE X-HEIGHT,
WHICH CONSISTS OF UPPER-
CASE CHARACTERS ONLY.

and they are used for different reading tasks, ranging from quick reference to studied consultation. A recommended typeface may not fit the particular kind of table you are producing. The only way to be sure that a typeface works for a given document is to test it in circumstances that are as close as possible to those in which it will be used.

But as well as being too general, guidelines can also be over-specific, implying that a different typeface is needed for each new application. It is worth bearing in mind that although manufacturers genuinely aim to help typeface users, their aims also include selling as many copies of each of their typefaces as possible, so their recommendations may err toward a wider range of typefaces than is necessary. Most designers, however, use only a handful of typefaces in their working practice, selecting those with which they are familiar and which work across a range of documents (Figure 3.42).

Figure **3.42**
These text samples, all set in Melior, show that a single typeface can serve a variety of functions either within a single document or across different documents.

money paid in	is payment for	index which applies
June 1981	July 1981	May 1981
July 1981	Aug 1981	June 1981

first payment made in	contract starts on	index for first payment
June 1981	1 July 1981	May 1981

last payment made in	contract finishes on	index for end of 5 years
May 1986	1 July 1986	May 1986

What an adviser needs to know about you to give general advice

Age

Health

Married/single

Number and ages of children/dependants

Size of family income (and how it's made up)

Prospects (eg job prospects/legacies)

Expenditure/commitments

Tax position

and National Savings Certificates (2nd Index-linked Issue). They decide to go for regular savings in a unit trust. They realise this could be a risky choice – but they're hoping it may be worth it. They feel it's more flexible than a unit-linked savings plan. They decide to add odd savings to their building society ordinary share account (where they've got their emergency fund). When they've built up a big

yearly rate of inflation	what £1,000 will be worth after 10 yrs	after 15 yrs	after 20 yrs
5%	£614	£481	£377
10%	£386	£239	£149
15%	£247	£123	£61
20%	£162	£65	£26
25%	£107	£35	£12

Received wisdom about the match between classes of typeface and particular genres of document can often be over-simple too (Figure 3.43). For example, many people believe that sans serif typefaces are particularly suitable for scientific and technical publishing. But if you examine a range of published scientific documents, you will find that many, perhaps the majority, are set in seriffed faces. (Figure 3.44 shows the same text, reproduced in different journals in a sans serif and seriffed typeface.) Examining professionally published documents of the kind you intend to produce may provide the best guidelines to typefaces, type size and document format. You may feel you would like to depart from standard formats, but you should bear in mind that readers will be expecting usable documents rather than innovative typography. So any innovation in your choice and use of typefaces should be justifiable in terms of benefits to the reader.

Figure **3.43**
Some people make very specific suggestions for the typefaces most appropriate for the 'mood' of particular documents. These quotations, from Vincent Steer's *Printing Design and Layout* (written in the 1930s) should perhaps not be taken too seriously.

On typefaces for books

A detective story, for instance, might read more convincingly in a matter of fact face like Scotch Roman. A book intended to be read by a doctor or a scientist might suitably be set in a precise and pedantic type like Bodoni Book, while a light novel for a holiday maker would call for a more robust typeface.

On display typefaces

The plain and severe typeface will appeal to the masculine mind and will give the right atmosphere to printing which serves the pupose of the plumber, the plain business man or the engineer. The sprightly italic will suggest the swirl of skirts and the pirouettes of a ballet dancer.

Figure **3.44**
If you examine documents from a particular genre you will find that similar kinds of text (and, in this case, the same text) are set in different typefaces and formats.

Table 2. Types of communication and 'Journal' planned for LINC programme

1. Chit-chat	Informal
2. Work messages	
3. LINC News—network and related information in a monthly newsletter	
4. Enquiry-answer system between experts	
5. Bulletin—project and work progress reports	
6. Annotated abstracts journal	
7. Discussions and questions on papers	
8. Poster papers journal	
9. Refereed papers journal	Formal

TABLE 2. *Types of communication and 'journal' planned for LINC programme*

1. Chit-chat	Informal
2. Work Messages	
3. LINC News—network and related information in a monthly newsletter	
4. Enquiry-answer system between experts	
5. Bulletin—project and work progress reports	
6. Annotated Abstracts Journal	
7. Discussion and Questions on Papers	
8. Poster Papers Journal	
9. Refereed Papers Journal	Formal

Perhaps one of the most problematic aspects of desktop publishing is the implication of formality in typeset, rather than typewritten, text. In books and journals, the formality of a typeface is quite appropriate. But the formal appearance of a typeface can be at odds with the more ephemeral quality of some desktop published documents, such as lecture notes, documentation and, especially, correspondence. Current opinions about the appropriateness of using typefaces in these documents may well change as more people have access to typefaces through desktop publishing systems. In the meantime some typeface manufacturers have responded to the problem by commissioning typefaces especially for informal use (Figure 3.45). These typefaces have the further advantage that they are often especially designed for reproduction at medium resolution and so may reproduce better on laser printers than most other typefaces (see section 6.1 on laser printer technology).

Figure **3.45**
a The use of Stone Informal in this flier preserves the informality of the content (although the centred arrangement of words on the page suggests formality, see Figure 3.46, over page).
b These exhibition notes are set in Lucida. Although more formal than typewritten notes the choice of Lucida is, perhaps, appropriate, given the ephemeral quality of the document.

a

The Nutcracker
Tchaikovsky

7.30 p.m. Wednesday, 17 January 1990
Royal Festival Hall, London

I have booked 20 seats @ **£6.50 each to students** and **£9.50 each for non-students.** These are offered to me on a sale-or-return basis, and so there has to be a deadline, after which I cannot guarantee seats. All the usual rules apply—no cash, no seat; all monies payable to me.

b

'Chromos' and 'Oleos': a brief note on an exhibition of chromolithographs

Department of Typography & Graphic Communication
University of Reading, January–February 1990

Scope of the exhibition	This exhibition sets out to show some of the principal applications of chromolithography in Britain. It is not concerned with the beginnings of colour printing by lithography, but only with its widespread commercial use in the second half of the nineteenth century. In this period it was the major colour printing process.
Beginnings of chromolithography	The word 'chromolithographie' was used by Godefroy Engelmann to describe the process of colour printing by lithography he patented in France in 1837. A few years later the word 'chromalithography' was used in England to describe a similar process in Thomas Shotter Boys's *Picturesque architecture in Paris, Ghent, Antwerp, Rouen, etc.* (London, 1839). But even before the 1830s, when colour printing began to take off across a range of processes, there had been isolated attempts to print lithographs in colour. In Britain, the period 1835 to about 1850 saw colour lithography established as one of the principal colour-printing processes, particularly for the reproduction of illuminated manuscripts and similar decorative work.

Figure **3.46**
A typewriter face
does not deliver the
impact you need
and an informal
typeface may not be
available.

```
The Nutcracker
Tchaikovsky

7.30 p.m. Wednesday, 17 January 1990
Royal Festival Hall, London

I have booked 20 seats @ £6.50 each to students
and £9.50 each for non-students. These are offered
to me on a sale-or-return basis, and so there has
to be a deadline, after which I cannot guarantee
seats. All the usual rules apply - no cash, no
seat; all monies payable to me.

Since it is now the end of term, I will have to
ask you to mail the cheques to my home address in
Norfolk. (My address and telephone number are
given overleaf.) Please give me your telephone
number and address over the holiday, with some
indication of your availability. I will not ring
anyone if there are no changes in the seating
prices and arrangements. Fill in the enclosed form
and send it to me with an s.a.e. If you don't
enclose an s.a.e. I'll keep the tickets for you
until next term. Cheques should be made payable to
Alex Ellwood.

Deadline for tickets: 19 December 1989
Please allow 2 days for the cash to arrive at my
address, or you may not receive your tickets. Ring
me if you're not certain the cash will arrive for
the 19th.
```

A traditional type-
face with a centred,
symmetrical page
format may appear
too formal.

THE NUTCRACKER
Tchaikovsky

7.30 p.m. Wednesday, 17 January 1990
Royal Festival Hall
London

I have booked 20 seats @ **£6.50 each to students** and **£9.50
each for non-students.** These are offered to me on a sale-or-
return basis, and so there has to be a deadline, after which I
cannot guarantee seats. All the usual rules apply—no cash, no
seat; all monies payable to me.

Since it is now the end of term, I will have to ask you to mail
the cheques to my home address in Norfolk. (My address and
telephone number are given overleaf.) Please give me your
telephone number and address over the holiday, with some
indication of your availability. I will not ring anyone if there
are no changes in the seating prices and arrangements. Fill in
the enclosed form and send it to me with an s.a.e. If you don't
enclose an s.a.e. I'll keep the tickets for you until next term.
Cheques should be made payable to Alex Ellwood.

Deadline for tickets: 19 December 1989
*Please allow 2 days for the cash to arrive at my address, or you
may not receive your tickets. Ring me if you're not certain the
cash will arrive for the 19th.*

The level of formal-
ity can be reduced
by an asymmetric
page format.

The Nutcracker
Tchaikovsky

7.30 p.m. Wednesday 17 January 1990
Royal Festival Hall, London

I have booked 20 seats @ **£6.50 each to students** and **£9.50
each for non-students.** These are offered to me on a sale-or-
return basis, and so there has to be a deadline, after which I
cannot guarantee seats. All the usual rules apply—no cash, no
seat; all monies payable to me.

Since it is now the end of term, I will have to ask you to mail
the cheques to my home address in Norfolk. (My address and
telephone number are given overleaf.) Please give me your
telephone number and address over the holiday, with some
indication of your availability. I will not ring anyone if there
are no changes in the seating prices and arrangements. Fill in
the enclosed form and send it to me with an s.a.e. If you don't
enclose an s.a.e. I'll keep the tickets for you until next term.
Cheques should be made payable to Alex Ellwood.

Deadline for tickets: 19 December 1989
*Please allow 2 days for the cash to arrive at my address, or you
may not receive your tickets. Ring me if you're not certain the
cash will arrive for the 19th.*

Defining the particular qualities that make a typeface
informal is difficult, but informals tend to have softer con-
tours than formal typefaces (although there are also some
sharp, angular informals). Some of the qualities that give a
typeface higher formality are high stroke contrast, fine
details, and very symmetric, vertical or regular letterforms.
So if an informal typeface is not available, or is unsuitable
for other reasons, you may consider using a typeface that is
traditional but does not have all the hallmarks of formality.
It is also possible to imply informality by the overall typog-
raphy of the document; for example, by ranging text left
rather than justifying it, adopting asymmetric page formats
and avoiding using capitals in headings. (A ranged-left
format is likely to produce better spaced text in any case;
see section 3.2.) But if either an informal typeface or an
informal format still deliver too high a level of formality
then you may be making a genuine 'genre error' and it may
be better to stick with a typewriter face such as Courier or
Elite (Figure 3.46).

A mistake to avoid is trying to make text appear informal
by using outlined or shadowed fonts or by using decorative
display faces. These appear so different from the standard
range of typeface variants that they can be very distracting.
They are also often difficult to read.

The conventions of typeset documents

Whether a relatively formal or informal typeface is used,
there are particular conventions for the presentation of
typeset documents that differ from those of typewritten
documents. These conventions depend partly on the more
specialized character sets of printing types (see chapter 1 on
the character set). The best guides to the conventions of
typeset documents are Butcher's *Copy editing*, *The Chicago
manual of Style*, and Williamson's *Methods of book design*
(see Further reading). If you are preparing a document for
publishers, you should check whether they have a list of
conventions (house style) for you to follow and should
agree on the treatment of any special cases, not covered by
their list. If external publishers are not involved you should
keep your own record of the conventions you use within
your text (for example, the contexts in which you use single
or double quotation marks) so that you can apply them
consistently throughout your documents. In the meantime
the following paragraphs may help you avoid some classic
desktop publishers' slips.

Removal of the ELPHO Page Printer

Alternative facilities are being provided on a
Qume LaserWriter and are described in detail
below.

PC SOFTWARE

WordPerfect 5.0:
There has never been an option to print on the
Elpho from WordPerfect 5.0 so users should not
be affected by the demise of the Elpho. Two
Macros have been written to ensure page sizes,
top and bottom margins, and the choice of
printer are correct: Alt M for the draft quality
dot matrix printers and Alt L for the high
quality laser printer. Read Using the Qume
ScriptTen from WordPerfect 5.0 before using the
Qume.

ChiWriter:
There used to be a service from Computer
Services Reception for getting ChiWriter output

Removal of the Elpho page printer

Alternative facilities are being provided on a Qume Laser-Writer and are described in detail below.

PC Software

WordPerfect 5.0
There has never been an option to print on the Elpho from WordPerfect 5.0 so users should not be affected by the demise of the Elpho. Two macros have been written to ensure page sizes, top and bottom margins, and the choice of printer are correct: **Alt M** for the draft quality dot matrix printers and **Alt L** for the high quality laser printer. Read *Using the Qume ScriptTen from WordPerfect 5.0* before using the Qume.

ChiWriter
There used to be a service from Computer Services Reception for getting ChiWriter output on the Elpho. This service has now been replaced with a more generalized printing service where any PostScript file can be printed on the Qume on a 'next day' basis. There are one or two points you need to be cautious of when generating PostScript output from ChiWriter. These are documented

Figure **3.47**
Typists depend on underlining, capitalization and the use of simple spatial relationships to distinguish or emphasize individual text elements. Printing typefaces allow a far more subtle range of distinctions to be made; see also Figure 3.17 (p.31).

Emphasis
Typewriters have only limited means of emphasizing text compared with desktop publishing systems. Consequently, typists use whatever manner of emphasis is available to them: underlining and double underlining, letter spacing, capitalization and so on. These are usually inappropriate for typeset documents where emphasis can be indicated by typefaces in a range of sizes and variants and by different degrees of vertical spacing. It is also common in typewritten text to signal the junction between heading and text by a colon. But the typographic distinctions in typeset text are so much more salient to the reader than in typewritten text that these additional markers are unnecessary (Figure 3.47).

Characters with special functions
In some typewriter faces the same letterform is given by the keys for lower case 'l' and the numeral 1, and for capital (or sometimes lower-case) 'O' and the numeral '0' (zero), so the keys can be used interchangeably. But in printing typefaces, these characters are graphically distinct (Figure 3.48).

Figure **3.48**
a In the top example the lower-case 'l' ('ell') and the numeral '1', and the capital 'O' and the numeral '0' have been used interchangeably. Below the 'l', '1', 'O' and '0' have been used correctly.
b When prime signs are substituted for opening and closing quotation marks the purpose of the punctuation may not be clear (top). Correct use of an apostrophe and opening and closing quotation marks clarifies meaning (bottom).

a

the 1900 and 1911 rebellions

the 1900 and 1911 rebellions

b

'Ours, not the ministers',' she said.

"Ours, not the ministers'," she said.

Other typewriter characters serve multiple functions: quotations and apostrophes are marked by vertical prime signs (') whereas printing typefaces have distinct, directional marks to open and close quotations and for apostrophes; three full points are used to signal ellipsis, whereas printing typefaces usually have a special, single ellipsis character; and hyphens are used not only in conjoined words but also to signal the passage of time and parenthetical information, whereas printing typefaces include longer dashes for these functions (see Figure 1.4, p.4).

The use of tabulation and word spaces

With typewriters, all characters are monospaced (see Figure 9.13, p.96). So typewritten text can be positioned horizontally (for example, in tables) by counting the number of characters and spaces between particular points on a page. But with proportionally spaced typefaces, the horizontal position of a character depends not only on the number of characters preceding it, but also on which particular characters those are. So horizontal positioning should be controlled by tabulation (Figure 3.49). It is also conventional in typesetting to follow full points, question and exclamation marks, commas, colons and semi-colons with a single space only (or even to use a space that is smaller than the word space in order to give a visually equal space between words with and without punctuation). Adopting the British typewriting convention of inserting two or more spaces after punctuation disrupts the even appearance of the text (Figure 3.50). In some software automatic line-breaking routines may put one of a series of spaces at the end of one line and the following space at the beginning of the following line, so creating an indent that may be mistaken for a new paragraph.

a

Entry	Weight	
Bartlett	14 lb	8 oz
Broca	12 lb	2 oz
Cattell	11 lb	14 oz
Galton	15 lb	0 oz
James	10 lb	11 oz
Lashley	14 lb	0 oz
Thorndike	12 lb	2 oz
Thurstone	11 lb	5 oz

b

Entry	Weight	
Bartlett	14 lb	8 oz
Broca	12 lb	2 oz
Cattell	11 lb	14 oz
Galton	15 lb	0 oz
James	10 lb	11 oz
Lashley	14 lb	0 oz
Thorndike	12 lb	2 oz
Thurstone	11 lb	5 oz

Figure **3.49**
a The information in the table has been positioned using word spaces between the entries in each column. Because the characters in the first column are not all the same width as the word space, characters in the second column cannot be aligned properly.
b The information in the second column has been aligned using a tabulation setting.

a

and eight other representatives of Civic Forum presented Mr Adamec with demands they said should be met by tomorrow. These included the release of all political prisoners, an end to censorship, and an independent inquiry into security force violence

b

and eight other representatives of Civic Forum presented Mr Adamec with demands they said should be met by tomorrow. These included the release of all political prisoners, an end to censorship, and an independent inquiry into security force violence against

Figure **3.50**
a Adopting the typewriting convention of putting more than one word space after punctuation introduces irregularities into the horizontal spacing of the text.
b In typeset documents, all punctuation should be followed by a single space.

chapter 4 When nothing works

If the typefaces you need are not available for any DTP system you may have to consider creating your own typefaces or, at least, adding special characters to existing typefaces. For most desktop publishers this should be a last resort, since creating characters is time-consuming and requires considerable expertise; having typefaces made is expensive. So before you launch into typeface production you should be sure that it really is necessary.

If the problem is simply that a particular typeface that you had hoped to use is not available on your system, or fails to reproduce well on your system, then you almost certainly do not need to construct that typeface yourself (unless it is a rare, non-latin script) – in any case, the un-authorized copying of typefaces is likely to put you on the wrong side of copyright laws. You should examine type-faces available on your system to find a substitute that may have the qualities of the typeface you had originally hoped to use (Figure 4.1). The matrix in Figure 3.7 (p.25) should help you check off characteristic features across typefaces.

This advice to substitute available typefaces may appear to be contradict most of the preceding text, given the emphasis so far on the fine details and visual distinctions among letterforms of different typefaces. Nevertheless, the financial constraints on many desktop publishers often make it more appropriate to concentrate on making avail-able typefaces work well rather than buying new typefaces. If you are preparing text for publishers, however, you should check that they agree with the substitution you make (and if they insist on a particular typeface, see how they feel about helping you to buy it).

If the character set of the available typefaces does not include characters that are essential to your text, such as special accents, diphthongs or symbols, you will need to create these characters. Do-it-yourself (DIY) character cre-ation is only possible in certain kinds of system – those where the user has some access to the programming lan-guage in which characters are described (see chapter 7). Although creating characters with these systems is techni-cally straightforward, ensuring that the characters blend in appearance with existing typefaces requires close attention to detail and an experienced eye. The matrix in Figure 3.7 gives some of the features of new characters that should be

Hamburger
Bembo

Hamburger
Galliard

Hamburger
Garamond

Hamburger
Trump Mediæval

Hamburger
Bodoni Book

Hamburger
Walbaum

Figure **4.1**
The typefaces within these groupings differ in detail, but, within the groupings, have enough similarity to be substituted for one another if necessary.

matched to the existing typeface, but you will only produce characters that make a good match by experimenting with and refining a series of drafts (see section 7.2 on procedures in DIY character production). If you do not have a system with which you can create characters you may be able to ask a type manufacturer or independent type designer to do so for you. In this case Figure 3.7 may, again, provide a starting point when you specify your requirements to the person producing the characters.

If you are handling texts that require a range of non-latin scripts then the facilities in your system for typeface creation will be critical. However, before you create new typefaces for particular scripts, check, as far as you can, that acceptable typefaces have not already been produced by other specialists. Depending on the kind of texts you need to produce, you may also wish to scan in handwritten script to your desktop publishing system, at least as an initial alternative to creating new typefaces. Scanned texts will have the status of pictures in your system, and so you will not be able to edit or manipulate them once they have been scanned in. Whether you create your own typefaces or scan in handwritten text, bear in mind the other typefaces with which they are likely to be combined and balance their dimensions and positions as far as is possible, given the inherent characteristics of the individual scripts.

part 2 Typeface production,
reproduction and
multiplication

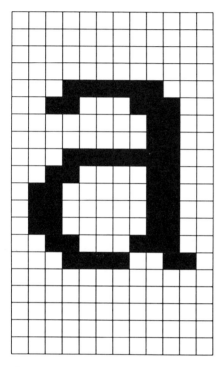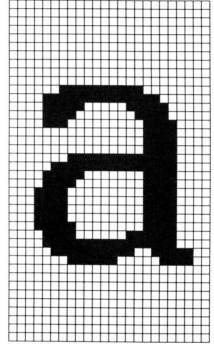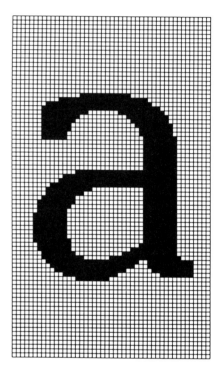

Figure **5.1**
In their final form, the characters of DTP typefaces are digitized
sequences of on/off codes. The higher the resolution of the output
device, the more fine-grained the digital descriptions and the closer
their approximation to the curved contours of characters.

Figure **5.2**
Outline character descriptions specify only the character contours, and these are automatically filled in at a given resolution by the output device.

chapter 5 Technology and typeface management

As the range of desktop publishing systems increases, a grasp of the technology underlying character imaging is essential for people buying typefaces. You can certainly produce documents without fully understanding the technology you are using, but some basic awareness will reduce the chances of your encountering unexpected constraints during production.

Font technology is an area of great competition among manufacturers. The developments that the competition brings mean that technological limitations on the use of typefaces are disappearing. Manufacturers usually publicize changes in their technology; the most authoritative reviews of the implications of those changes can currently be found in the *Seybold report on desktop publishing* and the *Seybold report on publishing systems*.

5.1 Bitmap and outline character descriptions

Whatever DTP system you use, the type will, in its final form, be laid down as digital constructions of dots and lines. At lower resolutions, for example on a low-resolution screen, you can sometimes see the digital structure of characters with the naked eye. With higher resolution output devices, however, the digital structure of a well-made typeface is finessed to give an accurate rendering of character contours (Figure 5.1).

There are two main routes to the reproduction of digital type, each based on a different method of storing character descriptions: *bitmap* and *outline* storage. Bitmaps record the state of every cell of the digital description of each character. These data are stored in the system and laid down directly by the output device. In contrast, outlines record only a description of the lines and curves that make up the contours of the characters. The output device produces a filled-in version of the outline as it lays down each character (Figure 5.2). Note that there are also descriptions in which characters are defined as single lines, called *strokes* or

inlines, with instructions about the thickness with which the lines are to be produced. Typewriter faces (which have even stroke weights and relatively simple letterforms) are often stored as inlines. Similar skeletal structures can also be used to specify characters in the character production system METAFONT (see chapter 7).

Bitmap descriptions

Bitmaps are potentially a very precise way of specifying a character's appearance, but they are also very demanding of storage capacity, especially at higher resolutions and for large-sized characters. Some systems increase the efficiency of bitmap storage by recording series of pixels that are in the same state rather than the state of every pixel in the character area. These records are converted to states of activity for individual pixels when the character is reproduced. Although compression techniques of this kind save space, bitmapped character descriptions still increase in size as resolution or size increase (Figure 5.3).

Since there is a one-to-one correspondence between bitmapped descriptions and output, a separate description must be available for each size at which characters will appear. The relatively large amount of storage needed, even for compressed character descriptions, may restrict the number of fonts that can be used within a single document in bitmap systems (note that the term 'font' refers to a particular typeface variant at a particular size; see section 8.1 on the terminology of typefaces). Restricting the number of font changes within one document, however, may not necessarily be a bad thing (see discussion of differentiating text elements by font changes in section 3.1). A further limitation of bitmap descriptions is that they are restricted in scope: character descriptions are designed for a particular kind of output device working at a given resolution, so you may only be able to use bitmapped fonts on one type of printer.

Bitmapped fonts are often supplied as *hard fonts*; that is, on a printed circuit either in the printer itself or on a cartridge that slots into the main body of the printer. Printers using hard fonts usually have a standard seriffed and sans serif typeface and a typewriter face (possibly with two different sizes of each). In cartridge-based systems you can buy additional fonts on cartridges that can be substituted for the original. A typical cartridge contains between four and eight different fonts. This arrangement effectively limits the number of fonts within a document to the number of fonts that are on a single cartridge.

A more flexible way of producing bitmaps is by using scaleable or *soft fonts*. These are programs giving master

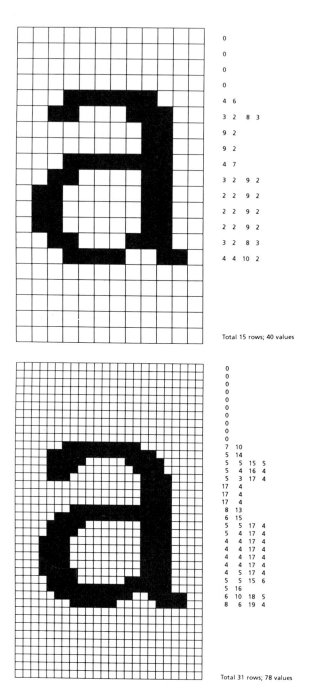

Figure **5.3**
Doubling the resolution at which a character is to be reproduced increases the number of pixels it comprises by a factor of 2^2. Even with compression techniques that record only the points at which there is a change in pixel state, doubling the resolution also doubles the number of instructions needed to describe the higher-resolution bitmap.

outline descriptions of a typeface, produced for a particular system. Before producing a document, you can nominate the typeface variants and sizes you want. Bitmaps corresponding to the fonts you have chosen are then generated from the master descriptions and stored in the system so that they can be called up when necessary during document production. The process of sending fonts from the computer to be stored in the output device is known as *downloading*. Downloading can be time-consuming, so in many systems downloaded fonts are stored permanently (even after the system has been switched off) until their removal is requested. Downloaded bitmaps take up a large amount of storage space so you may prefer to keep the number of stored fonts to a minimum.

Most DTP systems have WYSIWYG (what-you-see-is-what-you-get) screen displays that deliver screen representations of fonts, approximating their appearance on paper. Some low-cost bitmap systems do not attempt to reproduce fonts on screen, delivering a standard non-WYSIWYG computer display. Note that even WYSIWYG displays give only an impression of the appearance of type on paper; most are unlikely to represent accurately either the letterforms of characters or their spacing (see Figure 5.9, p. 63).

If a system is WYSIWYG, then for each font that can be output on the printer there must also be a corresponding *screen font* to reproduce the typeface at the relatively low resolution of the screen. The system or desktop publishing software you use may have some inbuilt screen fonts (for example, a serif and a sans serif typeface and a typewriter face) but you will need to add appropriate screen fonts to get a good screen representation of any new printer fonts you install. Most soft font systems generate screen fonts from the same descriptions they use to generate printer fonts. For better quality, some manufacturers provide hand-tuned screen bitmaps, but usually only for the smaller sizes where outlines suffer the most at the low resolution of the screen. The documentation for any fonts you buy for your desktop publishing software should explain how to add screen fonts to your system.

Bitmap-based systems tend to be identified with the 'low end' of DTP. This is, perhaps, unfair since, theoretically, the one-to-one mapping between character description and character means that more finely tuned characters could be produced from bitmaps (at least, from hard fonts) than from outlines. The reputation for lower quality may be a consequence more of the restrictions on output device, and of the limited font storage and manipulation in current bitmap-based systems, than of the quality of the images they produce. The positive side of bitmap systems is the relatively low cost of the systems themselves, and possibly of the fonts used on them.

Outline descriptions

Outline fonts are master descriptions of typeface characters, rather like the master descriptions of the soft fonts described on pages 58–9. The difference is that outline fonts reside within the system in outline form and are only scaled or transformed when appropriate instructions are input to the system, so they are a very economical means of storing character shape information. The outlines are composed of a series of conjoined curves (some systems use quadratic curves, others cubic curves – in PostScript these are called Bézier curves) that give the level of control over typeface appearance type designers need, and are computationally efficient (Figure 5.4).

When you use a DTP package you are, of course, unaware of the outlines or of the transformations applied to them: you simply select an option that calls up the typeface and the relevant variant, size and spacing settings. The DTP package then re-formulates your instructions into appropriate commands in its own programming language. These commands drive the output device (Figure 5.5).

A major advantage of systems using outline descriptions is that, in principle at least, you can perform any transformation you want on the character shapes. In practice, though, the transformations you make should be bounded by the limits of legibility (see chapter 2). In some special circumstances you may need to manipulate characters beyond the range of options allowed by the desktop publishing package (for example, you may need to scale character sizes by increments that are finer than those available in a particular package). In such situations it may be possible to send commands directly to the output device, either via a special programming option in a DTP package or by programming the system explicitly. (This programming option is usually only exploited by enthusiasts.) Direct access to the output device may also mean that you can create your own fonts or characters, either by using a proprietary package or, once again, by explicit programming (see chapter 7 on DIY character production).

Manufacturers code outline font descriptions in *formats* that are usually specific to themselves or to a group of manufacturers, but are interpretable by a wide range of systems. (Manufacturers either make their formats generally available or license them to particular developers; see section 5.2.) Fonts that can be used on a range of systems are described as *device independent*. Device independence means that you can proof text during document preparation, at relatively low cost, on a medium resolution device and then reproduce final camera-ready copy on a high resolution *imagesetter*. Remember, though, that if final output is to be produced on an imagesetter, the detailed visual checks

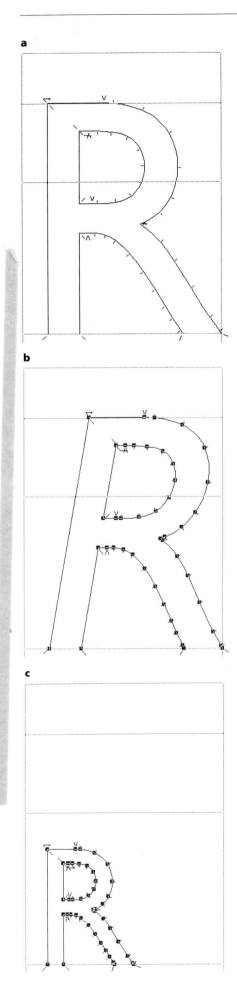

a

b

c

Figure **5.4**
a Outline font descriptions are composed of a series of conjoined curves.
b The curves can be transformed to produce variants of the typeface, such as the sloped variant here.
c The curves can be scaled to produce fonts at different sizes.

a

```
/yline 270 def
/xline 220 def
xline yline moveto   %% X Y coordinate of first baseline
/linefeed 14 def
/Times-Roman findfont 12.5 scalefont setfont

/xline currentpoint pop 2 add def

(It was a signi\256cant \256nd but his colleagues failed to
understand its importance. After several attempts to alert the
rest...)

220   %% measure
{xline yline moveto show
/yline yline linefeed sub def}
linebreakproc   %% refers to previously established procedure
```

b

c

It was a significant find but his colleagues
failed to understand its importance. After
several attempts to alert the rest...

Figure **5.5**
a Transformations of character descriptions can be input relatively effortlessly via the menus and dialog boxes of a DTP package, such as PageMaker 3.5 shown here. The package translates the options selected into the relevant commands in the system's programming language.
b Some of the PostScript code necessary to achieve the result delivered by the dialog box selections and positioning data in **a**.
c The end result delivered by **a** or **b**.

underlying typeface choice should be made on output from the imagesetter itself, or, better still, on printed reproductions of that output.

Outline fonts can perform well on output devices of different resolutions because, although they are designed principally to be reproduced at high resolutions, their character descriptions can be adapted to the coarser bitmap grids of medium or lower resolution devices by additional information, known as *hints*. Hints control the mapping of character descriptions to a relatively coarse grid, ensuring that character outlines do not break up and that, as far as possible, all characters scaled to a particular size appear with equal stem and counter widths and uniform serif shapes (Figures 5.6 and 5.7). However, as the schematized diagrams in Figure 5.6 show, the mapping process may involve some compromise of the original outline shape, especially in the reproduction of small font sizes, where hints must adapt the outline character descriptions to a relatively limited number of pixels.

Figure **5.6**
When a character outline (**a**) is mapped onto a coarse pixel grid (**b**), the mismatch between outline and grid means that some pixels are not activated and some character strokes break up. If the outline is adapted by hinting routines to fit the grid (**c**), then the pixels will be activated to give a complete, albeit slightly distorted, character image (**d**).

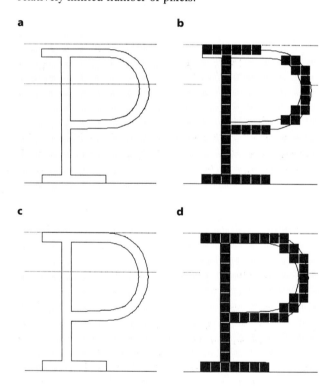

Figure **5.7**
a These characters are unhinted and show the following defects: the right-hand stem of the 'H' is thicker than the left-hand stem, the serif at the top of the 'k' stem is not well formed and the upper diagonal of the 'k' is very fine compared to the lower diagonal, the serif at the top of the 'p' stem is not well formed, nor is the junction between the bowl and the stem of the 'p'.
b These characters are hinted and most of the irregularities visible in **a** have been smoothed.

If hints are built into character descriptions they usually cannot be 'turned off' at higher resolutions, even though they can be detrimental to character images, causing a minor flattening of some contours and the loss of subtleties in their design. Type manufacturers who are not prepared to compromise on the appearance of typefaces may therefore supply *unhinted fonts*, which will not reproduce well at medium resolutions (Figure 5.7), or *semi-hinted fonts*, a compromise between hinted and unhinted fonts (Figure 5.8). Semi-hinted fonts have almost as controlled an appearance as hinted fonts at medium resolution but their letterforms are less compromised at high resolution. An

alternative to building hints into font descriptions themselves is to build general hinting programs that operate on unhinted outlines when required. This approach has been adopted, for example, for F3 fonts used in Sun systems.

Hinting should allow the same font descriptions to be used on paper (at medium and high resolutions) and on screen (at low resolution). But hinting routines demand processing capacity. So, in order to economize on processing, many current DTP systems use ready-made bitmaps for characters on screen rather than generating characters from outline descriptions. These systems have separate master descriptions to represent fonts on screen (screen fonts) and on output devices (printer fonts). Although the screen fonts are designed to replicate printer fonts, they may not fully represent the appearance of text as it will be reproduced by an output device (Figure 5.9). The discrepancies between

Figure **5.8**
a Unhinted version of Monotype Joanna in PostScript language format, output at 300 dpi. Note how thick the character images appear.
b Semi-hinted version of Joanna (Monotype Classic Font) in PostScript language format, output at 300 dpi. Semi-hinting has regularized the character images but it has also changed their appearance substantially.

a

Mr Ceausescu remained intransigent in a speech to the rally, repeating his claims that the unrest was being fanned from abroad. He said that Romania would defend "its national integrity with all its might".

national integrity

Figure **5.9** (below)
a The screen fonts for Galliard and Lucida give only a rough impression of character appearance, particularly of character spacing.
b The printer fonts at medium resolution.
c The printer fonts at high resolution. Note how hinting at medium resolution can change typeface appearance (see also Figures 5.7 and 5.8).

b

Mr Ceausescu remained intransigent in a speech to the rally, repeating his claims that the unrest was being fanned from abroad. He said that Romania would defend "its national integrity with all its might".

national integrity

a screen font	**b** printer font, medium resolution	**c** printer font, high resolution
Galliard	Galliard	Galliard
Heavy fighting took place in Bucharest throughout the day, so intense that bodies littered the streets until well into the evening. Celebrations to mark the end of the régime were cut short as Securitate forces, still loyal to the Ceausescus, began sniping from strategic positions or firing random volleys into crowds of celebrants which they had infiltrated.	Heavy fighting took place in Bucharest throughout the day, so intense that bodies littered the streets until well into the evening. Celebrations to mark the end of the régime were cut short as Securitate forces, still loyal to the Ceausescus, began sniping from strategic positions or firing random volleys into crowds of celebrants which they had infiltrated.	Heavy fighting took place in Bucharest throughout the day, so intense that bodies littered the streets until well into the evening. Celebrations to mark the end of the régime were cut short as Securitate forces, still loyal to the Ceausescus, began sniping from strategic positions or firing random volleys into crowds of celebrants which they had infiltrated.
Lucida	Lucida	Lucida
Heavy fighting took place in Bucharest throughout the day, so intense that bodies littered the streets until well into the evening. Celebrations to mark the end of the régime were cut short as Securitate forces, still loyal to the Ceausescus, began sniping from strategic positions or firing ran-	Heavy fighting took place in Bucharest throughout the day, so intense that bodies littered the streets until well into the evening. Celebrations to mark the end of the régime were cut short as Securitate forces, still loyal to the Ceausescus, began sniping from strategic positions or firing ran-	Heavy fighting took place in Bucharest throughout the day, so intense that bodies littered the streets until well into the evening. Celebrations to mark the end of the régime were cut short as Securitate forces, still loyal to the Ceausescus, began sniping from strategic positions or firing ran-

screen representation and output are significant enough to have encouraged Adobe, the developers of PostScript (which, in many DTP systems, uses separate screen and printer fonts) to devise software to translate Adobe printer fonts for screen display. This software, known as *Adobe Type Manager*, gives a more faithful screen representation of printer fonts than the separate screen fonts originally used (at least, at large sizes; it still uses bitmaps for small sizes). Note that the software can only be used on systems that have adequate memory for it to operate and it may still slow down the working of the system. Currently the only system running PostScript that automatically draws on the same font descriptions for both screen display and output device is the NeXT system.

Note that if you are using a dot matrix printer it will reproduce the screen representation generated by your system. However, the resolution of the dot matrix printer is sometimes much less than that of the screen, so improving the screen display will not necessarily enhance the appearance of characters on the dot matrix printer. To get the best results on a dot matrix printer it may be better to use typefaces that have been specially designed for reproduction at low resolution.

Outline printer fonts can be stored on the output device. Many laser printers are supplied with a basic set of fonts plus additional memory for users to install further fonts. However, the memory built into output devices is limited, often making it necessary to store some fonts on the input device. These fonts are downloaded to the output device as documents are printed out, a process that may sometimes slow down printing.

5.2 Raster imaging, page description languages and font formats

Raster image processing

The same mechanism underlies the production of typeface characters, whether it be on a WYSIWYG computer screen, on the plain paper fed into a laser printer or on special photo-sensitive paper or film used in imagesetters. In each case a marking beam moves back and forth in a regular pattern across the page area. The path in which the beam moves is called a raster (from the Latin for snake), and so the technology of DTP is known as *raster image processing* (Figure 5.10). In WYSIWYG displays, the marking beam is an electron beam that activates the surface coating of the computer screen, causing it to give off light. Similarly, in

Figure **5.10**
Each sweep of the raster beam builds up the image of typeface characters. On screen the image is refreshed and renewed by a moving raster beam. In laser printers and imagesetters the beam usually sweeps back and forth along the same horizontal whilst the substrate advances beneath it.

Heavy fighting took place in Bucharest throughout
Heavy fighting took place in Bucharest throughout
Heavy fighting took place in Bucharest throughout
Heavy fighting took place in Bucharest throughout
Heavy fighting took place in Bucharest throughout
Heavy fighting took place in Bucharest throughout

imagesetters a laser or light from an electron beam cathode ray tube exposes the coating of a sensitized paper or film substrate. In laser printers the marking beam is a laser beam that lays down charge on an intermediary drum. Particles of toner are attracted to the image area on the drum and then transferred and fused (by heat) to plain paper.

The resolution of the character images depends on the raster device being used. On screen, the smallest unit area that can be activated individually (known as a *pixel*) may be as large as 1/72 inch square, so the resulting resolution is low. In imagesetters there is very fine-grained control both over the interruption of the beam's firing across each line of the raster and over the distance that the substrate advances for each new line. Consequently, character images can be built up in increments as small as 1/2500 inch. (See section 6.1 on laser printer technology for further discussion of resolution.)

Page description languages

Raster image processors have no inherent limitations on the kind of image that can be laid down, except the resolution of the imaging device. As Figure 5.10 shows, raster image processors are not tied to dealing with individual characters, nor are they constrained to producing rows of type at a particular size or position. The commands to the laser beam are derived from a description of the page as a whole. This page specification is constructed by the DTP system in a particular kind of programming language called a *page description language* (Figure 5.11, over page). If you can input instructions to a system in its page description language, either via a desktop publishing package or directly into the raster image processor, you should be able to generate any characters you require, at any size, position or

orientation. In practice some systems (such as the bitmap-based systems described in section 5.1) have page description languages with limited capabilities that can only be accessed through a dedicated desktop publishing package.

Page description languages can be likened to a glue that connects the different elements of a desktop publishing system (Figure 5.12). Their role as connectors is perhaps most obvious when they are used to link general purpose computers, running desktop publishing software, to purpose-built imagesetters (with their own, dedicated input systems and programming languages). Instructions from DTP software are fed to a stand-alone raster image processor that

Figure **5.11**
Page description languages (PDLs) link the instructions that you enter into the computer to the output device and, in some recent systems, to the screen display as well. Most systems, however, derive the screen display from the input instructions separately, since they cannot interpret the page description language rapidly enough to provide an interactive display.

If you program the computer directly in the PDL, the screen will not show the results of your instructions unless you are using a programming environment that can interpret the PDL interactively. So you will not be able to preview the results of your instructions on screen before sending them to the output device.

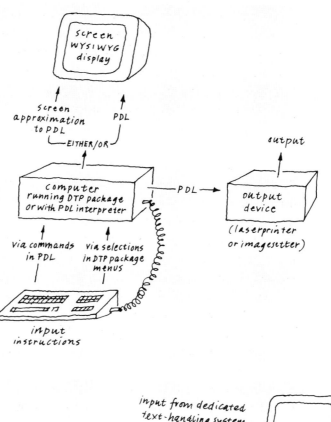

Figure **5.12**
Page description languages can link microcomputers to imagesetters via raster image processors (RIPs) that act as an interface between the two systems.

Although input to the imagesetter via the microcomputer and the dedicated terminal remain separate, each operating in its own mode, the output from the two devices can be coordinated via link workstations (not shown in this diagram). This coordinated route is common in newspaper production: a dedicated text-handling system leaves 'windows' so that desktop published diagrams, tables and pictures (coded in the page description language of the DTP system) can be inserted on-line.

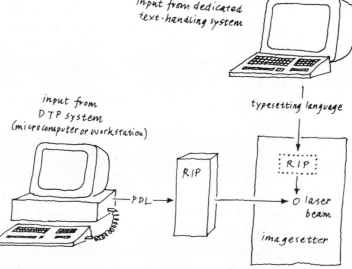

acts as an interface to the imagesetter. ('Raster image processor' is often abbreviated to 'RIP' and pronounced as the word 'rip'.) The RIP converts the instructions in the page description language that it has received from the computer into the programming language of the imagesetter. In this way it sends instructions directly to the imagesetter laser beam, bypassing the imagesetter's dedicated input device.

Font formats

Theoretically, fonts in formats that can be read by a particular page description language should be usable on any part of any system that understands that language. In practice some developers of font formats and page description languages have protected their own products by adding *encryption codes* (rather like computational locks) to their font descriptions that are only readable by systems with special interpreters (or keys). Information about encryption codes may only be available to other developers on payment of a license fee.

The best-known example of protection has been Adobe's PostScript fonts, whose encryption codes were originally made available only to a small number of font and equipment manufacturers. Since PostScript dominated the early days of DTP, both as a page description language and as a font format, but could only be used by a handful of licensed developers, unlicensed manufacturers began to produce clones of PostScript devices that used unencrypted copies of PostScript fonts. Only licensed Adobe PostScript devices could use Adobe PostScript fonts whereas cloned PostScript devices could only use their own fonts, so the advantage that a general purpose page description language might bring was lost. The situation changed, however, when Bitstream, a type manufacturer without an Adobe license, broke Adobe's font encryption codes and so was able to supply PostScript fonts in a form readable by both licensed and unlicensed PostScript devices. However, Bitstream could not decode Adobe's hints and so its PostScript fonts were (initially) unhinted (Figure 5.13, over page).

More recent developments suggest that there will be a further move away from the dominant and protected position of Adobe PostScript, not least because Adobe have recently published the formats for their own encrypted and hinted fonts. The publication (see Further reading) is not a straightforward recipe for the incorporation of Adobe encryption and hinting routines into typeface descriptions. But many type manufacturers will use it to develop typefaces that are compatible with Adobe PostScript. A further change may result from system manufacturers adopting or

Figure **5.13**
a These characters of Bitstream's PostScript fonts are unhinted and so may have a less regular appearance than characters from Adobe PostScript fonts when they are reproduced at medium resolution.
b At high resolutions, however, it is hard to detect any difference in the quality of character reproduction.
c Note that there may be design differences among characters of typefaces with the same name produced by the different manufacturers. Compare these characters from the Bitstream and Adobe versions of ITC Galliard (see also Figure 9.5, p.94).

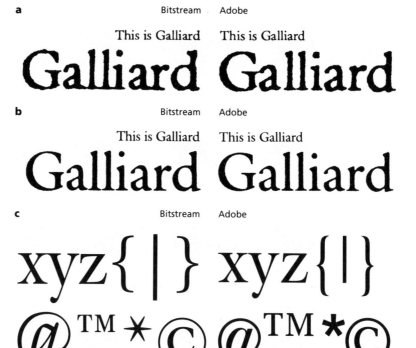

producing new font formats that are available without licensing agreements (for example, the Sun F3 and Apple TrueType formats). Since typeface manufacturers are likely to produce fonts in any format they believe will be popular with users, they will probably offer some typefaces in several different formats. Similarly, DTP system manufacturers are likely to ensure that their systems are equipped with software that accepts a range of formats.

Note that Adobe have a convention of describing Post-Script fonts that incorporate their hints as 'Type 1' format (their Type 1 fonts are also encrypted and compressed), and PostScript fonts that do not incorporate hints as 'Type 3' format (there is no 'Type 2' format). This terminology is now used widely, but it is worthwhile checking by means of a full verbal description whether any PostScript fonts you intend using are hinted, semi-hinted or unhinted; encrypted or unencrypted; licensed or cloned.

The availability of different font formats means that you should always specify the format you are using, distinguishing, for example, between Times in Adobe PostScript language format, Bitstream Postscript format or F3 format. Mixing fonts from different manufacturers within the same system may lead to problems (even if the fonts appear to be in the same language). Type manufacturers give their fonts numeric identities that are read by systems as documents are reproduced. Since font numbering is not standardized, different manufacturers may use the same numbers to signify different typefaces, and these may lead to unexpected substitutions during document reproduction.

chapter 6 Technology and typeface appearance

An understanding of the technology of typeface reproduction should extend beyond the software involved at input. The characteristics of individual output devices influence the appearance of character images, as do the processes of producing multiple copies in printing or photocopying.

Original character images may be reproduced many times during the production of multiple copies. When a document is to be printed, the original is likely to be photographed and the film image transferred (photographically) to a printing plate (although see section 6.2 on imagesetting to film). At each stage there is a possibility that character images will degrade. Furthermore the printing process itself degrades character images; the kind of degradation depends on the paper used and on how the ink is applied to it. Similarly, photocopying is likely to degrade character images.

It is possible to design typefaces suited to or modified for a particular multiplication process (such as photocopying) but this is seldom done outside typefaces for newspaper printing. In future systems, parameters describing the multiplication process (giving details of the output device and any further reproduction expected) may be passed to the character imaging software, either by the operator or by the imaging device itself, and the character descriptions modified accordingly. But this technology is some way off. In the meantime you need to be sure that the typefaces you choose have characters that are robust enough to survive the specific production route your document will follow. Character degradation is likely to be greatest when typefaces are small or very dark, in which case the junctions of character strokes and internal spaces may fill in (Figure 6.1). At the other extreme, characters with fine strokes and small serifs may break up in the reproduction and multiplication process (Figure 6.2, over page).

Figure **6.1**
a Printed from plates produced with a high resolution original.
b Printed from plates produced with a medium resolution original.
In both of these samples, the character images have degraded. The serif structures have lost definition and the open spaces of the characters have partially filled in. These effects are most pronounced in **b** where using a medium resolution original has allowed little margin for the effects of photographic and printing processes on character definition.

a

Pop Will Eat Itself plus The Membranes plus The Gathering. Admission £3.00 (£3.50 on the door). 24 November.
Age of Chance. Admission £2.00 (£2.50 on the door). Saturday 5 December.

Age of Chance.

b

Pop Will Eat Itself plus The Membranes plus The Gathering. Admission £3.00 (£3.50 on the door). 24 November.
Age of Chance. Admission £2.00 (£2.50 on the door). Saturday 5 December.

Age of Chance.

Michael Macdonald-Ross, Calvin Schmid, Michael Twyman, Howard Wainer and Patricia Wright. Very special thanks to the editors for being willing to extend the funds of *IDJ* to reproduce so many of William Playfair's charts.

to reproduce so

Figure **6.2**
The character images here are so fine that they resemble a light variant of the typeface. In some places the strokes of the characters break up completely.

Figure **6.3**
a In write-black laser printers the toner-attracting charge spreads outwards from the character area.
b In write-white laser printers the toner-repelling charge spreads inwards towards the character area.

write-black write-white

a

At the newly opened Potsdamer Platz crossing from East Berlin they are now selling commemorative T-shirts of Mikhail Gorbachev as Superman.

Superman.

b

At the newly opened Potsdamer Platz crossing from East Berlin they are now selling commemorative T-shirts of Mikhail Gorbachev as Superman.

Superman.

Figure **6.4**
a This sample was reproduced at 300 dpi on a laser printer with a write-black marking mechanism.
b This sample was reproduced at 300 dpi on a laser printer with a write-white marking mechanism. The characters are thinner and more ragged-edged than those produced on the write-black laser printer.

If you are making judgements about the quality of character reproduction you may find a small magnifying glass helpful when you examine documents. Faults that are not visible to the naked eye at the early stages of document preparation may, if undetected, develop into faults that are all too visible in the later stages of document multiplication, and you may detect these faults sooner if you examine characters under magnification. However, you should be careful not to focus exclusively on the details of individual characters. As with all visual checks, character performance has to be judged in the wider context of the document as a whole. Remember that the final reader of a document is most unlikely to be focusing on individual characters through a magnifying glass.

6.1 **Laser printer technology**

'Write-black' and 'write-white' laser printers

All laser printers operate on the same principle of laying down charge that attracts toner electrostatically. But there is an important difference in mechanism across printers. In some printers the starting point is a laser beam that moves across the page area, laying down charge that attracts toner to the area on which the character image should appear. These printers are described as 'write-black' laser printers. In other laser printers the starting point is a completely black page area on which character images are laid down by a charged beam that *repels* toner from the area in which the image should *not* appear. These printers are described as 'write-white' laser printers.

The two printer mechanisms may seem to be equivalent but in fact they can produce character images with different appearances. This difference is a consequence of the spread of electrostatic charge beyond the area in which it has been laid down (Figure 6.3). In write-black laser printers the toner-attracting charge spreads outwards from the character area, creating a thicker image than is actually described in the instructions to the laser beam. In write-white laser printers the toner-repelling charge spreads from the non-image area over the character image, creating a thinner and more ragged-edged image than has been described (Figure 6.4). The difference in image quality between write-black and write-white printers decreases at higher resolution if the spot size of the laser beam (that is, the size of the area that the beam sensitizes) is also reduced (Figure 6.5).

Although laser printers can, technically speaking, operate at very high resolutions (600 dpi laser printers are already available) their actual resolution is limited by the spot size of the laser beam. Some laser printers are designed to produce a relatively large spot so that shaded areas in illustrations have a solid appearance. This has a knock-on effect of thickening and rounding corners of the character images of typefaces (Figure 6.6).

A laser printer with an 'intelligent' marking spot has been developed by Hewlett Packard (the LaserJet III). This printer makes local adjustments to the size and firing position of the marking spot at character edges. So it produces smoother outlines than would normally be expected from a medium resolution device (Hewlett Packard call the process 'Resolution Enhancement'). The possibility of adjusting the size of the marking spot means that solid black areas can be produced using the maximum spot size with less compromise of the detail of typeface characters.

Whatever the mechanism or spot size of medium resolution laser printers, the appearance of character images produced by a given printer is likely to vary according to the position of the characters on the page (Figure 6.7). Many factors contribute to this variation. A marking beam that produces a circular spot at the centre of its scan lines may well yield a somewhat elliptical spot at the ends. The effect of this change in spot shape on the appearance of individual characters will depend on their orientation with respect to the scan lines of the raster, as well as their position on the page. (Note that some laser printers have a marking spot that is intentionally elliptical, so the appearance of character images may be affected by their orientation wherever they are positioned on the page.)

Characters at different orientations may also vary in appearance if the printer does not have exactly the same resolution in the horizontal and vertical directions. For example, some laser printers with a nominal resolution of 300 dpi have actual resolutions that are slightly higher than 300 dpi in one dimension and slightly lower in the other. And even within one orientation and at one position, character images may be subject to slight differences in the rasterization of their outlines, either among different kinds of printers (Figure 6.6) or among different printers of the same kind.

low resolution high resolution

Figure **6.5**
The raggedness of character images produced on laser printers with write-white mechanisms decreases with higher resolution and a smaller spot size.

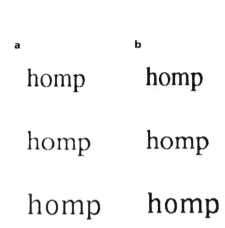

Figure **6.6**
Characters reproduced on a laser printer with a relatively small spot size (such as the 300 dpi LaserWriter Plus in **a**) are likely to have more clearly-defined contours than characters produced with a laser printer of the same resolution that has a larger spot size (such as the 300 dpi LaserWriter IINTX in **b**).
Note also the small discrepancies in alignment between the rows of the two samples (most noticeable in the bottom row). These discrepancies are likely to have arisen from differences in the rasterization of the character descriptions by the two output devices.

a

homp

b

homp

c

homp

Figure **6.7**
These characters were positioned at different places and in different orientations on a page and reproduced on a LaserWriter IINTX. There are visible differences among the images produced at different positions and orientations on the page.
a, **b** Images positioned, respectively, centrally and peripherally on the page, with their baselines parallel with the scan lines of the raster.
c Image positioned peripherally and aligned at right-angles to the raster scan.

a

Superman.

b

Superman.

Figure **6.8**
a Character images reproduced using a toner cartridge due for replacement.
b Character images reproduced using a new toner cartridge.

a

in front of the house
in front of the house

b

in front of the house
in front of the house

c

in front of the house
in front of the house

Figure **6.9**
Although paper quality can affect the appearance of laser-printed character images, it may not be the most significant factor contributing to image quality. Here, there appears to be little difference among character images reproduced on gloss art paper (**a**), uncoated cartridge paper (**b**) or rough-surfaced newsprint (**c**).

Note that the amount of toner attracted to the printer drum and, consequently, the density of character images on the page, decreases as the toner cartridge is used (Figure 6.8). Furthermore the adhesion of toner to the page may depend on the smoothness of the surface of the paper being used. If the paper is very glossy, toner may not adhere to it, so that character images begin to break up (a similar problem arises when laser printers are used to produce transparencies for overhead projection). Smooth matt papers may also fail to trap toner particles on their surface and rougher papers may tend to scatter toner particles, thickening character images. Some paper manufacturers sell special papers for laser printing which are intended to distribute toner as evenly as possible. However, before paying the premium for these special papers you should check that they really do improve the quality of character images produced on your printer (Figure 6.9).

Boosting the clarity of laser-printed images

One way to get a sharper image from text produced on a medium resolution output device is to output the original copy at a larger size than is required and then reduce it photographically. If, for example, you output an original at 125 per cent of the required size, the subsequent reduction to produce the required size (80 per cent) will increase the number of dots per inch making up the character images (Figure 6.10). The procedure to increase resolution will depend on the system you are using. If your system can only output documents at the size at which they are designed, then you will need to design the document at a larger size than you require. So you will need to make some careful calculations to ensure you get the correct end-result. If your system allows you to output a document at a percentage of the size at which it has been designed, the task is much easier: you can prepare and proof the document at the size you require and simply print it out at the larger size. In both cases the enlarged document can be reduced in the photographic processes leading to plate-making or during photocopying.

a

prepare document
at required size (100%)

b

produce document
on laser printer at
enlarged size (here 125%)

c

reduce output
photographically to
required size (here 80%)

Figure **6.10**
To increase the resolution of original copies reproduced at medium resolution (assuming a system that will output documents at a percentage of their designed size):
a Prepare the document at the size at which it will finally be required.
b Print out the document at a size larger than the required size (the enlarged output will still be at the resolution of the printer).
c Reduce the enlarged output photographically, or during photocopying, to the required size, so increasing its resolution.

6.2 **Imagesetting and the photographic process**

Imagesetting on paper and on film

Usually imagesetters reproduce images on sensitized paper which is photographed to produce a film copy for plate-making. But if a document includes *half-tone* illustrations that have been scanned into the system, film should be substituted for paper in the imagesetter. Using film cuts out a stage in the reproduction process and so helps preserve the range of light and dark shades in half-tones. Cutting out a stage in the reproduction process should also help retain crisp character images in the text. If the printer or typesetting bureau intends to set your documents to film you should agree about the precise format in which output is required. Depending on the type of film being used, the text may need to be reproduced back-to-front, as a mirror image, so that it transfers the right way around on to the printing plate. Desktop publishing software usually allows you to select a 'mirror image' option when you print a document. So your routine for designing the text should not be affected by the change of substrate from paper to film.

Not all imagesetting bureaux are prepared to use film – they may suggest setting the text on paper and reproducing the illustrations separately on film, to be slotted into the text once it has been photographed for platemaking. You should check your bureau's procedure before submitting documents with half-tones to them.

The photographic process

The character images produced on sensitized paper and film are not always consistent: they can be affected by the focus and exposure setting of the imagesetter or of the photographic and platemaking equipment used subsequently. Varying focus and exposure when medium resolution originals are photographed for platemaking can improve the appearance of character images. But any adjustments will need careful control if the end result is to be an improvement rather than a degradation of the image, and should only be attempted as a last resort (Figure 6.11).

Note that just as with any other photographic processing, the age of the chemicals used to develop sensitized paper or film after it has been exposed can affect the quality of the character images. So if you are producing different sections of a long document, or parts of series, over a period of time, you will need to ensure that there is consistency throughout production (see section 6.4 on quality control).

a

conflict

b

conflict

c

conflict

d

conflict

Figure **6.11**
a This medium resolution image, in focus and correctly exposed, has bumpy character contours.
b Moving the camera out of focus smooths the contours but also thins the lines of the characters.
c Decreasing exposure thickens the lines of the characters.
d If exposure is decreased too much the definition of character contours may be lost.

a

Individual projects

During the Easter break, Susie and Katie had been taken by their parents to see Suzanne's first major

b

Individual projects

During the Easter break, Susie and Katie had been taken by their parents to see Suzanne's first major

Figure **6.12**
This text was photocopied from both a high resolution original (**a**) and a medium resolution original (**b**). The clearer character outlines and contrast of weights in the high resolution original deliver better quality multiple copies.

a

90 per cent.²

b

professional

c

MANAGERIAL

Figure **6.13**
Non-absorbent papers tend to give very sharp printed images and so preserve the fine strokes of high resolution character images (**a**). They faithfully replicate the relatively bumpy con-tours of character images reproduced at medium resolution; see the medium-resolution character images printed on gloss coated paper (**b**) and on matt coated paper (**c**).

a

professional

b

understanding

Figure **6.14**
a The spread of ink from character images printed on absorbent paper tends to smooth out character contours.
b Ink spread can also thicken up character outlines so that they run into one another.

Department of

Department of

Figure **6.15**
In the top example, over-inking has transformed the appearance of the typeface, delivering bold characters that appear 'ultra-bold' and begin to run together. Below, the characters are correctly inked.

6.3 **Printing and photocopying**

Decisions about whether to photocopy or print a document will probably depend on the number of copies needed and the cost per copy of each method. If the cost difference is small, the better typeface quality of printing, compared with photocopying, may make it worthwhile. If you are using originals produced at medium resolution, then photo-copying may compound any degradation of character images in the original copy. If your budget allows a half-way measure between printing and photocopying, try experimenting with photocopying high resolution output in order to maintain character quality and preserve contrasts between variants of different weights (Figure 6.12). (See section 3.1 for a discussion of roman/bold contrasts in laser-printed texts.)

If a document is to be printed, the smoothness and absorbency of the paper will affect the distribution of ink on its surface and, consequently, the appearance of typeface characters. Paper manufacturers make papers smooth by *loading* them (packing them with china clay to fill in the spaces between fibres) or by *calendering* (pressing the paper between high pressure rollers). Absorbency is reduced by *coating* the paper surface with mixtures of pigment, water-proofing agents and adhesive – coated papers are often called *art papers*.

Non-absorbent papers tend to give sharper images than absorbent papers. They will faithfully reproduce the bumpy dot structure of medium resolution characters (Figure 6.13). If papers are not heavily coated there is an opportunity for ink to seep into the fibres. This seepage may smooth off bumpy character contours, improving the appearance of medium resolution character images (Figure 6.14). However, ink seepage must be carefully controlled: if it goes too far characters will lose their definition and begin to run into one another, a problem that will become acute if the characters are over-inked during printing. Very absorb-ent papers may allow ink to seep down into their fibres, right away from the surface, with the result that character images on the surface of the paper begin to break up.

One of the most common faults in printing is over-inking. It can undo all the careful steps you have taken to ensure the preservation of clear character images. At the level of the text as a whole over-inking can reduce legibility, obliterate distinctions between different weights of charac-ter and give documents a very different appearance from the one intended (Figure 6.15). Unfortunately printing is the stage in document production over which you are likely to have least control. But it is worthwhile drawing your printer's attention to potential problem areas within your

document, such as characters at small sizes, reversed-out
characters or characters with particularly fine strokes.

6.4 **Quality control and record keeping**

The main lesson to be learned from this discussion of
document reproduction and multiplication is that character
image quality is prone to variation. As far as possible, you
should try to avoid variation in appearance within a parti-
cular document, so you should carry out quality control
procedures, especially when you are producing long docu-
ments or, similarly, a series of documents. Over a period of
time, the information you gather through quality control
should also help you make predictions about how typefaces
will appear in their final, multiplied form. Such predictions
should be useful during the planning of future documents.

The only way to control and predict typeface appearance
is to build up detailed records of the samples you prepare
as you plan documents, of work in progress and of com-
pleted documents. You will need to check documents that
are in preparation against these benchmark copies through-
out the reproduction and multiplication process. The
checklist in Figure 6.16 (over page) suggests the kind of
information that you need to record with the sample and
control copies you produce.

It is worthwhile recording not only the production pro-
cess itself, but also any problems or advantages of particular
options you choose, and the responses of other people
involved with the document to your decisions (for example,
the responses of authors, designers, printers and readers).
Document production can extend over many months and if
the reasons for, and responses to, decisions are not recorded
at the time they are made, then it may be difficult to
remember them at later stages of the production process.

If you use an existing document, produced by someone
else, as a template for a document you plan to produce
yourself, it will help to know as many details of its produc-
tion as you can find out so that you can replicate the
appearance of the template document accurately. The
checklist in Figure 6.16 should serve as a prompt for the
kind of information you should gather about the document.
But if the document has been produced by conventional
typesetting rather than desktop publishing, you will need to
adapt the categories of information accordingly.

Production record

Name of document
..

Styles & templates for this document

File names Dates
..
..
..

Document styles Document templates

Tag Element Name Used for

..
..
..
..
..
..
..
..

DTP system

Hardware System software DTP software
..
..

Typefaces used in this document

Name & variant Manufacturer Format
..
..
..
..
..
..
..
..

Summary of styles for this document

Element (tag)	typeface & variant	size	line space	measure	justificn	h&j style
———						
———						
———						
———						
———						
———						
———						
———						
———						
———						
———						
———						
———						
———						

Output device for laser printing

Type of printer Comments
..

Type of paper
..

Output device for imagesetting

Bureau Comments
..

Imagesetting system
..

Date / Cost per page
..

Comments

..
..
..
..
..
..

Multiplication

Printer/copy bureau Comments
..

Date
..

Type of paper
..

Figure **6.16**
You should record as much detail as you can of the document production process for future reference. A commentary on the decisions you have made during production will also be useful.

chapter 7 DIY character production

Since DIY (do-it-yourself) character production is very
time-consuming, and difficult to do well, you should check
thoroughly that the characters you need are not already
available in a format that can be used on your system. If
you need characters for a non-latin script, check their avail-
ability with publishing houses or other institutions that
may already be using the script.

You can produce characters either by using interactive
character production packages – the approach that most
desktop publishers are likely to adopt – or by programming
character descriptions. Whichever method you use, you
should bear in mind that most of the effort in character
production goes into drafting and refining details of charac-
ters. It is relatively easy to arrive at a first approximation to
a new character, but far more difficult to ensure that the
character fits well with other characters, both in its letter-
form and its spatial characteristics. As Figure 7.1 shows, it
is unlikely that initial drafts will deliver new characters that
match existing characters in, for example, their weight, or
degree of contrast, or direction of stress. So you should be
prepared to go through many cycles of proofing, amending
and re-proofing.

a

Ȝipisinȝ, Ȝipis Ƿiȝinȝ, Ƿiȝ Freaƿininȝ
Friþoȝar Bronding, Brond Bȝldaeȝing

b **c**

Ȝipisinȝ, Ȝipis Ƿ
Friþoȝar Brondi

Ƿ Ȝ

d

Ȝipisinȝ, Ȝipis Ƿiȝinȝ, Ƿiȝ Freaƿininȝ
Friþoȝar Bronding, Brond Bȝldaeȝing

e

Ȝipisinȝ, Ȝipis Ƿ
Friþoȝar Brondi

Ƿ

Figure **7.1**
a In this first proof of Anglo-Saxon characters, designed to be
combined with Times characters, the new characters do not
blend well with the existing typeface.
b Individual characters have particular defects; see the junction
of the bowl and stem of the capital wynn.
c The lower-case yogh is clumsy and cramped.
d In a later proof some of the difficulties of the first proof have
been resolved.
e Many of the characters require further work; see how the
bowl of the capital wynn has now become too thin.

7.1 **Methods of character production**

The capabilities of character production software are changing as font production technology develops, so you should investigate the available options carefully before committing yourself to a particular method. You may have access to software to produce either bitmapped or outline character descriptions. Outline descriptions are likely to be less straightforward to produce than bitmapped descriptions, but they will be considerably more versatile, since one set of character descriptions can be scaled to several sizes. However, the outline descriptions you produce may not be as versatile as those sold by type manufacturers. For example, in PostScript systems, at least at the time of writing, you cannot produce hinted characters for medium resolution output (this situation is likely to change, however, given the recent publication by Adobe of their own font formats; see section 5.2). The absence of hints means that if you intend to reproduce new characters on both medium resolution and high resolution output devices you will need to produce different versions of characters for each resolution (see section 5.1 for detailed discussion of hinting). You may also need different outlines for characters of different sizes at medium resolution. An unhinted outline that works well at 24pt may not be rendered well on the limited number of pixels available at, say, 9pt (see Figure 5.6, p.62). In contrast, size has a negligible impact on the rendering of character images at high resolution.

The characters that you can produce yourself (often called user-defined characters, or, in Adobe's terminology, Type 3 characters) will occupy more storage space than manufactured characters: manufacturers program compression routines into their own character descriptions. Some character production packages include such routines but these are not as effective as manufacturers' routines.

Interactive character production packages

In interactive character production packages you can examine characters on screen during drafting. The working character images are magnified several times but a version of the images at their screen size is also visible (examining the screen image, though, is not a substitute for examining images produced on your final output device).

In bitmap packages, such as *FONTastic*, you lay down a separate bitmapped description for each character, at every size at which it will be reproduced. You may produce bitmaps from scratch, or copy and modify bitmapped versions of characters from fonts in your system. You can usually set

up guidelines (displaying, for example, the baseline, x-height and ascender height of characters) to help you maintain consistent dimensions across a series of characters (Figure 7.2). The character shapes produced with bitmap packages are limited to the resolution of the screen on which they are produced. But with some systems characters can be output at a smaller size than the size at which they are created on screen, so increasing their resolution. Alternatively, they can be output at the size at which they are produced and then reduced photographically to increase their resolution (see Figure 6.10, p.72). Most bitmap packages allow the scaling of characters designed at one size to another size, but scaled characters are likely to require editing at each size to improve their appearance.

For most desktop publishing applications you will need greater flexibility than is allowed by bitmap packages (unless you are producing only a few special characters for one or two sizes). So you should opt for packages in which you can produce outline character descriptions, such as *Fontographer* or *FontStudio*. With these packages you can produce character images that can be scaled and manipulated: the curves and vectors of the outlines can be transformed as entities rather than by editing individual pixels. Like bitmap packages, outline packages allow you to set guidelines to delimit character dimensions. But, in contrast to bitmap packages, the guidelines and points on the character outlines themselves can be specified numerically, at resolutions that are not limited by the resolution of the screen (Figure 7.3, over page). The numerical specifications are then translated and interpreted at the resolution of the output device. The higher degree of spatial control in outline packages extends beyond the description of the letter itself to the space in which the letter resides. Most outline packages allow you to specify kerning tables for newly created characters.

Some DTP character production packages are approaching the sophistication of professional font production systems and, almost certainly, outstripping them in their ease of use. Recently, a version of the type manufacturers' production system, IKARUS, has been developed to produce PostScript output on Apple Macintosh and IBM systems. Drawings of existing characters can be scanned into the system, or digitized via a tablet or mouse, and manipulated using a 'WIMP' (windows, icons, mouse, pointer) interface. Although expensive, the system might be a justifiable investment for users who are committed to producing large numbers of new characters from existing images. Alternatively you may be able to commission character production work from manufacturers who produce desktop publishing typefaces and are likely to own IKARUS or similar software.

Figure **7.2**
Stages in the modification of an existing bitmap to produce a new character in FONTastic Plus. The screen resolution dictates the precision with which modifications can be made. The character is represented at its actual size at the top left of the character-editing window.

Figure **7.3**
a In outline packages (such as Fontographer, shown here) you cannot always pinpoint precise locations at the low resolution of the screen.
b Numerical specification allows you to work at a level of accuracy that is not constrained by the screen resolution.

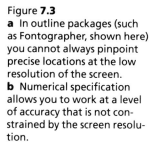
a

b

Programming character descriptions

The two character programming languages that are likely to be available to desktop publishers are PostScript and METAFONT.

In PostScript the programming code describes character inlines or outlines which can be transformed and scaled and (in the case of outlines) filled in by the output device. The characters delivered by PostScript programs should be usable on any PostScript device (although, without hinting, separately designed descriptions will be necessary for output devices of different resolutions). It is worth noting that PostScript character descriptions were never really intended to be programmed directly, but rather to be generated by other applications. In the early days of DTP, PostScript programming was the only way for some desktop publishers to produce characters. Now the sophistication of dedicated, interactive production packages has led many people to use them instead. Interactive packages overcome a major drawback of programming character descriptions: they bridge the gap between analytic programming mode and sensitivity to the visible form of characters. There are some programming environments that give a screen view of the image created by programming code, but in most cases this view is not given as interactive feedback, and can only be seen in a special preview mode.

In contrast to PostScript, METAFONT should perhaps be thought of more as a research tool than a practical production tool. As its name suggests, METAFONT was intended to build universal typeface characters (skeletal structures) that could be transformed to give any variant, at any size, on any output device. This principle has not yet been successful in practice and those typefaces that have been created in METAFONT have been produced by using it as an outline system, where it loses its 'meta' properties. METAFONT was used as an outline tool to produce the typeface Computer Modern (which can be used in TEX; see Figure 1.5, p. 6) but production was a difficult and drawn-out process.

If, despite these rather discouraging comments, you decide to proceed with character programming, your starting point for PostScript programming should be the *Adobe PostScript tutorial and cookbook, Adobe PostScript reference manual* and *Adobe PostScript program design book* (these books are known, respectively, as the 'red', the 'blue' and the 'green' book); for METAFONT you will need *The META-FONT book*.

7.2 Procedures in character production

Character production can be broken down into three sub-tasks – researching the character, drafting the character and evaluating the drafts. But the three sub-tasks are not discrete and feed into one another in the cyclic process of character production.

Researching characters

Researching a character involves getting to know the details of its appearance and the appearance of the characters with which it will be combined. You may have looked at a character many thousands of times without fully noticing its construction. For example you may not have noticed that different kinds of serif or terminal are often used within a single character; or that the elements making up characters are not symmetrically arranged, nor aligned to the vertical positions suggested by the appearance of the typeface as a whole; or that character strokes that appear to have uniform width actually vary in width along their length (Figure 7.4).

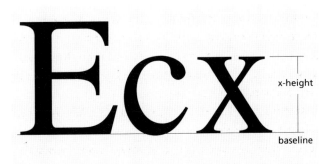

Figure 7.4
Close examination may show that characters have a less regular construction than is apparent at first glance. Contrast the vertically-angled serif at the top of the 'E' with the oblique serif at the bottom, or the bulbous terminal at the top of the 'c' with the pointed terminal at the bottom. The middle arm of the 'E' is sightly above the half-way point between the top and the bottom of the stem, but not level with the x-height; the bottom curve of the 'c' dips slightly below the baseline (see also Figure 9.10, p.95). The strokes of the 'x' taper towards their crossing point.

Although you should always bear in mind the appearance of a character at its normal size, some of the details of its construction are not discernible at text sizes. So, in order to examine characters properly, you should work at a large scale; a working size of between 10 and 15 centimetres (between 4 and 6 inches) is probably about right.

BRIEF CHECKLIST
7.2 Procedures in character production

Research the character you intend to produce. Gather information about the character itself and the characters with which it will be combined. Examine the characters at a large size.

Carry out initial drafting at a large scale. Evaluate the harmony of the new letterform and existing characters.

Test the performance of the new character at a range of sizes, evaluating its legibility, differentiation from and harmony with existing characters.

If the intended output device differs in resolution from the device used in character production, test and revise the character on the final output device.

ȝ Tgy

Figure 7.5
Note particularly the features of existing characters with elements that resemble elements of the character you intend to produce; in this case the shapes of the 'T', the 'g' and the 'y' may have a bearing on the design of the lower-case yogh.

heuȝunȝe
niuȝ ȝe

Figure 7.6
The lower-case yogh, as it appears in different reproductions of Anglo-Saxon manuscripts. Deciding which version to use for a new character will involve considering both the fidelity of the new character to the original script and current readers' expectations about character shape.

You should note the general features of the letterforms you are examining, such as their dimensions (ascender height, capital height, x-height and descender depth), their weight and contrast (see Figure 3.7 on p.25 for a listing of letterform features). You should also note the special features of individual characters, especially those that resemble the new characters you will be producing. Your aim should be not so much to assemble new characters from the features of existing ones as to improve the harmony between the old and the new by reflecting details of existing characters in the new ones (Figure 7.5).

There may be more than one version of the character that you intend to create, with no version seeming to be more 'correct' than any other. It may be quite appropriate for you to follow your own preference in choosing between these alternate versions, but usually it is advisable to consult other people who may use the character, in order to arrive at a consensus about the best version. Note that the best version of a new character may not necessarily be the one that has traditionally been used by printers over past centuries, especially in non-latin scripts. There is a long history of western Europeans producing non-latin characters to fit their own typesetting systems without sufficient sensitivity to the script and its tradition. So it is worthwhile looking at characters as they appear in original scripts. At the same time you will need to bear in mind how well different versions of characters will combine with other characters, and what the readers' expectations of character appearance will be (Figure 7.6).

Drafting

The drafting process is to some extent dictated by the technology being used. A character production package may allow you to draft new characters by adapting characters from existing typeface variants (where appropriate). Or it may allow you to trace automatically (*auto-trace*) over templates for new characters that have been scanned into your system (usually, hand-drawn images or existing printed images). Both these options of working from an existing image are likely to be more successful than attempting to draw an image directly on screen, where the relative scales and proportions of character images are difficult to judge (Figure 7.7). If you do draw directly on screen you should have planned your character well enough to be able to input the points around its outline as numerical coordinates, rather than attempting to draw freehand. Even when you are working from a pre-drawn image, though, character shapes should be as well defined as possible before input to your system, since making design modifications on screen is

a b

c d

Figure 7.7
In outline packages, such as Fontographer, you can 'auto-trace' the outlines of templates that have been called up from existing typeface variants or have been scanned into your system.
a A template has been copied into Fontographer from a hand-drawn image, previously scanned into the DTP system.
b The image has been auto-traced.
c The initial template has been removed.
d The auto-traced outline has been adapted using Fontographer tools so that it matches the original image.

usually more tedious than making them on paper. Planning on paper before working on screen may seem to add an extra stage to character production, but it should save time in the end.

Note that when characters are imported from existing typefaces as templates for new characters, the character production package may limit the amount of information about the original character descriptions that can be accessed (Figure 7.8). Some packages allow direct access to existing character outlines. But in other packages, arriving at an outline may be a two-stage process. The package may only render a character template from the original outline description. The template must then be traced (either manually or automatically) to generate an outline that can be worked on. Alternatively, an outline can be produced using a separate package (such as *Metamorphosis*), which delivers outlines that can be imported into the character production package for editing. In some outline packages imported character descriptions may be distorted in order to copy protect the original. You should check for character distortion by comparing output using imported characters against the original characters, used in software other than the character production package.

If you are programming character descriptions rather than using an interactive package, short cuts similar to the use of templates may be possible. For example, you may be able to develop new character descriptions from sections of programs for existing characters. But whether you use existing images or existing programs as the basis for new characters you should have noted, in your initial examination of the characters, precisely where and how the characters you intend to produce diverge in appearance from the existing characters on which they are based. Attention to this level of detail when you examine characters in the early stages of character production will help save time during drafting.

Figure **7.8**
a Some outline packages, such as Fontographer 3.0.5, deliver templates of characters from existing typefaces which must be traced to produce an outline to work on.
b, **c** Other packages, such as FontStudio 1.0, deliver character outlines that can be worked on directly.

Evaluation

As you draft new characters you should evaluate them according to legibility criteria (see chapter 2) as well as for their resemblance to the intended character shape. The characters should be legible individually and distinguishable from one another and from the existing characters with which they are to be combined. They should harmonize with one another and with existing characters both in their shapes and in their spacing. So when you assess how well drafted characters work you should look at them both individually and in combination with other characters, at a large scale and at the size at which they will be reproduced.

The further on you are in the drafting process, the more likely you are to need to examine characters at their intended reproduction size, especially to check the harmony of their shapes, their horizontal spacing and their vertical alignment.

Remember that unhinted character descriptions do not perform well over a wide range of sizes at medium resolution. Figure 7.9 shows medium resolution proofs produced in an exercise to design Times non-ranging numerals 1, 2 and 4 (the others shown are Times ranging numerals, some of which have been re-positioned vertically to give a makeshift simulation of non-ranging numerals). Drafting was carried out in Fontographer using large-scale characters. Whilst the newly-drafted characters balance with the existing characters at 24pt, they appear heavier than the existing characters at 9pt. Additionally, the numeral 4 fits well, spatially, with the other characters at 24pt but appears crowded at 9pt. This is because horizontal space settings that are appropriate for characters at large sizes are not necessarily appropriate for characters that have been scaled down to smaller sizes. (See section 8.1 for a discussion of the horizontal spacing of characters at different sizes.)

When hinting routines are not available (in most cases of DIY character production) it is essential to tailor new characters to an output device of a specific resolution. A character that has been drafted at 300 dpi is likely to need significant revision before it is usable at high resolution (Figure 7.10). So the later stages of drafting must be based on feedback from the intended output device.

Final checks on the characters should be carried out using sample settings of texts in which they are likely to be used, set at the intended output size and on the intended output device.

a

1234567890

b

1234567890

c

1234567890

Figure **7.9**
a At 24pt the newly-drafted non-ranging numerals 1, 2, and 4 balance the weight of the original Times numerals, although the horizontal spacing of the '1' requires further adjustment.
b At 9pt the same characters appear heavier than the existing characters (see enlargement in **c**) and the '4' appears crowded between its neighbours.

a

010	020	030	040	050	060	070	080	090	000
111	121	131	141	151	161	171	181	191	101
212	222	232	242	252	262	272	282	292	202
313	323	333	343	353	363	373	383	393	303
414	424	434	444	454	464	474	484	494	404
515	525	535	545	555	565	575	585	595	505

b

010	020	030	040	050	060	070	080	090	000
111	121	131	141	151	161	171	181	191	101
212	222	232	242	252	262	272	282	292	202
313	323	333	343	353	363	373	383	393	303
414	424	434	444	454	464	474	484	494	404
515	525	535	545	555	565	575	585	595	505

c

010	020	030	040	050	060	070	080	090	000
111	121	131	141	151	161	171	181	191	101
212	222	232	242	252	262	272	282	292	202
313	323	333	343	353	363	373	383	393	303
414	424	434	444	454	464	474	484	494	404
515	525	535	545	555	565	575	585	595	505

d

010	020	030	040	050	060	070	080	090	000
111	121	131	141	151	161	171	181	191	101
212	222	232	242	252	262	272	282	292	202
313	323	333	343	353	363	373	383	393	303
414	424	434	444	454	464	474	484	494	404
515	525	535	545	555	565	575	585	595	505

Figure **7.10**
In the exercise shown in Figure 7.9, separate character descriptions were produced for medium resolution and high resolution output.
a When characters designed for medium resolution are output at medium resolution, the new characters and existing characters balance in appearance.
b At high resolution, the characters designed for medium resolution are too feint.
c When characters designed for high resolution are output at medium resolution, the new characters are too heavy compared to the existing characters.
d At high resolution, the designed high-resolution characters blend with existing characters.

part 3 The technical description
of typefaces

merits of unification — light

merits of unification — roman

merits of unification — bold

unification — ultra bold

merits of unfication — light italic

merits of unification — italic

merits of unification — bold italic

merits of unification — condensed

merits of unification — bold condensed

unification — ultra bold condensed

Part of the Gill Sans typeface family

merits of unification — roman

merits of unification — semi bold

merits of unification — bold

merits of unification — italic

merits of unification — semi bold italic

merits of unification — bold italic

Part of the Baskerville typeface family

Figure **8.1**
Each of the fonts in these two samples has a unique identity. The fonts from the Monotype Gill Sans family share visual features, as do the fonts from the Monotype Baskerville family, and so each grouping coheres. (The Gill Sans Ultra Bold and Ultra Bold Condensed variants are shown at larger font sizes, since they were designed as display faces rather than as text faces.)

chapter 8 Terminology for typefaces and their variants

However much desktop publishing is a do-it-yourself activity, you will often need to communicate about the documents you are producing with other desktop publishers, editors, type manufacturers, typesetting bureaux and printers. Ideally this communication should rest on a common, precise vocabulary with which you can specify typefaces and their spatial arrangement. However, you are likely to find that different people use typesetting terminology in different ways, often varying their use of terms across contexts. So it is absolutely essential to base your discussions about typefaces on visible specimens (see also chapter 1 on creating specimen character sets and chapter 3 on creating samples of your documents). The discussion below aims to provide an internally consistent vocabulary to describe typefaces.

8.1 **Typefaces, variants and fonts**

The terms *typeface* and *font* are often used interchangeably, but the best use of 'typeface' is as a general term to describe a family of fonts all of which bear a visual relationship to one another and which are produced by a single type manufacturer (Figure 8.1). Using the term 'font' in this general sense is misleading: you can talk about the typeface Helvetica, but not the font Helvetica. (Desktop publishing software, which offers a choice of typeface under a menu headed 'font', adds to the confusion.) The visual relationships within a typeface family are usually clearest in sans serif typefaces where the italic and condensed variants are almost certain to be adaptations of the roman. Some more traditional seriffed typeface families have grown up from the conjunction of independent roman and italic variants that were, historically, independent typefaces but, nevertheless, cohere visually.

The roman variant (the variant most commonly used for continuous text) is often taken as the typeface norm, but the typeface is only fully represented by all its variants: its roman and italic (at least in latin script) and, if they exist,

problems of unification
Helvetica

problems of unification
Helvetica Condensed

problems of unification
Helvetica Narrow

Figure **8.2**
Helvetica Condensed is a separately
designed variant of Helvetica.
Helvetica Narrow is a variant of Helvetica
created by compressing it horizontally.

	roman	italic
Helvetica	gaffe	gaffe
Gill Sans	gaffe	gaffe
Times	gaffe	gaffe
Galliard	gaffe	gaffe

Figure **8.3**
In some typefaces, the shapes of indi-
vidual characters, such as 'a', 'f' and 'g',
differ in the roman and italic variant.
Here, only the characters of Helvetica
have similar shapes in the roman and
italic variant. Note that Gill is an unusual
sans serif typeface because it has a two-
storey 'g', rather than the single-storey
'g' more common in sans serifs (and
shown here in Helvetica).

a

ABCDEFGHIJKLMNOPQRSTUVWXYZ
1234567890

Compensation was not felt to be a PRIMARY
CONCERN and so could not be discussed at the
plenary session.[3] It was tabled for the agenda of
the committee meeting that would follow.

b

ABCDEFGHIJKLMNOPQRSTUVWXYZ
1234567890

Compensation was not felt to be a PRIMARY
CONCERN and so could not be discussed at the
plenary session.[3] It was tabled for the agenda of
the committee meeting that would follow.

Figure **8.4**
a Designed small capitals and superscripts from
Monotype Bembo Expert Set.
b Transformed small capitals and superscripts
produced in QuarkXPress 2.12.
Note how the long-tailed Bembo 'R' has been
adjusted in the designed small capitals, so that it
harmonizes with other characters, but not in the
transformed small capitals (see also Figures 1.6, p.6,
and 2.4, p.12).

light, bold, extra-bold, condensed and expanded variants.
Not all typefaces have all these variants.

Note that some manufacturers use the term 'roman' to
signify seriffed typefaces in contrast to sans serif typefaces,
but here it is taken to mean the upright text variant of any
typeface, as opposed to an inclined or bolder variant. There
is further potential for confusion between the use of the
word 'roman' to describe a typeface variant and the name of
the Monotype typeface 'Times New Roman'.

Variants of digital typefaces may be specially designed to
go with the roman, but produced independently of the
roman; or they may be generated by software that trans-
forms the character descriptions of the roman. Specially
designed variants usually look and work better than those
generated by software because although variants are related
in appearance, the relationship cannot always be captured
by simple mathematical transformations. Figure 8.2 com-
pares a font of Helvetica Condensed (a designed variant of
Helvetica) with a font of Helvetica Narrow (a transformed
variant of Helvetica). The characters in Helvetica Con-
densed have an even appearance, each having been re-
designed to suit its new proportions; in Helvetica Narrow,
however, some characters seem more condensed than
others and, generally, they appear uneven and crowded.

In most seriffed typefaces (and some sans serifs, such as
Gill Sans), there are specific differences between the shapes
of certain characters in the true italic variant and the
roman. So, in these typefaces, a true italic cannot be gener-
ated simply by sloping the roman (Figure 8.3). Even in
typefaces where the basic structures of roman and italic
characters are the same, sloping the roman to produce an
italic can distort stroke weights and yield awkward shapes.

Some DTP software uses transformations to produce a
range of variants otherwise unavailable in many typefaces:
for example, outline and shadowed variants. These are not
generally suitable for text setting (see section 3.3 on docu-
ment genre). The same kinds of transformation can be used
to produce small capitals or superscripts and subscripts,
which are useful for text setting. However, specially
designed versions of these characters are often available in
extended character sets (see Figure 1.6, p.6) and are usually
of better quality than those produced by transformations.
The comparison in Figure 8.4 shows how specially
designed small capitals, superscripts and subscripts tend to
be heavier, but more compact vertically, than the trans-
formed variants. The adjustments of the dimensions of
designed characters improves their harmony with the
roman characters of the typeface and makes them more
likely to survive the processes of reproduction and multipli-
cation, despite their small size.

The term 'font' is often used interchangeably with the term 'variant' (for example, to refer to Adobe PostScript Univers medium italic) rather than to refer to a variant of a typeface at one particular size (for example, 12pt Adobe PostScript Univers medium italic). A technical way of clarifying the distinction between these two usages is to use the terms *virtual font* to refer to a set of character descriptions that, theoretically, can be used to generate characters at any size and *actual font* to refer to the realization of character descriptions at one particular size. In practical discussions, though, these terms can seem cumbersome. So, indeed, may the terms variant and font. In the end one may have to accept the usefulness of the loose term 'font', despite its ambiguity, and ask for clarification when its meaning really is not clear.

In most cases DTP fonts (that is variants of a typeface at a particular size) are scaled to their size from a single master description (although type manufacturers may use more than one master to improve the precision with which fonts are rendered over a range of sizes – Linotype Times has masters at 10pt and 12pt). Either individual fonts are scaled from their master descriptions by the type manufacturer, who then supplies users with a set of fonts at fixed sizes for any given variant; or else individual fonts are scaled on-line when the user instructs the system (via the DTP package) to scale a stored master (see discussion of outline character descriptions in section 5.1).

Most scaling algorithms apply linear transformations to the dimensions of characters and the space surrounding them. Whilst, technically speaking, characters could be scaled to any size, linear scaling only works well over a small size range. The 12pt masters common for DTP text typefaces usually work well when scaled to sizes from 9pt to 14pt. But at smaller sizes, fonts can appear crowded and may not give clearly distinguishable character images after printing; at larger sizes the lateral spacing of the characters may appear too loose (see Figure 2.11, p.15).

As the sophistication of font-scaling routines increases there is likely to be a move away from linear scaling. Some manufacturers are already producing type with non-linear scaling routines, which should improve the rendering of very large or very small fonts (for example, Apple claims that its TrueType font format can be scaled non-linearly). However, not all DTP software may be capable of using non-linear scaling routines, even when the routines are built into typefaces.

8.2 **Character sets and characters**

The letters, numerals, accents, punctuation marks and symbols that form the text on the page are known as the *character set* of a typeface. Manufacturers often do not supply a full listing of the character sets of their typefaces so you may need to create your own (see chapter 1). Most latin-script typefaces from a particular manufacturer have the same character set. You can expand the range of characters by using extended character sets, if they are available, or by drawing on special symbol fonts (see chapter 1). Alternatively, in certain systems, you can create additional characters (see chapter 7).

A character usually includes both the character shape (the *letterform*) and an allowance for space surrounding it. Although the two can be thought of independently, they are interdependent (see section 9.2 on the horizontal dimension of typefaces). Many people use the term 'character' to refer both to the character as a whole and to the character shape in particular. It is worthwhile maintaining the distinction between the two as a reminder to pay attention to the spatial attributes of characters as well as their letterforms.

chapter 9 Measuring typefaces

In most desktop publishing systems type is measured in
units with the same name as the traditional printer's unit of
measurement: the *point*. But the value of the point in DTP
is not the same as the value of the point in conventional
typesetting technology. In DTP software, the point is
0.3528 mm or 0.01389 inch (1/72 inch, an imperial meas-
urement used in typewriter technology). But the traditional
point, still used by most printers in Britain and North
America, is 0.351 mm or 0.01383 inch (1/72.27 inch); other
countries use the Didot point which is 0.376 mm. The
point is usually combined with a larger-scale unit, the pica
(equivalent to 12 points). In DTP the pica is 4.23 mm,
0.1667 inch; printers' picas are 4.2 mm, 0.166 inch; and
Didot points are grouped into units of 12, called *ciceros*,
measuring 4.5 mm.

Although small, these differences in the basic unit of
type measurement can have a cumulative effect, yielding
discrepancies in the position of elements in documents pro-
duced with different technologies. The rulers (typescales)
calibrated in points and picas that can be bought from
graphic arts suppliers are likely to have been produced for
printers' measurement systems and so will not be appropri-
ate for DTP.

Type measurement often involves size comparisons
between a text in which the typesize is unknown and type
specimens that give samples of typefaces in their full range
of sizes (see Figure 9.1, over page). Here again, the type
specimens produced for use in traditional typesetting and
printing will not be appropriate for comparison with DTP
samples. Furthermore, the samples of DTP typefaces pro-
vided by manufacturers may not give a full range of font
sizes, so you may need to create your own specimens.
Photocopying manufacturers' specimens may slightly
reduce the size of character images, so you should only use
specimens that have been produced directly on a laser
printer or imagesetter, or that have been printed from ori-
ginals produced on a laser printer or imagesetter.

Bear in mind that the point is a tiny unit and difficult to
measure accurately with scales or rulers. Accurate measure-
ment is made more difficult, too, by the degradation of
character images during the processes of reproduction and
multiplication (see chapter 6). Since measuring type is

foundMAP™ *DTP reference*

Trump Mediæval

ABCDEFGHIJKLMNOPQRSTUVWXYZ&ŒÆ
abcdefghijklmnopqrstuvwxyz
1234567890
.,;:!?£''~({[<$fifl•*—

The mind is the arbiter in letterforms, not the tool or the material. This is not to deny that tools and materials have had a very great influence on letterforms. But that influence has been secondary, and for the most part it has been exerted without the craftsman's conscious

The mind is the arbiter in letterforms, not the tool or the material. This is not to deny that tools and materials have had a very great influence on letterforms. But that influence has been secondary, and for the most part it has been exerted without the craftsman's

The mind is the arbiter in letterforms, not the tool or the material. This is not to deny that tools and materials have had a very great influence on letterforms. But that influence has been secondary, and for the most part it has been exerted without the craftsman's

The mind is the arbiter in letterforms, not the tool or the material. This is not to deny that tools and materials have had a very great influence on letterforms. But that influence has been secondary, and for the most part it has been exerted without the craftsman's

Δ 11pt · ◊ 11, 12, 13pt · ⇥ 100% · # 0% · · · 17pica

The mind is the arbiter in letterforms, not the tool or the material. This is not to deny that tools and materials have had a very great influence on letterforms. But that influence has been secondary, and for the most part it has been exerted without the craftsman's conscious

The mind is the arbiter in letterforms, not the tool or the material. This is not to deny that tools and materials have had a very great influence on letterforms. But that influence has been secondary, and for the most part it has been exerted without the craftsman's conscious

The mind is the arbiter in letterforms, not the tool or the material. This is not to deny that tools and materials have had a very great influence on letterforms. But that influence has been secondary, and for the most part it has been exerted without the craftsman's conscious

Δ 10pt · ◊ 10, 11, 12, 13pt · ⇥ 100% · # 0% · · · 16pica

The mind is the arbit
the tool or the materi
deny that tools and n
very great influence c
that influence has be
the most part it has b
the craftsman's consc

The mind is the arbit
the tool or the materi
deny that tools and n
very great influence c
that influence has be
the most part it has b
the craftsman's consc

The mind is the arbit
the tool or the materi
deny that tools and n
very great influence c
that influence has be
the most part it has b
the craftsman's consc

The mind is the arbit
the tool or the materi
deny that tools and n
very great influence c
that influence has be
the most part it has b
the craftsman's consc

Δ 9pt · ◊ 9, 10, 11, 12pt · ⇥ 100%

Key: Δ Typesize, ◊ Row height,
⇥ Tracking (200% – en)|100u – c

Type source: **Adobe Systems Inc**
Printed by: **First Impressions**
Designed ω/ published by: © Lc
Porters North · 8 Crinan Street
foundMAP is a trademark of Lock

Some examples may be given. John Edmonds*, gent of Newbury, took out a 21 year lease in 1664 of James Cooper's* farm (four hearths). It consisted of 277 acres for which he agreed to pay £150. William Holmes*, on the other hand, at about the same time[1], was charged an entry fine of £42.10.0 for a three-lives lease of some 20 acres in West Enborne, paying an annual rent of 5s4d. Robert Sciblehorne of West Enborne in 1662 leased a cottage and orchard and one rood of land near Hamsteade Parke Corner for an annual rent of 1s. Robert was exempted from payment of the Hearth Taxes. His son was a blacksmith in East Woodhay later in the century.

The social status of some of the inhabitants can be gleaned from the **heralds' visitation** in 1665/6. Three people in Enborne were involved: the Rector (Greetham), Mr John Edmonds*, and William Meeres* were summoned to appear before the heralds. All three made a disclaimer to arms. But clearly these three were seen to be socially superior in this parish.

There are few other signs of social status. The title 'Master' is given to some men in various records but without any consistency, and not all of these were residents though presumably they were property holders in the parish. The Hearth Taxes refer to Mr Hugh Webb (two hearths) and Mr Cooke (five hearths); neither of them (as far as we know) served as a parish officer. On the other hand, John Edmonds* is described as 'Mr' when he was chosen as churchwarden in 1682 and 1683 and again as Surveyor of the Highways in 1680[2]. John Franklin* too is called 'Mr' when he was elected overseer of the poor for East Enborne in 1663. He paid for five hearths in 1663–4, and Robert Spinage too was called 'Mr' when he became overseer in 1681 and surveyor of the highways in 1686. Other persons are occasionally called 'Mr' in rate lists (Mr Pike*, Mr Tyley*, Mr William Hunt, Mr Weston, Mr Thomas Wilson, Mr Richard Cooke, Mr Hugh Webb,

[1] The year is illegible but it is in the 1660s

[2] It is noteworthy that during his tenure of the churchwardenship, his relation Mr Thomas Edmonds was allowed to bury his infant son inside the church on payment of the appropriate fee

Figure 9.1 (top)
If you make comparisons between an existing document and a type specimen you should be sure that the specimen has been calibrated in point units of the same kind as the document. Here, a document set in ITC Trump Mediæval is compared with a printed DTP specimen. Note that the increments of the font sizes in the specimen are whole points, but that fonts can be reproduced at fractional point sizes in DTP, so a direct match between document and specimen may not always be possible.

Figure 9.2 (bottom)
In this typographic layout, type sizes and vertical spacing are specified in point units, and dimensions that specify the position of the text on the page, in millimetres.

time-consuming and prone to inaccuracies it is worthwhile keeping paper records of your documents marked up with their dimensions (see also section 6.4 on record keeping).

Although type is measured in points and picas, the page on which the type will appear is likely to have been specified in either millimetres (in Europe) or inches (in North America). So it is usual to specify the position of type on the page (such as margins, or page number positions) and sometimes larger-scale measurements (such as the width or depth of a block of text, or the position of indents) in millimetres or inches. It helps to be consistent in the units you use for particular dimensions so that you avoid having to make conversions between documents or when you use different software packages (Figure 9.2).

9.1 **The vertical dimension**

Dimensions of a character

The nominal size of a DTP font is not related to any measurable part of its characters. The measurable vertical dimensions of characters are shown in Figure 9.3.

In many typefaces there is a small space allowance that may be distributed above the ascender line and below the descender line of the letterforms of characters (Figure 9.4, over page). So, for example, in a typeface such as Linotype Times, the distance from the top of a 10pt 'k' to the bottom of a 10pt 'p' is 7.973pt, although the nominal size of the font is 10pt. There is a further complication: typefaces are not always designed so that individual character shapes fit

Figure **9.3**
The measurable vertical dimensions of characters. None of these dimensions can be related directly to the nominal size of the font to which the characters belong. Note that in seriffed typefaces the capital height is often less than the ascender height. In many sans serif typefaces the capital height and ascender height are the same (although some exceptions to this rule of thumb are Futura, Syntax, Frutiger, Lucida and Stone).

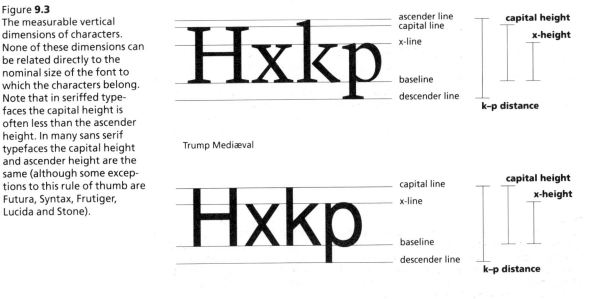

Trump Mediæval

Helvetica

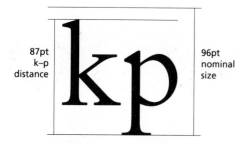

Figure **9.4**
Since each character of Bembo includes a small amount of vertical space, the kp distance is less than the nominal point size. Here, the nominal size is 96pt, the k–p distance approximately 87pt.

a

After the anarchy of the past few days, it took just hours for an interim government to be announced, elections called for next April, the first political parties to be formed and the first independent newspapers to be distributed to cheering crowds from lorries speeding

b

After the anarchy of the past few days, it took just hours for an interim government to be announced, elections called for next April, the first political parties to be formed and the first independent newspapers to be distributed to cheering crowds from lorries speeding

Figure **9.5**
a In Adobe's version of ITC Galliard ascenders and descenders are constrained to fit within the nominal type size, so there can never be clashes between the ascenders and descenders of successive rows of type if the typeface is *set solid*.
b In Bitstream's version of ITC Galliard the descenders are not constrained to fit within the nominal type size, so if the typeface is set solid, there may be clashes between the descenders of one row and ascenders of the next. (See also Figure 5.13 on p.68 for a discussion of other differences between Adobe's and Bitstream's Galliard.)

Figure **9.6**
In metal type the letter image was positioned in relief on a body. The distance from the front to the back of the body was the font size. Unlike the vertical space of digital typefaces, the body size was visible and measurable.

within the nominal size of a font. Some ascenders and descenders, accented capitals and ornamental characters may extend beyond the limits of the nominal type size (as, for example, the descenders of Bitstream's ITC Galliard in Figure 9.5b).

This confusing relationship between the nominal size of a font and the actual size of its letterforms is a throwback to metal-type technology where each character consisted of a letter image, positioned in relief on a rectangular support-ing *body* whose front-to-back dimension was the body size (Figure 9.6). In digital typography, the preservation of a nominal font dimension that resembles a body, but which does not really exist, has the unfortunate consequence that it is impossible to be sure of the nominal size of a font sim-ply by measuring the letterforms on a page with a rule or typescale. If you do not know the size in which a piece of text has been set, the only way to identify it is to compare the text with specimens of the typeface produced at known sizes (see Figure 9.1, p.92).

Just as the upper and lower limits of a letterform cannot be predicted from the nominal type size, so other vertical dimensions, such as capital height, x-height and k-p dis-tance vary in their relative proportions according to the design of the typeface. Furthermore, the x-height (and capital height) of an italic variant can be slightly less than the roman of the same typeface family (although the differ-ence is too small to reproduce at medium resolution) and the x-height of a bold variant is often greater than the roman. The alignment of individual typefaces within the vertical space delimited by the nominal size also varies among typefaces (Figure 9.7). Many DTP packages auto-matically adjust alignment, or give you the option of making an adjustment to alignment, so that all fonts, what-ever the typeface and whatever the size, align to a common baseline (see also section 3.2 for discussion of the vertical spacing of typefaces).

Always bear in mind that nominal size gives a poor indi-cation of the appearing size of a font. Appearing size depends on many factors but especially on x-height (see section 2.1). Although the fonts used in Figure 9.7 are the same size, the characters of Helvetica, which has a rela-tively large x-height, appear to be larger than the characters of Trump Mediæval (see also Figure 2.9, p.14).

Space between lines

Even when characters include a small amount of vertical space above and below the ascender and descender lines, rows of type will appear to be very close together unless they are set within a vertical distance that is considerably larger than the nominal size (Figure 9.8) (see also section 3.2 on the vertical spacing of typefaces).

Most DTP systems describe the vertical spacing of rows of type as 'leading', the term used in metal-type technology to refer to space inserted in between rows of characters by adding strips of lead (Figure 9.9). The vertical space setting would be better referred to simply as 'vertical space', or 'line increment', 'row distance', or 'line feed'.

In blocks of continuous text you can find out the vertical space setting by measuring from the baseline of one row of type to the baseline of the next row. Note, however, that curved characters and some pointed characters descend below the baseline, even though they appear to rest on it. (Type designers deliberately increase the size of these characters to compensate for a visual illusion that they are smaller than other characters of the same dimensions.) So you should be sure to measure vertical distance from the bottoms of the vertical strokes of lower-case characters, such as k's, l's and m's (Figure 9.10).

When you specify a typeface you should give both the font size and the vertical space in which it is set. A 10pt font with a 12pt vertical space setting is often described as 'ten on twelve', written as '10/12'.

a

hkp hkp

b

hkphkp

Figure **9.7**
a When set as independent text 'blocks' in QuarkXPress 2.12, the vertical alignments of Trump Mediæval and Helvetica differ, even when are both are set at the same nominal size (here, 60pt) and with the same vertical spacing parameters.
b When the same fonts are used together within a single row of text, the software adjusts the alignment of the fonts so that they have the same baseline. Note that in some software combining different fonts disrupts the regular spacing of rows of text (see Figure 3.26, p.37).

After the anarchy of the past few days, it took just hours for an interim government to be announced, elections called for next April, the first political parties to be formed and the first independent newspapers to be distributed to cheering crowds from lor-

After the anarchy of the past few days, it took just hours for an interim government to be announced, elections called for next April, the first political parties to be formed and the first independent newspapers to be distributed to cheering crowds from lor-

Figure **9.8**
Lines of text that are set solid (that is, set only within the space of the characters themselves) appear very densely packed. Setting text within a vertical space that is greater than the font size makes the contour of the words visible and improves legibility.

Figure **9.9**
In its original and accurate sense, 'leading' referred to strips of lead, inserted between rows of metal characters in order to increase the vertical distance between them. In DTP, it is used, misleadingly, to refer to the vertical space from one baseline to the next.

xompd

Figure **9.10**
At normal text sizes these characters appear to rest on the baseline and to be level with the x-height (with the exception of the ascender and descender). If you examine the characters at large scale it is clear that some of the strokes dip slightly below the baseline and rise slightly above the x-height.

9.2 **The horizontal dimension**

The horizontal dimensions of typeface characters are shown in Figure 9.11. Within each character width there are spaces to the left and right of the letterform known as *side bearings*. The information about horizontal spacing built into a typeface is known as its *font metrics*.

The characters of most DTP typefaces are proportionally spaced; that is, each character occupies a horizontal space that is tailored to the shape of individual letterforms and depends on the design of the typeface as a whole (Figure 9.12). The numerals of a font are usually an exception to this generalization. They occupy a *standard width* so that they align vertically in tabular setting (see Figure 3.49, p. 52). Similarly, monospaced typewriter faces (such as Courier or Elite) have a standard width. In this case, rather than adapting horizontal space to the letterforms, the letterforms themselves are designed to fit units of the same width (Figure 9.13).

Figure **9.11**
The horizontal dimension of typeface characters.
(The size of the side bearings has been exaggerated here.)

Janson Text

Times

Helvetica Condensed

Figure **9.12**
The characters of typefaces are proportionally spaced. Their widths vary within typefaces according to the letterform. The width of any single character also varies across typefaces, according to the design of the typeface as a whole.

Times

Courier

Figure **9.13**
Whilst the amount of lateral space in a traditional typeface varies from character to character, typewriter character shapes are designed to fit one, standard width.

a

Tow
Van

b

Tow
Van

Figure **9.14**
a 'To' and 'Va' have the same spatial parameters as the other characters with which they occur, but they appear loosely spaced.
b After kerning, their spacing is more in keeping with the rest of the characters.

Many typefaces include conditional spatial information, held in *kerning tables*, that can be called upon to reduce the space between particular character combinations that always appear too loosely spaced (Figure 9.14) (see also section 2.2. on horizontal cohesion).

In DTP the term 'kerning' has come to mean both closing and opening the space between two characters, whereas people with backgrounds in traditional typesetting technology may understand it as a process specifically of closing up space. In metal type a kern was part of a character that extended beyond the character body (that is, into the horizontal space occupied by adjacent letters; Figure 9.15).

Often DTP software allows you to make further adjustments to the horizontal spacing of character combinations, either by applying additional kerning to particular character pairs, or by making an overall adjustment to the fit of a typeface, using a 'tracking' or 'character spacing' option (see section 2.2). Depending on the software, these options adjust horizontal space either by a fixed amount or by a proportion of the space that the type manufacturer has allowed within the character. The adjustment is usually made at one side of the character. You should be extremely cautious in making adjustments to horizontal space, and particularly any global adjustments, since they may reduce the overall legibility of the typeface (see Figure 2.15, p.17).

The interpretation of the information about horizontal spacing given in font metrics can vary among software packages (see Figure 2.14, p.16) or, within the same software package, according to the system being used or the text format (see section 3.2 on typeface performance and document format). The differences in interpretation may be too small to be visible on screen so you should check for them on paper.

Figure **9.15**
A kerned metal character.

Further reading

On typography

Hochuli, J. 1987 *Detail in typography*. Wilmington, Mass: Compugraphic

McLean, R. 1980 *Typography*. London: Thames and Hudson

Miles, J. 1987 *Design for desktop publishing*. London: Gordon Fraser

Simon, O. 1945 *Introduction to typography*. London: Faber and Faber

Spencer, H. 1968 *The visible word*. London: Lund Humphries

Spiekermann, E. 1987 *Rhyme and reason: a typographic novel*. Berlin: Berthold

Unger, G. 1987 *Typography: basic principles and applications*. Venlo (Netherlands): Océ

On book design and production

Rice, S. 1978 *Book design: systematic aspects*. New York: Bowker

Williamson, H. 1983 *Methods of book design* (3rd edition). New Haven: Yale University Press

On the technology of typefaces and typesetting

Bigelow, C. & Day, D. 1983 Digital typography, *Scientific American*, 249/2, 108–119

Fenton, E. 1989 *The Macintosh font book*. Berkeley, Ca: Peachpit Press

Rubinstein, R. 1988 *Digital typography*. Reading, Mass: Addison Wesley

Seybold, J.W. & Dressler, F. 1987 *Publishing from the desktop*. New York: Bantam Books

Seybold, J.W. 1984 *The world of digital typesetting*. Media, Pa: Seybold Publications

On type design

Bigelow, C. 1982 The principles of digital type (Part 1) *Seybold report on publishing systems*, 11/11, 3–23

Bigelow, C. 1982 The principles of digital type (Part 2) *Seybold report on publishing systems*, 11/12, 10–19

Carter, S. 1987 *Twentieth century type designers*. London: Trefoil

Frutiger, A. 1980 *Type, sign, symbol*. Zurich: ABC

Karow, P. 1987 *Digital formats for typefaces*. Hamburg: URW

Tracy, W. 1986 *Letters of credit: a view of type design*. London: Gordon Fraser

Journals dealing with typography, and typeface design and use

Baseline, Esselte Letraset, St George's House, 195–203 Waterloo Road, London, SE1 8XJ

Desktop publishing today, Industrial Media, Blair House, 184–186 High Street, Tonbridge, Kent TN9 1BQ

DTP corporate publishing and presentations, Dennis Publishing, 14 Rathbone Place, London W1P 1DE

Information design journal, PO box 185, Milton Keynes, MK7 6BL

MacUser, Dennis Publishing, 14 Rathbone Place, London W1P 1DE

Seybold report on desktop publishing, Seybold Publications, 428 E. Baltimore Pike, PO box 644, Media, Pennsylvania 19063

Seybold report on publishing systems, Seybold Publications, 428 E. Baltimore Pike, PO box 644, Media, Pennsylvania 19063

TEXline, PO box 1897, London NW6 1DQ

Upper & lower case, International Typeface Corporation, 2 Dag Hammarskjold Plaza, New York, NY 10017

Visible language, Rhode Island School of Design, Graphic Design Department, 2 College Street, Providence, Rhode Island, RI 02903

Reference books

GLOSSARIES

Brown, B. 1983 *Browns index to photocomposition typography*. Minehead: Greenwood

Glaister, G.A. 1979 *Glossary of the book* (2nd edition). London: Allen & Unwin

ON THE PRESENTATION OF TEXT

British Standards Institution 1990 *Recommendations for the presentation of theses and dissertations*. BS 4821

Butcher, J. 1981 *Copy editing: the Cambridge handbook*. Cambridge: Cambridge University Press

The Chicago manual of style: rules for authors, printers and publishers recommended by the University of Chicago Press (13th edition). 1982, Chicago: University of Chicago Press

Hart, H. 1978 *Hart's rules for compositors and readers at the University Press Oxford* (38th edition). Oxford: Oxford University Press

MLA handbook for writers of research papers, theses and dissertations. 1980, New York: Modern Language Association

ON PROGRAMMING

Adobe Systems 1990 *Adobe Type 1 Font Format*. Palo Alto, Ca.

Adobe Systems 1988 *PostScript language program design*. Reading, Mass: Addison Wesley

Adobe Systems 1985 *PostScript language tutorial and cookbook*. Reading, Mass: Addison Wesley

Adobe Systems 1985 *PostScript reference manual*. Reading, Mass: Addison Wesley.

Knuth, D. 1986 *The METAFONT book* (volume C of Computers and Typesetting Series). Reading, Mass: Addison Wesley

INTERNATIONAL STANDARDS FOR CHARACTER SETS

ISO 6937, *Information processing – Coded character sets for text communication*

 1 1983 Part 1: *General introduction*

 2 1983, & Addendum 1 1989. Part 2: *Latin alphabetic and non-alphabetic graphic characters*

ISO 5426, 1983 *Extension of the Latin alphabet coded character set for bibliographic information exchange*

ISO 5427, 1984 *Extension of the Cyrillic alphabet coded character set for bibliographic information exhange*

ISO 5428, 1984 *Greek alphabet coded character set for bibliographic information exhange*

ISO 6438, 1983 *African coded character set for bibliographic information exhange*

ISO/DP 8957 *Documentation – Hebrew alphabet coded character sets for bibliographic information exhange* (due as full Standard in June 1992)

List of illustrations

◊ and * indicate illustrations produced in QuarkXpress 2.12 and output on a Linotronic 300 via a Linotype PostScript RIP. Those marked ◊ were output at 1270 dpi; those marked * were output at 2540 dpi. (See p. 106 for more production details.) All the enlargements and reductions described here are linear.

1.1 Characters of 12pt Monotype Bembo delivered by default encoding for Apple Macintosh computer, with additional Adobe PostScript symbol characters. ◊

1.2 Adobe Type Library Standard Character Set Keyboard Map. Copyright © 1989, Adobe Systems Inc., all rights reserved. Permission granted.

1.3 Full Adobe PostScript character set in 12pt Linotype Times, generated by re-encoding the default Macintosh encoding in TEX and output at 300 dpi on an Apple LaserWriter IINTX. Produced by Richard Southall.

1.4 Typewritten text, 12 pitch Courier on IBM electric typewriter; typeset text, 10/14pt Linotype Janson Text. ◊

1.5 TEX character set in 12pt Computer Modern and output at 300 dpi on an Apple LaserWriter IINTX. Produced by Richard Southall.

1.6 Character set of 12pt Monotype Bembo Expert Set for Apple Macintosh. ◊

1.7 a Adobe PostScript symbols, set at 10pt. ◊ **b** (top) 10/14pt Linotype Times (subscripts, 6pt Linotype Times), 9/14pt Adobe PostScript bold symbols; (bottom) 9/14pt Linotype Frutiger (subscripts, 6pt Linotype Frutiger), 9/14pt Adobe PostScript bold symbols. *

1.8 a 10pt Linotype Times produced in Ventura Publisher Professional Extension 2.0 by Catherine Griffin. **b** Reproduced from Formulator 1.2 user manual. Copyright © 1989, Icon Technology Ltd. Permission granted. **c** Produced in ChemDraw 2.0.1 and laser printed (at 300 dpi) by the Royal Society of Chemistry. Permission granted.

2.1 10/13pt ITC Zapf Chancery, 10/13pt ITC Avant Garde Gothic, 10/13pt Monotype Biffo Script. ◊

2.2 14/18pt Linotype Times, produced in PageMaker 3.5 and output at 1270 dpi on a Linotronic 300 via a Linotype PostScript RIP.

2.3 10/13pt Linotype Times produced in TEX by Richard Southall and output at 300 dpi on an Apple LaserWriter IINTX. Extract from 'Czechs win right to visit West without permits', Michael Simmons, *The Guardian*, 15 November 1989; permission granted by Guardian News Services Ltd. Portuguese translation by Flávio Cauduro.

2.4 a 10/13pt ITC Bookman. **b** 10/13pt Monotype Bembo. **c** 14pt Monotype Gloucester Old Style. **d** 18pt ITC Galliard italic. ◊

2.5 12pt Linotype Helvetica and 12pt Monotype Baskerville. ◊

2.6 10/13pt and 36pt ITC Galliard italic. ◊

2.7 14pt Monotype Bodoni Book, 14pt New Century Schoolbook. ◊

2.8 9pt ITC Bookman: roman, italic, Demi roman, Demi italic. ◊

2.9 48pt and 10/13pt Lucida, 48pt and 10/13pt Linotype Times. ◊

2.10 44pt New Century Schoolbook, 44pt Linotype Glypha. ◊

2.11 12pt and 40pt Trump Mediæval. ◊

2.12 a 14pt New Century Schoolbook set ranged left with no tracking in QuarkXPress 2.12. **b** 14pt New Century Schoolbook set ranged left with 3 units (0.015 em) tracking in QuarkXPress 2.12. ◊

2.13 10pt Monotype Bembo Expert Set, with 100% word spacing, 0% character spacing; with 125% word spacing, 25% character spacing; with 180% word spacing, 60% character spacing. ◊

2.14 a 12pt Linotype Times bold, in Word 4.0. **b** 12pt Linotype Times bold, in QuarkXPress 2.12. ◊ **c** 12pt Linotype Times bold, in Word 4.0. **d** 12pt Linotype Times bold, in QuarkXPress 2.12. ◊ (**a** and **c** output at 1270 dpi on a Linotronic 300 via a Linotype PostScript RIP.)

2.15 a 12pt Trump Mediæval, set ranged left with no tracking. **b** 12pt Trump Mediæval, set ranged left and tracked by minus 5 units (0.025 em). ◊

2.16 10pt ITC Galliard without ligatures and with 'fi' and 'fl' ligatures. 10pt Monotype Bodoni Book without ligatures and with 'fi' and 'fl' ligatures ◊. Ligatures enlarged to 150%. *

2.17 48pt ITC Galliard and 48pt Monotype Bodoni. ◊

2.18 24pt Linotype Palatino, **a** without kerning, **b** with automatic kerning, **c** with automatic and manual kerning. **d** 10pt Adobe Linotype Palatino without kerning. All produced in PageMaker 3.5 and output at 1270 dpi on a Linotronic 300 via a Linotype PostScript RIP.

3.1 From *Journal of neuroendocrinology*, 1/1, 1989 (reduced to 29%). Permission granted by Oxford University Press. (Additional text, 8pt Lucida. *)

3.2 8/10.5pt Lucida roman and bold. ◊

3.3 'Specimen pages' (reduced to 85%) in Monotype Bembo and Bembo Expert Set. Text, 7/9pt; bibliographical note and quotation, 6.5/8pt; footnotes, 5.5/7pt; headline, page number, and chapter number, 7pt; chapter title, 10/12pt. ◊

3.4 a Linotype Helvetica and Linotype Palatino. Reproduced from *Public courses 1990 – 91*, University of Reading, Department of Extended Education. Permission granted. **b** Linotype Iridium (not PostScript) and Linotype Univers (not PostScript), output on a Linotronic 300. Reproduced from Cockburn, J. and Smith, Philip T., *Middlesex elderly assessment of mental state*, Thames Valley Test Company, Titchfield, Fareham, Hampshire, 1989. Permission granted by Thames Valley Test Company.

3.5 Monotype Bembo, Monotype Baskerville, Monotype Bodoni Book, all at 10/12pt, 12pt, 54pt, and 66pt. New Century Schoolbook at 9/11pt, 53pt, and 66pt. ◊

3.6 a 42pt Monotype Times New Roman. **b** 42pt Monotype Times New Roman PS. **c** 42pt Linotype Times. **d** 42pt Linotype Times Ten. All output at 1000 dpi on a Monotype Lasercomp. Produced by Mike Johnson.

3.7 24pt Linotype Glypha, Linotype Frutiger, Linotype Futura Book, Linotype Helvetica, Linotype Optima; 24pt Monotype Bembo, Monotype Bodoni, Monotype Bodoni Book, Monotype Gill Sans, Monotype Joanna; Lucida. *

3.8 8/10pt Linotype Helvetica with italic, condensed light, bold, bold italic, condensed bold, black variants; 8/10pt Monotype Gill Sans with italic, light, bold, bold italic, extra bold variants. *

3.9 9/11pt Linotype Times. Polish produced in TEX by Richard Southall. Portuguese extract as Figure 2.3. Both texts output at 300 dpi on an Apple LaserWriter IINTX.

3.10 10/12pt Monotype Garamond, ◊. English extract as Figure 2.3. Dutch translation by Karel van der Waarde. Classical Latin by Richard Simpson.

3.11 a 9/11pt Monotype Bembo, Adobe PostScript symbol characters. **b** 9/11pt Monotype Bembo, Monotype Bembo Expert Set, 7.5/11pt Adobe PostScript symbol characters. **c** 9/11pt Monotype Bembo, Monotype Bembo Expert Set, Adobe PostScript symbol characters. ◊ Extract reproduced by permission of Michael Twyman.

3.12 Headings: **a** 9.5pt & 10.5pt New Century Schoolbook, **b** 9.5pt & 11.5pt New Century Schoolbook. Text: 9.5/13pt New Century Schoolbook. Reduced to 75%. *

3.13 Headings: **a** 9.5pt Linotype Times italic, **b** 9.5pt Linotype Times bold italic, **c** 11pt Linotype Times bold italic. Text: 9.5/12pt Linotype Times. Reduced to 67%. * Extract from Giles, A.K. and Errington, A.J. (eds), *Farm business data*, Reading University Department of Agricultural Economics & Management, 1990. Permission granted.

3.14 Reproduced from Costigan-Eaves, P., 'William Playfair's line graphics', *Information design journal*, 6/1, 1990, p.39. Permission granted.

3.15 Headings: **a, b, c** 9.5pt Linotype Helvetica bold. Text: **a, c** 9.5/12pt Linotype Helvetica, **b** 9.5/12pt Linotype Helvetica Light. Reduced to 77%. All produced in QuarkXPress 2.12; **a, b** output at 300 dpi on an Apple LaserWriter IINTX, **c** output at 2540 dpi on a Linotronic 300 via a Linotype PostScript RIP. Extract as for 3.13.

3.16 Headings: **a** 9.5pt Linotype Helvetica bold with 7pt space before heading, **b** 10pt Linotype Helvetica bold with 7pt space before heading, **c** 9.5pt Linotype Helvetica bold with 15pt space before heading and 4pt space after heading. Text: **a, b, c** 9.5/12pt Adobe PostScript Helvetica. Reduced to 77%. **a, b, c** output at 300 dpi on an Apple LaserWriter IINTX. Extract as for 3.13.

3.17 a, b Reproduced from *Reading medieval studies*, 13, 1987. Reduced to 79%. Permission granted by the Graduate Centre for Medieval Studies, University of Reading.

3.18 Reproduced from *Classroom issues in assessment and evaluation*, ed. Veronica Treacher, Berkshire Education Authority, 1989. Reduced to 41%. Permission granted by Berkshire Arts Initiative.

3.19 Reproduced from laser-printed (300 dpi) samples for new design of *Screen*, 31/1, 1990. Reduced to 49%. Designed by Information Design Unit. Permission granted by Oxford University Press.

3.20 Extract: **a** 9.5pt Linotype Helvetica bold, 10/13pt Linotype Times, **b** 10.5pt Monotype Gill Sans bold, 11/13pt Monotype Joanna. Display sizes in **a, b** 18pt. ◊ Extract reproduced by permission of Michael Twyman.

3.21 Headings: **a** 10pt Linotype Times bold, **b** 10pt Linotype Helvetica bold, **c** 12pt Linotype Times bold. Text: **a, b, c** 10/12pt Linotype Times. ◊

3.22 Headings: 10pt Linotype Times bold and 10pt Linotype Helvetica. Text: 10/12pt Linotype Times. Reduced to 84%. *

3.23 Reproduced from *Classroom issues in assessment and evaluation*, ed. Veronica Treacher, Berkshire Education Authority, 1989. Reduced to 45%. Permission granted by Berkshire Arts Initiative.

3.24 10/13pt Monotype Gill Sans, 10.5/13pt Monotype Joanna. Reduced to 90%. *

3.25 a 10/14pt Linotype Times, 10/14pt Greek typeface (Adobe PostScript symbol characters, with additional diacritical marks produced by Richard Simpson). **b, c** 10/14pt Linotype Times, 9/14pt Greek typeface (as in **a**). **d** 10/14pt Linotype Times, 9/14pt italic Greek typeface (as in **a**). Produced in Final Word II and output at 300 dpi on an Apple LaserWriter Plus by Richard Simpson.

3.26 Headings: (top) 10pt Linotype Times bold italic, (middle) 12pt Linotype Times bold italic, (bottom) 10pt ITC Bookman Demi italic. Text: 10/12pt Linotype Times. **a** produced in Word 4.0, **b** produced in PageMaker 3.5. Both output at 1270 dpi on a Linotronic 300 via a Linotype PostScript RIP.

3.27 Monotype Joanna and Monotype Gill Sans. *

3.28 9/11pt Monotype Baskerville, 9/11pt Monotype Baskerville with 24/11pt word spaces. ◊ Extract from 'Comrades are sinking slowly into the West', Martin Kettle, *The Guardian*, 29 November 1989; permission granted by Guardian News Services Ltd.

3.29 10/11pt Monotype Baskerville, 10/11pt Monotype Garamond, 10/13pt Monotype Baskerville. 10/13pt Monotype Garamond. ◊ Extract as 3.28.

3.30 a 9/10pt ITC Galliard. **b** 9/12pt ITC Galliard. ◊ Extract and Dutch translation as 3.10.

3.31 a 18/18pt Monotype Arabic Naskh (not PostScript). **b** 18/22pt Monotype Arabic Naskh. **c** 10/12pt Linotype Times, 9/12pt Greek typeface (as 3.25). **d** 10/14pt Linotype Times, 9/14pt Greek typeface (as 3.25). **a, b** produced by Catherine Griffin, output at 1000 dpi on Monotype LaserComp. **c, d** produced in Final Word II and output at 300 dpi on an Apple LaserWriter Plus by Richard Simpson.

3.32 7/8pt Lucida, 7/9pt Lucida, 7/10pt Lucida. Extract from 'Czechs scrap one-party rule', Michael Simmons and Jon Bloomfield, *The Guardian*, 29 November 1989; permission granted by Guardian News Services Ltd. *

3.33 12/14pt Linotype Janson Text, 12/14pt Linotype Helvetica. ◊

3.34 a 9.5/13pt ITC Galliard, justified and hyphenated. **b** 9.5/13pt ITC Galliard, justified without hyphenation. ◊ Extract as 3.32.

3.35 a 9.5/11pt ITC Galliard, justified and hyphenated. **b** 9.5/11pt ITC Galliard, ranged left and hyphenated. ◊ Extract as 3.32.

3.36 Typewritten text, Courier; typeset text, Linotype Palatino. Reduced to 57%. *

3.37 8/10pt, 8/14pt Lucida. *

3.38 'Thumbnails' produced in QuarkXPress 2.12. ◊

3.39 Reproduced from *Newsletter* of the British Computer Society Electronic Publishing Specialist Group. Reduced to 40%. Permission granted. **a** Issue 5/1, July 1989, designed by Paul Greenland and Mark Griffin (student project in Department of Typography & Graphic Communication, University of Reading). **b** Issue 5/2, December 1989, revision of design by newsletter editor.

3.40 a Reproduced from *Bitstream type and use guide* Copyright © 1988, Bitstream Inc., Cambridge, Mass. Permission granted. **b** Reproduced from *Adobe type library catalogue* (2nd edn, 1987) Copyright © 1987, Adobe Systems Inc., all rights reserved. Permission granted.

3.41 Reproduced as 3.40**b**

3.42 Reproduced from *The Which? book of saving and investing* (2nd edn). Copyright © Consumers Association, 1983. Designed by Banks and Miles. Permission granted.

3.43 10/15pt Trump Mediæval roman and italic. Extracts from V. Steer, *Printing design and layout*. London: Virtue and Co. [no date].

3.44 Reproduced from Shackel, B., Pullinger D.J., Maud, T.I., & Dodd, W.P., 'The BLEND – LINC project on "electronic journals" after two years' *The computer journal*, 26/3, 1983 and *Aslib proceedings*, 35/2, 1982. Permission granted.

3.45 a, b output at 300 dpi on an Apple LaserWriter IINTX, reduced to 71% **a** Produced by Mike Johnson. Extract reproduced by permission of Alex Ellwood. **b** Extract reproduced by permission of Michael Twyman.

3.46 Set in Courier and New Century Schoolbook; each reduced to 44%. * Extract as 3.45**a**

3.47 (Left) 8/12pt bold Courier (to simulate typewritten text); (right) Lucida 10/11pt. ◊ Extract from University of Reading, Computer Services Centre *Newsletter*. Permission granted.

3.48 a 12pt Monotype Bembo. * **b** 10pt Monotype Bembo. ◊

3.49 10/12pt Linotype Times. ◊

3.50 9/10pt Monotype Garamond. ◊ Extract from 'Premier strikes back', Michael Simmons, *The Guardian*, 27 November 1989; permission granted by Guardian News Services Ltd.

4.1 20pt Monotype Bembo, 19pt ITC Galliard, 21pt Monotype Garamond, 18pt Linotype Trump Mediæval; 20pt Monotype Bodoni Book, 21pt Monotype Walbaum. *

5.1 Produced in METAFONT and output at 300 dpi on an Apple LaserWriter by Richard Southall.

5.2 As 5.1.

5.3 As 5.1.

5.4 Character outlines in IKARUS M 1.2, output at 300 dpi on an Apple LaserWriter IINTX. Produced by Mike Johnson.

5.5 Screen shot of dialogue box from PageMaker 3.5 and PostScript code, produced by Steve Taylor.

5.6 Screen shots from Apple outline font technology demonstration. © 1989 Apple Computer, Inc. Permission granted.

5.7 12pt Monotype Times New Roman, **a** unhinted, **b** hinted in F3 format, output at 300 dpi on an Apple LaserWriter IINTX. Produced by Steve Taylor.

5.8 a 10/13pt Monotype Joanna (unhinted) output on Apple LaserWriter IINTX. **b** 10/13pt Monotype Joanna Classic Font (semi-hinted). Both output at 300 dpi on an Apple LaserWriter IINTX. Produced by Mike Johnson. Enlargements to 400%. Extract from 'Ceausescu unleashes carnage', Ian Traynor, *The Guardian*, 22 December 1989; permission granted by Guardian News Services Ltd.

5.9 8/10pt ITC Galliard and 8/10pt Lucida, **a** screen shot on Apple Macintosh SE30, **b** output on Apple LaserWriter IINTX, **c** output at 1270 dpi on a Linotronic 300 via a Linotype PostScript RIP. Extract from 'Countdown to the bloodiest revolution', John Gittings and Michael Simmons, *The Guardian*, 27 December 1989; permission granted by Guardian News Services Ltd.

5.10 Linotype Melior, produced in PageMaker 3.5 and output at 1270 dpi on a Linotronic 300 via a Linotype PostScript RIP.

5.11 Page description language diagram.

5.12 Page description language diagram.

5.13 ITC Galliard in Bitstream PostScript format and Adobe PostScript format; **a**, **b** same size (top) and enlarged to 400% (bottom). Reproduced from *The Seybold report on desktop publishing*, 3/5, 1989. Permission granted by Seybold Publications, Inc.

6.1 9/11pt Linotype Palatino, produced in PageMaker 3.5. Medium resolution original output at 300 dpi on Apple LaserWriter Plus; high resolution original output at 1270 dpi on a Linotronic 300 via a Linotype PostScript RIP. Enlarged to 250%. Reproduced from the University of Reading *Diary*, 139, November/December 1988. Permission granted by the Office of the Registrar, University of Reading.

6.2 7pt Linotype Trump Mediæval; enlarged to 375%. From *Information design journal*, 6/1, 1990. Permission granted.

6.3 Reproduced from *The Seybold report on desktop publishing*, 3/5, 1989. Permission granted by David R. Spencer & Associates, Gifford Way, Melville, NY

6.4 a Output at 300 dpi on an Apple LaserWriter IINTX. **b** Output at 300 dpi on Xerox 4045 printer. Produced by Richard Southall. Extract from 'Comrades are sinking slowly into the West', Martin Kettle, *The Guardian*, 29 November 1989; permission granted by Guardian News Services Ltd.

6.5 Reproduced from *The Seybold Report on Desktop Publishing*, 3/5, 1989. Permission granted by David R. Spencer & Associates, Gifford Way, Melville, NY

6.6 10pt Linotype Times, 10pt ITC Galliard, 10pt Lucida. Enlarged to 200%. **a** output at 300 dpi on an Apple LaserWriter Plus. **b** output at 300 dpi on an Apple LaserWriter IINTX.

6.7 10pt Linotype Times, output at 300 dpi on an Apple LaserWriter IINTX. Enlarged to 300%.

6.8 10pt ITC Galliard, output at 300 dpi on an Apple LaserWriter Plus. Enlarged to 200%.

6.9 7pt and 9pt Linotype Helvetica, output on an Apple LaserWriter IINTX; **a** on gloss art paper, **b** on printing cartridge paper, **c** on newsprint.

6.10 Procedures to increase resolution of medium resolution output.

6.11 10pt New Century Schoolbook, enlarged to 300%, with adjustments to focus and exposure.

6.12 10/12pt Linotype Times. **a** Photocopy of output produced at 1270 dpi on a Linotronic 300 via a Linotype PostScript RIP. **b** Photocopy of output produced at 300 dpi on an Apple LaserWriter IINTX. Extract as for Figure 1.42.

6.13 a High resolution character images on gloss coated paper, **b** medium resolution character images on gloss coated paper, **c** medium resolution character images on matt coated paper. (All enlarged to 350%.)

6.14 Medium resolution character images on uncoated cartridge paper, enlarged to 350%.

6.15 Character images produced from over-inked and correctly-inked printing plates. Demonstration produced by Peter Baker.

6.16 Production checklist, set in Lucida and reduced to 90%. *

7.1 Exercise to design Anglo-Saxon characters for Department of Medieval Studies, University of Reading. Produced in Fontographer 3.0.5 by Paul Hughes and Paul Weston (student project in Department of Typography & Graphic Communication, University of Reading).

7.2 Screen shots from FONTastic Plus 2.0.

7.3 Screen shots from Fontographer 3.0.5.

7.4 128pt Adobe PostScript Times. *

7.5 Character from reproduction of Anglo-Saxon manuscript and 44pt Adobe PostScript Times.

7.6 Characters from reproductions of Anglo-Saxon manuscripts.

7.7 Screen shots from exercise to reproduce drawn symbols in Fontographer 3.0.5. Produced by Chris Burke (student project in Department of Typography & Graphic Communication, University of Reading).

7.8 a Screen shot from Fontographer 3.0.5. **b**, **c** Screen shots from FontStudio 1.0.

7.9 Exercise to produce non-ranging numerals using Fontographer 2.0 by Chris Burke (student project in Department of Typography & Graphic Communication, University of Reading).

7.10 Non-ranging numerals produced using Fontographer 2.0. **a**, **b** output at 300 dpi on an Apple LaserWriter Plus. **c**, **d** output at 1270 dpi on a Linotronic 300 via a Linotype PostScript RIP. (Numerals produced by Chris Burke in student project; see 7.9.)

8.1 a 14pt Monotype Gill Sans Light, roman, bold, ultra bold, light italic, italic, bold italic, condensed, bold condensed; 24pt Monotype Gill Sans ultra bold and ultra bold condensed. **b** 14pt Monotype Baskerville roman, semi-bold, bold, italic, semi-bold italic and bold italic. ◊

8.2 a 14pt Linotype Helvetica. **b** 14pt Linotype Helvetica Condensed. **c** 14pt Linotype Helvetica Narrow. ◊

8.3 12pt Linotype Helvetica, Linotype Times and ITC Galliard; 12pt Monotype Gill Sans. ◊

8.4 a Sample characters: 14pt Monotype Bembo Expert Set. Text: 10/13pt Monotype Bembo and Bembo Expert Set. **b** Sample characters: 14pt (small caps) and 9pt (superscripts) Monotype Bembo. Text: 10/13pt and 6/13pt (superscripts) Monotype Bembo. ◊

9.1 Linotype Trump Mediæval specimen sheet from FountMAP, designed by Martin Locker © Locker Lakin Publications. Proof of booklet written by Alan Rogers and Enborne Local History Group; 9.5pt Trump Mediæval, 4 mm vertical spacing (57% reduction).

9.2 Layout produced during work on this book; reduced to 68%

9.3 60pt Linotype Trump Mediæval, 60pt Linotype Helvetica. ◊

9.4 96pt Monotype Bembo. ◊

9.5 a 10/10pt Adobe PostScript Galliard. **b** 10/10pt Bitstream PostScript Galliard. Extract from 'Freed Romania rejoices', Ian Traynor, *The Guardian*, 27 December 1989; permission granted by Guardian News Services Ltd.

9.6 Reproduced from Legros, L.C and Grant, J.C. *Typographical printing surfaces*. London: Longmans Green, 1916.

9.7 60pt Linotype Trump Mediæval and 60pt Linotype Helvetica. ◊

9.8 a 9/9pt ITC Galliard **b** 9/11pt ITC Galliard. ◊ Extract as 9.5.

9.9 Diagram of leading.

9.10 10pt and 48pt Linotype Janson Text. ◊

9.11 84pt Linotype Janson Text (outline). ◊

9.12 a 48pt Linotype Janson Text. **b** 48pt Linotype Times. **c** 48pt Linotype Helvetica Condensed. ◊

9.13 48pt Linotype Times, 48pt Courier. ◊

9.14 36pt Linotype Janson Text. **a** without kerning. **b** 'To' kerned by minus 20 units (0.1 em), 'Va' kerned by minus 10 units (0.05 em). ◊

9.15 Reproduced from Legros, L.C and Grant, J.C. *Typographical printing surfaces*. London: Longmans Green, 1916.

Index and glossary

The index gives brief definitions for key terms as they are used in the text. More detailed definitions and explanations of terms can be found in the text. Page numbers in italic refer to illustrations.

A4 pages, formats for, 44, *44*

accents, see diacritical marks

actual font, see font

Adobe, 46, 67

Adobe Type Manager, 2, 64

alignment – vertical position of baseline in total vertical space occupied by characters, 36, *37*, 94, *95*

appearing (apparent) size, see size

appropriateness, of typeface to genre, see genre; of type size, 44

Arabic, classical, *40*

arm – horizontal branching stroke, as in 'E' or 'f', *81*

art paper, see coated paper

ascender – character stroke rising above x-height, 39, *40*, *93*

ascender height – height from baseline to top of character ascender, 15, *15*, *93*

auto space settings – default vertical space settings in DTP software, 39, *40*

auto-trace – automatic generation of outline for image imported into character production software, 82, *82*

baseline – horizontal line where main strokes of characters without descenders appear to rest, 14, *14*, 39, *93*, *95*, 95

Bézier curves – cubic curves used in PostScript outline descriptions, 60

bitmap – array of consistently shaped and sized elements combined to deliver a character image, *56*, 57–9
 advantages of bitmap characters, 59
 creating bitmap characters, 78–9, *79*
 disadvantages of, 58–9, 66
 see also hard font and soft font

Bitstream, 67, *68*, 94

body – supporting base for relief letterform of metal character, 94, *94*

bold – variant of typeface with heavy strokes relative to roman, 41, 94
 at medium resolution, 30, *30*, 74, *74*

bowl – loop of a letter enclosing space, as in 'b' or 'g', 14, *77*

capital height (cap height) – height from baseline to top of capital letters, *93*, 94

capital letters, for emphasis, 36, 51, *51*
 spacing of, 16, *16*
 in text, 27

character – a letter, numeral, punctuation mark, or symbol, 3
 designing, 75–84
 differentiation of, 13, *13*
 over-distinctive characters, 10–12, *12*

character distribution – frequency of occurrence of individual characters or kinds of characters within text, 26–7, *27*

character set – set of characters available in a font, 3–9, 90
 extended – additional characters to supplement standard set, 6, 7
 standard – basic set of characters for font, usually most common characters, 4, 5–7

character shape (letterform), 21, *23*, 25, 53, 81, *81*, 90

character spacing, see horizontal spacing

ChemDraw, 8, *9*

chemical drawings, 8–9, *9*

chemical formulæ, 27

cicero – 12 Didot points, 4.5 mm, 91

classification of typefaces, 23, *23*

coated paper (art paper), 74, *74*

colour – overall impression of lightness or darkness given by block of text, 42, *42*

columns, length, 44, *45*
 narrow columns and justification, 41
 and page format, 44

compression, of characters, see width

compression, of character descriptions – programming to reduce storage required by a font; of bitmaps, 58, *58*
 of outlines, 68, 78

condensed font – narrow typeface variant, 31, *32*, 41, 88, *88*

contour, of words – global shape delivered by pattern of ascending and descending characters, 10, *11*, 15, *15*

contrast – degree of distinction between thick and thin character strokes, 21, 25

conventions, for characters used in typeset documents, 51–2, *51*
 for document format, 50, *50*
 for newly-designed characters, 82, *82*
 for type size, 44

counter – internal space enclosed by bowl of character, 14, 41

Cyrillic script, 35

dates, see numerals

degradation of character images in reproduction, 69, *69–70*, 72, *72*, 74, *74*

depth – number of lines or measured distance from top to bottom of text or page, 44, *45*

descender – character stroke descending below baseline, 93–4, *94*

designing, new characters, see character; pages, see page format

device independent (font) – font usable on different output devices, 60

diacritical mark – accent or mark signalling difference in sound or value of letter, 2, 4, 5, 6, 26
 position of, 11–12, *12*
 vertical spacing of text with, 39, *40*

Didot point – unit of type measurement, 0.376 mm, 91

digital character descriptions – numerical representations of character shapes, *56*, 57–64

directories, 24, *24*

display *PostScript*, 64

display face – decorative typeface, 10, *10*, 50, *86*

display size – fonts of 14pt and above, 15, 18

distinguishing elements of document, 19–23, *22*, 26
 headings and text, 28–34, *29–34*
 distinctions within text, 29, 34–37, *35–36*

distinctive characters, see character

DIY (do-it-yourself or user-defined) characters, 53–4, 77–84
 producing characters with interactive packages, 78–9
 programming character descriptions, 80–1, 83

document, parts of, *20*
 conventions of typeset documents, 50–2, *51–2*
 records, 75, *76*
 samples, see specimen pages

dot matrix printer, 64

dots per inch (*abbr.* dpi) – units in which resolution of laser output device is usually expressed, 64–5, 71–2

download – to send stored fonts to output device, 59

dpi, see dots per inch

Dutch, 7, 26, *27*, 40

em – horizontal distance of nominal type size, 39–41
 em-dash – dash approximately 1 em long, 4, 5

emphasis, 28, *29*
 using bold, 30, *30*
 using capital letters, 30
 using italic, 29, 30
 at medium resolution, 30, *30*, 74, *74*
 using underlining, 30, *31*, 51, *51*

en – horizontal distance of half-nominal type size; en-dash – dash approximately 1 en long, 4, 5

encoding – mapping between characters and the programming codes selecting them (via keyboard), 2, 3–5
 of Adobe PostScript character set in Apple Macintosh, 2, 4
encryption code – program used to copy protect font format, 67–8
English, 26, 27
equation setting, 8–9, 9
errors, commonly made in DTP, emphasis, 29–33, 30–33, 51, 51
 line length, 43, 43
 over-formality, 50, 50
 using conventions of typewritten texts, 4, 5, 44, 51–2, 51–2
Expert Collection – Adobe name for extended character set, see character set
Expert Set – Monotype name for extended character set, see character set
extended character set, see character set

F3 – Sun font format, 63, 68
film, in imagesetters, 73
fit – overall tightness or looseness of character spacing in original design of typeface, 15, 15, 17, 41
fitted numerals, see numerals (horizontal spacing of)
fixed width characters – characters with standard width, 27, 28, 96
font (fount) – one size of one variant of typeface produced by particular manufacturer, 89
 actual font – technical term for font, 89
 virtual font – technical term for master description from which actual fonts are generated, 89
 designing fonts, see character (designing)
 numeric identities of fonts, 68
font metrics – horizontal spacing data programmed into character descriptions, 15–16, 96–7
font production, see character
font-independent – characters intended to be combined with range of typefaces, 7
FONTastic, 78, 79
Fontographer, 79, 80, 82, 83
FontStudio, 79, 83
formality, of typefaces, 49–50, 49–50
 of page formats, 50, 50
format of font – manufacturer's style of programming font descriptions (often copy protected), 60, 67–8, 68
Formulator, 8, 9
fractions, 6, 7

genre, and typeface choice, 45–8, 45–8
 and typeface use, 49–50, 49–50
German, 7, 27
Greek, 4, 6, 7, 36, 36
 classical, 7, 40
 diacritical marks, 7
guidelines on typeface use, 45–8, 45–8

half-tone – representation of continuous tone (photographic) illustration as fine grid of dots for printing, 73
hard font – font supplied as sized bitmaps, 58
harmony among different kinds of characters, 8, 11, 35, 36, 88, 88

headings, 18, 28, 29
 medium resolution, 30, 30
 vertical spacing of, 30, 31, 33–4, 33–4
Hebrew, 35
hints – programs to adapt outline fonts designed for high resolution to medium or low resolution, 62-4, 62, 67–8, 78, 84
 semi-hinted fonts – fonts with a minimum of hinting information, 62, 63
 unhinted fonts – fonts that have no hints built into them, 62, 62
horizontal spacing, 15–18, 15–18
 within characters, 41, 96-7, 96
 of characters (character or letter spacing) – horizontal space between adjacent characters, 15–18, 37, 39, 41, 84, 97
 of words (word spacing) – horizontal space between adjacent words, 37–41, 38–9, 41
 optical adjustment of, 15
 software interpretation of, 16, 16, 39
house-style – individual's or institution's style of presenting text, 50
hyphen, 4, 5
hyphenation – 'intelligent' breaking of words at line endings, 38, 41–2, 42, 45

IKARUS, 79
imagesetter – high resolution output device in which laser beam exposes sensitized paper or film, 11, 60, 64–7, 66, 73
 film in, 73
indexes, 13
inkjet printer – medium resolution output device, viii
inline (stroke description) – character descriptions comprising single strokes of different thicknesses (and shape), 57
International Standards for character sets, 5, 99
italic – inclined variant of typeface, 87–8, 94
 in emphasis 29, 30
 legibility of, 13, 88

justification – adjustment of word spacing (and, in some DTP software, of character spacing) to deliver text with straight left- and right-hand margins, 16, 37, 38, 41–2, 42

k-p distance, 93–4, 94
kerning – adjustment of fit for specific character pairs, 17–18, 18, 97, 97
 kerning tables – kerning data for a font, 17, 97
keyboard map, 2

large print, 9
laser printer – medium resolution output device, 65, 70–2, 70–2
 image quality, 70–2, 70–2
 improving clarity of output, 72
 paper quality, 72
 write-white and write black 70–1, 70–1
LaserJet III, 71
Latin, classical, 26, 27
 in type specimens, 19, 26
latin-script – scripts with characters derived from those used in Latin, 5, 10
 character distribution of, 26
 legibility of, 6
leading – in metal type, strips of lead inserted to increase vertical spacing of rows of type, 39, 95, 95
 in DTP, see vertical spacing

legal texts, 27
legibility, 10–14, 30, 42–3, 46, 46, 60, 83
 testing, 11–12
letter spacing, see horizontal spacing
letter-spacing option in software, see tracking
letterform, see character shape
ligature – combination of two or more letters in one character, 5–7, 17, 17
line feed or increment, see vertical spacing
line length, 39–44, 43
linear scaling, see scaling
lining numerals, see numerals
lists, 13
lower-case letters – small letters (as opposed to capitals), 16, 95

marking beam, of raster device, 64
 spot size of, 30, 70–1, 71
mathematics 7–9, 28
MathType, 8
measure – width to which rows of type are set, 37–42, 38
 see also line length
measuring type, 91–5, 92
 measuring page dimensions, 92, 93
METAFONT, 58, 80–1
Metamorphosis, 83
Modern – a historical class of typeface, 23, 23
monospaced characters – characters with letterforms designed to fit standard width, 96, 96
musical notation, 9

NeXT, 64
nominal size, see size
non-latin scripts – scripts in which characters are not derived from those used in Latin, 9, 26, 53–4
 combining with latin scripts, 35–6, 36, 82
 designing characters for, 77, 82
non-linear scaling, see scaling
non-ranging numerals, see numerals
numerals, horizontal spacing of, 27, 28
 non-ranging (Old Style) numerals – numerals, not aligned to baseline, designed to harmonize with letters in text, 7, 27, 27
 ranging (lining) numerals – numerals of same height, aligned to baseline, 27, 27
 numerals in tables, 28, 52, 52
 numerals in text, 27

Old Face – a historical class of typeface, 23, 23
Old Style numerals, see numerals
optical scaling, see scaling
outline – description of boundary of character image intended to be filled in, 56, 57, 60–4, 61–3
 advantages of, 60
 creating outline characters, 78–81, 80
 disadvantages of, 62–4
outline font – decorative typeface variant that approximates outline of character shape, 50, 88

paper, quality in laser printing, 72, 72
 quality in printing, 74
page description language – programming language connecting input and output device(s) of DTP system, 65–7, 66
page format, 43–5, 43–5

page samples, see specimen pages

PageMaker, *18*, *37*

parallel texts, 37–8, *37*

pi font, see symbol font

pica – 12 points: in DTP usually 4.23 mm; in printing 4.2 mm, 91

pixel – smallest unit of information that can be displayed on an output device, 58, *58*, 65

photographic processes, 69, 73, *73*

platemaking, 69

photocopying, 14, 69, 74, *74*

point (*abbr.* pt) – unit of type measurement: in DTP usually 0.3528 mm; in printing 0.351 mm, *91*–3

Polish, *4*, 27

Portuguese, *12*, 27

PostScript – Adobe's page description and character programming language, 64, 67–8, *68*, 78, 80–1

printing, 14, 69
 inking in, 74, *74*
 from medium resolution originals, 74, *74*
 paper quality and, 74, *74*

printer font – font description that renders characters on output device, 63

programming character descriptions, 53, 66
 in *PostScript*, 80–1
 in *METAFONT*, 80–1

proportionally-spaced characters – characters with variable width, adjusted to shape of letterform, 28, 96, *98*

pt, see point

punctuation, 52, *52*

quality control, 73, 75, *76*

QuarkXPress, 16, *16*, 95

quotation marks, 51, *51*

quotations, 34, *35*

ragged right, see ranged left

ranged left (ragged right) – text aligned only to left-hand margin, 12, 16, 31

raster – horizontal sweeping motion of beam laying down image, 64, *65*
 variation in laser printer rasters, 71, *71*

raster beam – marking beam in imagesetter or laser printer, 64

raster image processing – the conversion of images, described in outline or bitmap form, to instructions driving raster beam, 64–7

raster image processor (RIP) – interface converting input program to instructions that drive a raster device, 66–7, *66*

reading processes, 10–11, 37

resolution – frequency of signal and, therefore, refinement of detail on output device, *56*, 57–65, 62–3, 71, *71*, 84, *84*
 printing and photocopying from originals at different resolutions, *69*

Resolution Enhancement – proprietary name for Hewlett Packard technology to increase clarity of medium resolution character images, 71

reversing out – light character images on dark background, 13, *13*, 16, *16*

RIP, see raster image processor

rivers – irregular areas of space between words in justified text, 42, *42*

robustness of character images, 69, *69–70*, 74–5, *74*

roman – upright type used for text, the equivalent of 'plain' in DTP systems, 87–8
 distinction from bold, 30, *30*, 69, 74, *74*
 distinction from italic in sans serif typefaces, 30

row distance, see vertical spacing

sans serif – typeface without serifs, 8, 21–5, *22*, *25*, 32–3, *33*, 35, *35*, 88, *88*, 93
 distinguishing among characters in, 13, *13*

scaling – altering the dimensions of typeface characters by applying an algorithm, 15, *15*
 of bitmaps, 58–9, 79
 of outlines, 60, *61*, 79, 84
 linear scaling – direct application of algorithm to scale type, 15, 89
 optical scaling, (non-linear scaling) – scaling adjusted to visual qualities of characters at particular sizes, 15, 89

screen font – font description that replicates printer font at resolution of screen, for bitmap character descriptions, 59
 for outline character descriptions, 63–4, *63*

semi-hinted fonts, see hints

setting solid – text set with vertical spacing equivalent to nominal size of font, 95, *95*

serif – small terminal stroke ending a main stroke, 8, 13, *13*, 21–5, *22*–5, 32–3, *33*, 35, *35*, 81, *81*, 87–8, *88*

Seybold, 57

shadow font – decorative variant of typeface that approximates 'shadow' of character images, 50, 88

side bearing – space in character at sides of letterform, 96

size, 36–39, *38*
 appearing size – actual, perceived size of typeface, which depends on its x-height, 14, *14*, 94, *95*
 nominal size – in DTP, the named size of a font, 14, 93–4, *94*
 of non-latin scripts, 36, *36*

sloped roman – inclined variant created by transforming roman character descriptions, 30, *61*

small capitals (small caps) – small capital letters used for emphasis in text, 7, 16, *16*, 88, *88*

soft font (scaleable font) – bitmap font supplied initially as outline from which bitmaps can be generated, 58–9

specimen character set, 3

specimen pages, 19, 21, *21*, *22*

spot size, see marking beam

standard character set, see character set

stem – thicker or main stroke of letter, 62, *62*, 77, 81, *81*

storage, of bitmap fonts, 59
 of outline fonts, 64, 78

stress – alignment of thicker part of curved characters with respect to vertical, 25

stroke description, see inline

stroke – single, curved or straight line in letterform, 81

subscripts 7, 28, 88, *88*

superscripts, 7, 28, 88, *88*

symbol font (pi font) – collection of symbols intended to be combined with fonts of any typeface 3, 7–8, *8*

symbols, 11

tables, 28, 46–7, 52, *52* 96

tabulation, 52, *52*

tail – part of letter below baseline (for example in 'j' or 'y'), also diagonal of 'R', 6, *12*, 88

terminal – stroke endings other than serifs, 81, *81*

TEX, 6, 8

Times, 24

tracking (sometimes called letter-spacing) – global adjustment of character fit for block of text, 17, *17*

Transitional – a historical class of typeface, 23, *23*

TrueType – Macintosh font format, adopted by MicroSoft, 68, 89

Type 1 format – hinted and encrypted PostScript fonts, 68

Type 3 format – unhinted PostScript fonts, 68, 78

type specimen – sample setting of different sizes of the variants of a typeface, 11, 91, *92*, *94*

typeface (typeface family) – family of fonts, produced by a single manufacturer, that have a visual relationship, 19, *86*, 87
 names, 24

typescale – rule calibrated for type measurement, 91

typewriter faces, *4*, 5, 43, *43*

underlining, 30, *31*, 51, *51*

unhinted fonts, see hints

user-defined characters, see DIY characters

variant – style of typeface characters, 30, *86*, 87

Ventura Publisher Professional Extension 8, 9

vertical spacing (line feed, line increment, row distance, in DTP 'leading') – vertical distance between baselines of successive lines of type, 14–15, 37–9, *38*–40
 of headings, 30, *31*, 33–4, *33–4*
 measuring, 95
 software interpretation of, 36, *37*

virtual font, see font

weight – thickness of main stokes of typeface, *23*, 30, *30*

width of characters– degree of spaciousness in horizontal dimension of typeface, resulting from design of letterforms and side bearings *23*, 44
 and justification, 42

Word, *16*, 37

word spacing, see horizontal spacing

write-black, see laser printer

write-white, see laser printer

WYSIWYG (what-you-see-is-what-you-get) display – screen display where character appearance approximates appearance on paper, 59, 63–5
 typeface appearance on, 11, 36, 63, 78
 designing characters on, 78–9, 82–3

x-height – height from baseline to the top of character 'x', 14, *14*, *25*, 33, *33*, 39, *39*, *93*, 94

A note on production

Typefaces for desktop publishing was desktop published.
It was designed and typeset by Paul Stiff and Alison Black
using Apple Macintosh computers. It was written in Micro-
soft Word 3.01; QuarkXPress 2.12 was used for typesetting
and page make up, and for most of the illustrations (except
those described otherwise in the List of illustrations on pages
100–102). Steve Taylor helped with the production of pages
and illustrations.

The sources of the illustrations are given on pages 100–102.
Unless otherwise stated, they were produced by the author
and the designer, and were output at 1270 and 2540 dpi on a
Linotronic 300, via a Linotype PostScript language RIP, by
Alphabet Set, London. The text was output in the same way,
at 1270 dpi. The book was printed by Butler and Tanner Ltd
at Frome; the cover was printed by George Over Ltd at
Rugby.

The main typefaces used are: 10/14pt Monotype Ehrhardt
and Ehrhardt Expert Set (for the text); and 8/9.5pt Linotype
Frutiger Roman and Black (for the captions).

Trademarks and registered names
Macintosh is a registered trademark of Apple Computer, Inc.
QuarkXPress is a registered trademark of Quark, Inc. Microsoft Word is a
registered trademark of Microsoft Corporation. Linotronic and Linotype
are trademarks of Linotype AG and/or its subsidiaries. PostScript is a
trademark of Adobe Systems Inc. All other hardware and software used is
mentioned by name: the brand or product names are trademarks or regis-
tered trademarks of their respective manufacturers.

All typefaces described as 'ITC' are ITC® typefaces in PostScript™ lan-
guage format. ITC is a trademark of The International Typeface Corporat-
ion. All typefaces described as 'Linotype' are Linotype® typefaces in
PostScript™ language format, unless otherwise described. All typefaces
described as 'Monotype' are Monotype® typefaces in PostScript™ lan-
guage format, unless otherwise described. Monotype is a registered trade-
mark of The Monotype Corporation plc. The shorthand 'PostScript' is
used to refer to typefaces in Adobe® PostScript™ language format.
Adobe is a registered trademark of Adobe Systems Inc.

Typeface names
Lucida is a registered trademark of Bigelow & Holmes.
Futura Book, Stone Informal, and Univers are registered trademarks.
ITC Avant Garde Gothic, ITC Bookman, ITC Galliard, and ITC Zapf
Chancery are registered trademarks of International Typeface Corporation.
Frutiger, Glypha, Helvetica, Iridium, Janson Text, Melior, Optima,
Palatino, Times, and Trump Mediæval are trademarks of Linotype AG
and/or its subsidiaries.
Monotype Baskerville, Bembo, Monotype Bodoni, Ehrhardt, Monotype
Garamond, Gill Sans, Joanna, Times New Roman and Monotype
Walbaum are registered trademarks of the Monotype Corporation plc.
Biffo Script and Gloucester Old Style are trademarks of the Monotype
Corporation plc.

SHEFFIELD CITY
POLYTECHNIC LIBRARY
PSALTER LANE
SHEFFIELD S1